Visible: A Femmethology, Volume One

Other books by Jennifer Clare Burke:
Visible: A Femmethology, Volume Two

Visible: A Femmethology, Volume One

Edited by Jennifer Clare Burke

Homofactus
PRESS

Published in 2009 by Homofactus Press L.L.C.
1271 Shirley
Ypsilanti, Michigan, 48198, U.S.A.
homofactuspress.com

Printed in the United States of America

ISBN: 978-0-9785973-4-4

1. Gender Studies. 2. Feminism. 3. Lesbianism. 4. Bisexuality — Women.

Cover Design © 2009 Maria Carbone, Director of Marketing, Homofactus Press, zealotry.com
Cover Photo © 2009 iStockphoto.com/ Kamel Adjenef (loriel60)
Book Design © 2009 Jay Sennett and Gwyn Hulswit

Hire them, please.

Visible: A Femmethology is dedicated to the memory of loved ones
who were lost during its production:

Jennifer Franet, 4.27.75–12.25.08
Christopher Carbone, father of Maria Carbone, 12.27.55–4.19.05
Henry J. Burke, father of Jennifer Clare Burke, 3.31.26–11.29.08

Thank you for your love, independence, faith and ability to inspire.
You are missed. You are loved. You are always here with us.

Table of Contents

untouchable

Introduction
by Jennifer Clare Burke

Welcome from the Editor of Femmethology, Volumes 1 and 2

In interviews and in conversations with *Femmethology* contributors, I am often asked what *femme* means in my life. I have never given a concise or straightforward answer. Often I say I *do* femme as opposed to saying I *am* femme. The difference between those two verbs indicates ambivalence about my gender journey throughout my life. Gender appears to me as a figure seen underwater with rippling edges and indefinite borders.

Femme means I won't compromise on complexity.

I don't have a neat, compact answer because my definition of femme can't be painted with black and white lines. Femme isn't linear. My femme refuses to occupy a circumscribed space.

Femme means hard-won energy. Sometimes femme means ambivalent but strategic gender enact-ment. Femme is a place where I still exist on the margins and where I can use ambiguity as a salve for all the gender-related questions I live daily.

Femme never has been a definite location on my map.

As a frustrated femme situated in more than one queer community, I have chafed against the practically codified definitions of femme and constrained scripts I've encountered. I have experi-enced the effects of misogyny and sexism within my queer communities. These ugly shortcomings strongly informed my selections for *Femmethology*. I chose essays that stretched the parameters of femme and called the queer community to be tolerant of complex identities and the life situations that may contribute to such identities.

Femme means I don't have to make it easy for you. It certainly isn't easy for me.

Above all, my femme is not your femme, which is the good news. Such unique differences can inspire vibrant political rebirth. These differences can become the situs of the work to be done on ourselves as community members who must individually decide whether to be inclusive of com-plex identities that we may not understand.

Femme means my sexuality, my partner choices, my definitions and my gender presentation might not match your labels.

As a queer femme, I was reassured and relieved by the strong, unique, fearless, complex view-points in these essays. I found peers who couldn't—and frankly wouldn't—play by any perceived status quo rules for How to Be Femme, How to Look Femme, How to Act Femme, and so forth. I found individuals who were just as concerned about disability rights, body politics, transpho-bia, class differences and biphobia. I found writing that dissects the impact of race and national

identity on queer politics as well as the politics of marriage, sex work, sexism and misogyny in our communities.

Through editing *Femmethology*, I realized I wasn't alone.

I saw plenty of views to which I have never related, but I realized that those lived narratives nonetheless formed an essential part of our community. The editing process showed me that I had to make inclusion a priority.

This anthology's content mirrors the story of this anthology's production, which was similarly loaded with pain, joy, frustrations, victories, setbacks, and new opportunities. The story of my editing *Femmethology* is also the story of helping my dad to die of cholangiocarcinoma and of being his primary caretaker on a twenty–four/seven basis for five months, from the diagnosis to the heavy morphine injections that led to his fatal respiratory failure.

In fact, in holding this book, you are holding tangible evidence of Dad's ferocious insistence on perseverance and believing in my writing projects. *Femmethology* represents my father's pit bull attitude as applied to literary practice—he himself agreed with this statement the night before he lost his mental clarity and, within a couple of days, his life. Dad died on November 29, 2008, and I submitted the two volumes of *Femmethology* on December 2 and December 3, 2008, to Homofactus Press.

Words and work took on a hyperkinetic power and meaning at the completion of *Femmethology* and of Dad's life. Dad's last words, our connection together, my writing, and my projects with Homofactus Press (which has genuinely believed in me, as did Dad) have since been joined permanently in memory. Accomplishing the last pieces of *Femmethology's* assemblage involved communications that were as much about writing as they were about my feelings about Dad's cancer and what pieces of humanity remain when doctors cannot find a cure for mortality. For example, I sent the email below on December 2, 2008, to Maria Carbone (Marketing and Promotion Director) and to Jay Sennett and Gwyn Hulswit (the founders and owners of Homofactus Press):

> At 6 pm, Maria, please send to me the Word docs [of *Femmethology*] at their most advanced stage.
>
> I'm so thrilled that the Word docs are already so together and so purty to boot. Wow.
>
> *Femmethology* might have been severely derailed and also compromised in quality if you, Maria, had not come through for me and this book. I want my forward to discuss your role and the backdrop of what was happening as all the important parts of this book came together.
>
> The biggest smile for my dad - while he still had his mind before his pain and fluid exploded again on Wed. morning - was on Tues. evening when I told him my progress on *Femmethology*, and that *A Life Less Convenient* was coming out again through Homofactus Press. He talked about what he thought of it....Then he told all the nurses about it. Little could I ever suspect the horror of what would come out of his his mouth 48

hours later [as his brain and body deteriorated into horrors], but anyhow, our last happy memory together is forever fused with his encouragement of, and appreciation for, my writing, my way of engaging the world, my investment in myself in quite a few things despite the stuff that would have signaled "give up, move on" to others.

Because the last week of Dad's life coincided with the last available work days before my *Femmethology* deadline, I needed help with triaging tasks as I corresponded with over fifty writers, some of whom had more than one substantial piece included. I could not have brought *Femmethology* to completion without the help of Maria Carbone, who became my hands and brain when I needed to deal exclusively with the contributors' finalized edits and essay placement in the volumes as well as manage the impact of death, then the undertaker, the needs of my dependent eighty-one-year-old mother, Dad's belongings, and money, money, money. During those last days of frenetic work, Maria simultaneously maintained her position with Homofactus as Marketing and Promotion Director for *Femmethology*.

Maria, Jay, and Gwyn were my backbone in helping me to complete my tasks as editor in the midst of a medical crisis and death while managing my chronic lupus symtoms. They assumed organizational and administrative work so that I could focus on facilitating the best writing possible from *Femmethology* writers.

I couldn't have been more pleased with the results of *Femmethology*'s call for submissions, and then the selected writers truly outdid themselves through revising and collaboration. But you don't need to take my word about contributors' excellence: the evidence is at your fingertips right now.

This is who we are.

This is *Visible: A Femmethology*.

Publisher's Note
by Jay Sennett and Gwyn Hulswit

We wish to thank Jennifer Clare Burke for her integrity, competence and professionalism; Maria Carbone—our marketing guru—for her wit, unique sense of typographical and graphic style and for understanding who we are and what we are about; and to all the contributors for their work.

We have endeavored to maintain the vitality of the English language. You will, in this volume, find Australian English, British English as well as several forms of American English. We realize that on matters of grammar and diction, verbal wars have been fought and style manuals written and updated.

Rather than attempt to make contributors conform to styles that are incorrect for the form of English they use, we have decided to let contradictions, both endnotes and footnotes, and seeming errors of grammar run through these pages.

English is, we believe, like gender—too dynamic to force into one style.

Diesel
by Daphne Gottlieb

adore / graffiti / honey[1]

I loved that bar. It's different now, of course, but back then, the beer was cheap, the booths were sticky, and the jukebox was a tawdry caterwaul. It was just dark enough and the staff was just busy enough that you could get away with just about anything in a secluded corner or beneath a table. Or on a barstool.

From the phone number exchange to the full-frontal lip crush, night after night, there were girls, free drinks, unblushing propositions, girls, and phone numbers.

For me.

And it was a straight bar.

It was my favorite bar, no question. The cheap beer started it, but the kisses and phone numbers sealed the deal.

While I wasn't complaining—I mean, who would?—I was highly confused—why here? Why me?

One night, before the bar approached its prime sardines-at-rush-hour capacity, I asked the bartender what was going on—after all, she was a straight girl, and she knew this bar inside and out.

"So tell me," I asked her, gesturing as best as I could with my forearm stuck to the bar in used beer, "How do all these straight girls know I'm queer?" She raised one perfectly twigged eyebrow at me from under jet rockabilly bangs. One side of her bee-stung mouth twitched up in a smirk. "That's what I was going to ask *you*," she said, teetering on her heels to go pour a beer, leering back at me over her illustrated shoulders.

ransom

The right way to pluck your eyebrows (get them waxed), the right height for shoes (not this year), the right era to emulate (but without shoulder pads, maybe this time with crinolines, more subversive than what's in the magazines, piss elegant and disruptive, you may pass for them, but you don't fool me, you're clocked).

underground / shag

I came into punk rock and fashion around the time I was fourteen; an understanding of my queer sexuality past simple desire came only a little later. Punk rock made sense to me not only aesthetically, but also emotionally—the capital *Fuck You* in every stompy-booted step was satisfying. Punk rock was a relief—it showed me that I was fine; it was the culture that was fucked.

1. All section headings are names of Urban Decay makeup products. The line was launched in 1996 with the slogan, "Does Pink Make You Puke?"

In college, women's studies armed my dangerous. Though I'd been dressing like a freak because I liked it, it turns out that I had also smartly seceded from the phallogocentric heterocompulsory economy (or something like that) and was participating in transgressive performative acts of gender treason (even while I thought I was just dressing funny). In other words, my politics and my aesthetics both said the same thing: Fuck You. I'm Not Wearing Stilettos. Unless I Feel Like It. My Other Stiletto Is A Knife.

And with that, I thugged my way across the country and landed, steel–toe first, in San Francisco. Back then, it was arguably the Butch–Femme Capital of the Universe, full of pretty little perfect femmes and perfect rugged butches. The perfect femmes pursed their pretty little lips at my suede–like shaved head, flicked imaginary lint off their pretty little skirts, and flocked away with each other. It was quite a performance. It was arguably a transgressive gender performance. But boy, did it suck for me.

The story has a happy ending, wherein soon thereafter, I found the Punk Rock Femmes, who looked like me, whom I made awkward, then real, friendships with. I knew in the PRFs, I'd found home—we talked about *substantial* things, like politics and hair dye, and not silly things, like politics and eyebrow waxings. A year after I met the PRFs, the queer scene suddenly trended punkwards—the stores were full of plaids and zippers and everyone ran to the corner drugstore to buy clippers. The Perfect Femmes, with their newly shorn heads, let me in. They wanted to know where I bought my boots. And they wanted to know the other PRFs, too.

zero / sting
The point is, I don't want to be like you. The point is, I don't even like you. Do I need to spell it out? Stop acting like you acted in the rest of the world, back in the straight world. Stop acting like that, or go back.

fishnet / heat
It was a pretty perfect San Francisco Saturday morning about a year ago—the day had started with the waking–up–and–rolling–into–sex, a lazy stroll to brunch with my lover, a lazy stroll back to bed with bellies full.

This being San Francisco, I saw people I know on the way to brunch and back, people who later asked vague questions like how I knew him, if he'd always gone by that name, and whom he used to date.

After the second friend's vague line of questioning, I caught on. They were trying to figure out if he was trans or cisgendered.

I'm tall. I am used to being about a head taller than my dates. This date, a few inches shorter than me, was, like me, cisgendered and, to the best of my knowledge, pretty solidly heterosexual.

On sight, by reputation, I'd queered a straight man.

On his turf—in the bars he frequented or the like—I don't think the reverse was true. No one thought I was straight because I was with him. But then, I live in San Francisco, and it's not unheard of for dykes to date men. And it's not unheard of for straight men to date dykes. And it's not

unusual for gossip to result. Because *she's not really a dyke. She can't be. But she sure looks like one.* It's not unusual, in San Francisco, for straight girls to dress like femmes. If a straight girl dresses like a dyke, how do you know she's not a femme? If you have to ask, you're not paying attention.

peace / scratch
If you've been paying attention, you'll know: you can probably tell. The femme does not look you in the eyes or she won't stop. She is the one flirting with girls or the wallflower. She's the one who hangs out only with other femmes—and with her guy pal.

afterglow
I believe this is the way the knowledge runs: butches are visible by virtue of their transgressive female masculinity, but are further endangered when their gender(s) are read in the presence of a femme, the "female" of the species, recognized through her bright plumage. Poor, poor invisible femmes, only visible when endangering another. What a plight.

What bullshit.

If you feel invisible, you have every opportunity in the world to make yourself visible. You can rock "Hothead Paisan" pins or wear your Ani t–shirt everywhere. You can embroider your retro apron with the legend "Muffdiver" if you want. Hell, nothing but good taste is stopping you from doing all of the above at once, or tattooing "I AM A BIG LEZZIE" on your forehead if you want.

Am I being silly and reductive? Absolutely. Femme visibility is as slippery as we are and sometimes, like black ice, we are barely perceptible. It's a privilege to be able to pass.

And it's one that I largely forego. But I live in San Francisco, and this is my choice. I hear a lot of whining about femme invisibility, but I see women, a lot of the time, making every effort to pass and then complaining that they pass. There's no question that (some) femmes are subject to invalidation by fitting into the more "traditional" gender roles (*you can't really be a dyke—you're so pretty*) as well as misogyny and gender stereotyping even in our home communities (as one butch said to the butch I was out with, *Don'tcha hate it when your girlie shows too much?*). I am not trying to diminish—for a second—the very real, essential right we have to make ourselves in our own image. Whether in Laura Ashley or Xena, Warrior Princess garb. But I am trying to point out that we do have agency. We have choices. We have visibility if we choose it.

exhale
(because seeing her saved my life, because she looked like me, because she knew me without knowing me, without having to, because her life was mine, her haircut, the places she'd walked in her boots, because I knew how to find her because of how she looked and she welcomed me home; when others had slammed the door, she welcomed me home)

score[2]
I go by "diesel femme" most of the time. I can't just claim "femme" with a straight face. It's too

2. Some of the rhetorical style used in this section owes a debt to "In Exchange for Forty Acres" from *Growing Up Free In America* by Bruce Jackson. The use of literary structure should not be misread as collapsing these two very different struggles for reclamation into each other.

"good girl" for me. I am messy. I am a Tura Satana femme, a Diamanda Galas femme, a Mary Magdalen femme. No Donna Reed here. (And isn't it odd that I can only come up with transgressive/queered representations of transgression from the "straight" world, not "authentic" queerness? Yeah, you got me on this one.)

But I have earned "femme," and it is mine now. I have earned it in sneers and whispers from queers and hets alike. I have earned it in hours of soul-searching and shopping for women's shoes in large sizes. I have earned it in your words at all the times I was told I was doing it wrong—too roughly or too angrily or too loudly or in the wrong color or the wrong size.

I have earned "femme," and I am keeping it. You can't have it back. I am a femme when I am in bed alone, when my hand is in a man's or when I am being flirted with by a straight girl. I am a femme when I brush my teeth and I am even a femme when I am Daddy. Which is to say: if the plethora of queer identities and of post-nuclear family constructions has interrogated traditional gender and family structures, femme self-representational production can't help but interrogate traditional feminine representation, provided the reader can see the handwriting on the wall.

So maybe I'll drop the "diesel." Just to piss someone off. It could happen.

Because this, too, in size 11 boots and bloodspurt-red lips—you bet your sweet ass this is femme.

Transition
by Allison Stelly

It is a familiar story by now—that we femmes are inevitably invisible in the straight world and queer world alike. Unless, that is, we have a butch by our side to out us.

I long reveled in playing the lady for a steady stream of butches. The old-school bulldagger, the young boi-dyke, the metrosexual butch, and at least one of the I-don't-believe-in-labels-and-therefore-won't-call-myself-butch types. (For the record, they are sometimes the butchest of them all.) I loved all types (and loved them well), but regardless of the particular butch, I especially loved the look of recognition I would finally get from other queers when out with my lover. I cherished that fleeting moment of visibility.

And I loved being visibly queer in the straight world. I loved that my lover's presence thwarted questions: "Are you married? Got a boyfriend? Looking for one?" Even when she wasn't around, I could respond: "No. I have a girlfriend," and I loved those looks of dawning realization. See, I hated that I moved through the world with straight privilege, with the assumption of "normality" in the eyes of employers, coworkers, other people on the bus, distant relatives. It didn't matter how short my hair or nails, didn't matter if I was in jeans and combat boots instead of a skirt and heels; I was always seen as a straight girl. I was acutely aware of my lover moving through the world in an entirely different way, and the only way I could right this imbalance was by coming out at every available opportunity.

By now, I'm sure you've noticed my use of the past tense.

My partner was a butch dyke when we first met, or so I (mis)labeled him. Soon enough he told me that he wanted to transition, wanted the outside to reflect the man he is on the inside. He has mostly succeeded in that plan, and soon I will no longer have a butch to out me. It is a familiar story too, yes? At least, this is a story I'm hearing over and over from my fellow femmes. When our partners transition, when our partners become men: what does that mean for us?

I find it hard to pinpoint what "femme" means for me now. When I first claimed "femme" for myself, I meant it as in "butch/femme." But of course, I knew I was still femme when not with a butch or even (gasp) when sleeping with a fellow femme. My femmeness was not dependent upon having a lover or the gender expression of that lover. Still, I knew that (sexually and romantically) I thrived on the erotic space that exists between a butch and me: the femme/butch dance, some have called it.

I used to define femme as "intentional, performative femininity," and although I still recognize this definition as true, I am also aware that not everything about me is intentional or performative. Yes, I am aware of the ways in which I intentionally "do" femininity, but why do I do femininity in the first place? Not every femme mannerism of mine is intentional or conscious. I don't fight 'em, but I didn't necessarily choose them either. Sometimes, I have to admit that it's not always about deconstructing or reconstructing or subverting the dominant paradigm: I just really like the way

skirts feel swishing around my legs or the feeling of my eyelashes heavy with mascara. I'm a girly girl, plain and simple.

Oh, but it was always so delightfully queer to be such a girly girl but know that I was going home to my butch. To walk arm in arm with her, knowing how visible we were as queers. To be performing femininity not for the gaze of men. That felt powerful, transgressive, subversive. What am I subverting now that I am in a heterosexual relationship and my femmeness is for the gaze of a man?

Of course, his transition has not suddenly made me a straight girl. I haven't changed. I still feel the same as I did before. I still feel like a queer femme. But in many ways, this is my transition as well, as how I am perceived has changed. Or rather—not how I am perceived but how we are perceived. To have gone from being a visible butch/femme couple to a heterosexual married couple, I define and redefine femme, attempting to make it fit me. Can I even still be a femme when partnered to a man? Can I still be femme even when I'm not seen as one?

I can no longer conveniently drop a female pronoun to let the world know who I am. Now, it requires more complicated conversations, finding ways to drop hints. I mention living with my ex–girlfriend, talk about my involvement in the drag king scene. But my disclosure inevitably intersects with his desire for privacy: if I talk about my queer history, then my audience eventually wonders how I married a straight man, and my partner doesn't necessarily want me telling the entire world that he wasn't a man when we met.

It is most painful to think of losing what little visibility I have within the queer community. Queer spaces have always felt like home to me, even when I haven't always been immediately recognized as a member of the club. Like most femmes I know, dykes have approached me in the bathroom, asking whether I knew that I was in a gay bar. I've overheard them tell their friends, "I think she's straight." But I felt at home, especially once I made friends with other femmes, butches, gender-benders, drag kings. They never asked whether I knew what kind of bar I was in.

My partner is often still seen as a butch in the queer community, even though he's read as a man all the time in the straight world. Or people are aware enough that they see him as a transman. But his facial hair is coming in more and more, and one of these days, we will walk into a queer space, and we will just be seen as a straight couple. He's excited by this idea—in his mind, this will prove that he's really "made it"—but I know I will mourn that day.

Snapshots: Being Femme, or Doing Femme
by Katie Livingston

When I was small, I'd crouch belly on knees, one hand resting on the cool, blue tile, the other creaking open the chipboard cabinet doors, pulling a dusty box of snapshots from far back on the shelf. I'd rifle through the family photographs, not art but history, telling myself stories about the people caught in each frame, a child's narrative based on what I saw there. I've only recently come to realize that the more interesting stories are those in the background of other stories, or at the margins, half cut off.

Snapshot, childhood: my Mother is standing to the left of a navy stroller, holding my baby brother, just born.

Sunny May suburban walk, Mom pulls on her red, terrycloth tube top, straps the baby into the stroller, safe. I am pigtail–braided and far ahead, at the margins of the story, observing. I'm riding my blue lightning bike, wobbly on new training wheels, streamers rustling, pedaling hard. Mom calls to me, "Sweet face! Not too far." I look back, and she's a speck.

All that baby does is smile. People stroll by, and it's all giggling, toothless grinning. Pavlov's got his bell, but Baby's got those thick, black lashes, bats them all coy and *ding*: "What a pretty little girl," people praise, to my Mom's dismay. I don't understand *his* satisfied, gurgled response.

This is a snapshot about "feminine" bodies, the ways we move through space and claim it. My baby brother liked the fawning, didn't get much razzing for being girly until he was older. He's just a slip of a thing still, small shoulders like both our parents, and those eyes. Biologically, he is beautiful, and in most eyes, feminine. I've been thinking about who has the authority to name our bodies feminine, how that descriptor marks us, depending on our sex. "What a pretty little girl," they say. Pretty girl. Little girl. They constructed him as feminine, and feminine as female; many of us do.

Snapshot, childhood: I am on the back porch grinning, holding a mason jar full of bugs.

Crouched with my bug book, I net insects as they fly in the cracks of our screened porch, press them between cloudy sheets of wax. I am labeling a fly with a peculiar, flashy blue thorax when my baby brother toddles in, terror–stricken. It starts quickly with a lip quiver. A single, chestnut curl falls over a puppy–brown eye. He doesn't turn, but backs away, begins to scream, begins to wail, his words almost indiscernible noise: "She…killed…it. That fly…had a family, too." A salty mess. Emotional wreck. Dramatic child.

"For the sake of Science!" I yell, superior. "Stop being such a pansy," I say, like it's the worst thing to be. Irreconcilable then, feeling and biology.

Why didn't I pick him up, hold his small, sobbing body to my heart, tell him I love how he loves? I was scared for him, afraid he wouldn't learn to "act right" out there in the world, learn to be

hard, to turn his emotions off. Scared I'd have to protect him forever, that he wouldn't survive. Even before I accepted gender as blurring the boundaries between "supposed to" and "want to," I understood the body as a shaped thing. I think often about how our bodies become gendered, about who has the authority to shape them and why. My femininity has always looked acceptable until I open my mouth, uncorked, sharp words hiding a softness my brother can't hide, a gentleness that just *is* inside him. If gender is constructed, why do we still associate feelings with femininity and femininity with weakness? From this angle, the picture is more complicated than either society or biology, gender as both constructed and embodied.

I live in a body labeled female since that slap on the ass when I was born. The snapshot shows a wrinkly, pink face and a body swaddled, contained. I wonder if it would've been possible for either of us to become anything else. I hear my mother's voice on why I can't possibly be queer, "But you wore dresses! You played Barbie until you were twelve," as if gender and sexuality are synonymous, as if sex and gender are dichotomies, manageable, finite options, enough. I am writing about the lessons we teach each other about how to be men and women, like if they'd just taken away his baby dolls sooner...as if there's no agency in becoming who we are. Our ideas about gender are shaped by those closest to us, our families and chosen families, people just as scared of transgressing as we are.

Snapshot, recent: a big, red ball is rolling to a stop at a chain link fence, the picture blurred.

Recently, I joined a queer kickball team and have been using it as awkward fodder for conversation with my parents, leaving out the queer, assuming they'll work it out. Before he knows how to stop himself, my Dad says, "We used to play Smear the Queer where I was from. We'd gang up on anyone too wimpy to play Slaughter Ball. We'd look for their fear and just clobber them."

"Oh, yeah?" I try to avoid engaging, avoid debating gender politics.

"Yeah! Always chase the little guy," he says, like it's Science. Survival of the Fittest.

"And the little guy was you?"

"Well," he thinks, "yeah, I guess it was."

In this moment, I understood so much about fear and survival, about the danger of being in between. I never fool myself into believing I am safe because I'm femme, because in some spaces I pass as straight. I know, like I know my own body, the fiction of safety, the way a person can become a photograph, the real story just outside the frame. I wonder how much of me is "doing" femme and how much "being," what parts of my femininity I learned from my brother, my father. There is something so powerful in constructing femininity from such unlikely sources, something so queer.

Snapshot, childhood: I am arm-in-arm with my father's first daughter, my older sister, in our shared floral and lace bedroom.

Sssnap. My big sister holds that hot pink Sassoon curling iron close to my head until I hear my

bangs *crack crack* against the heat. She teases and sprays, teases and sprays, while Janet Jackson's "Rhythm Nation" plays out of the tiny, pastel purple boom box near my floor–to–ceiling mirrored closet doors. My sister is fierce in a time that means teaching my much shyer kid–self the Running Man and big bangs that smell like burning. She does femme before I know the word, one hand on a thick hip, hot–pink lipstick, and that trick of cutting her eyes at me, hard.

Years later, she reappeared in the picture, this time out as lesbian, a femme fuck you. It is partially her eyes, a hardness, that characterizes femme for me, a refusal. My eyes are defiant. They say, I will not become who I "should be," but neither will I deny who I am because it looks like what is expected of femininity. In this way, femme is an action, a set of norms about femininity and the ways we transgress them, now the snapshot and the photographer, the lens, the light.

Femme is femininity taken back from being the object of the masculine gaze. I refuse to be confined, defined by masculinity. I am more than masculinity's opposite, more than traditional femininity's complement. Femme is subject: me writing about femininity, about femme, as the expert on my gender identity. In this way, femme transgresses expectations of women, but also expectations of femininity. We speak. We are both noun and verb.

Snapshot, coming out: my brother and I are half–smiling, pained, him with purple spiked hair, my hair cut short as it's ever been.

I hear my brother and our dad tussling before I see them. Reading in my room, *smash, crash,* I get to the top of the stairs, and there's my brother's Waldo lunch box all splayed open on the floor, glitter makeup everywhere. He is defiant, fifteen, wiping his snot on the worn sleeve of his too-small tee. Eyeliner smeared down thin cheeks, he glares but doesn't speak, collecting his makeup from the tile like some kind of trampled drag queen. I'm home from college, fresh from my girlfriend's dorm room bed, trying to pretend I'm less queer than I am.

It just goes on and on: "I don't like how you dress!" my Dad's yelling.

"Fag boy! Freak," in the hallway, him running. They shape him up. They shape him into something he's not. You ask him now, he'll call it "a phase." He'll bat those thick, black lashes, laugh, "Remember when I used to wear makeup? That was funny, man." He'll use his deeper voice, but he still talks with his hands.

My hands have always been rougher than his, and though I don't quite fit, still, I survive, revising what it means to be feminine. It is hard and daily work to be visible, to make clear my desire for other women while maintaining who I am: still full of sass and far ahead, rough around the edges, gruff–voiced, but not that tough. I am claiming my space in queer communities, moving hips first through the frame. I am writing about desire: mine.

** femininity as the opposite of masculinity vs. femme as a creature all its own. hmmm...*

Not so Much "MTF" as "SPTBMTQFF": The Identification of a Trans Femme-inist

by Josephine Wilson

I find it hard to give myself a label. In fact, I find it almost impossible. There are only two identifiers that have ever really stuck: the first being femme and the second being trans. Oddly, out of the two, femme kind of came first, even though I had realized I was probably trans-something before finding out what a femme even was.

To clarify, I first started to try to find out "who I was" at the tender queer age of early twenty-something. At that time, I found it hard to find a "trans" identity that actually fit. Through some interesting trial-and-error social experimentation (ok, going to a bar or two in London's Soho district), I realized very quickly that I wasn't a gay man, as I initially suspected from my desire to be more female. No, I realized, I was probably more like the people I had seen on the thoroughly non-exploitative *cough* *cough* talk show that I had seen on morning television—I was probably a "transsexual." Or at least something like that.

I was a bit worried because the people I had seen on TV were so frightened of exposure that they appeared only in silhouette. Also, I sensed there was something different between myself and them. I couldn't tell what though. There was a lot of our experience that matched: I too had never felt "male" and only felt like I was playing a role when trying to be "a boy" (whatever that was). I too felt completely out of place in my gender identity and felt like expressing myself. I too had been known to swap clothes with female school friends at a young age—both parties appreciating the opportunity to dress more freely. However, I didn't want to hide like the people I had seen on TV.

The sense of being "different" was even more apparent when, after realizing I wasn't a gay man, I decided to go to some trans support networks to find out who I might in fact be. Now, I need to qualify some of this story before I go further. I know the particular support networks that I attended are really important and useful for some people. They offer a safe haven to the most vulnerable of our community—the ones that cannot be out anywhere else—in a culture that is completely hostile to trans people. Nonetheless, it was a really difficult experience for me. I went there, a complicated trans girl: in a skirt, I still used the boy name I was given at birth and still called myself "he." I wasn't sure that I would ever change my name or pronoun at that time, but I knew that I was beginning to express something of myself. And I knew that was something female-ish.

At the support networks, the people I met didn't understand. They couldn't fit me in, even though they tried very hard. Despite my protests, for example, they gave me a female name and called me "she." They told me what clothes I should be wearing and how I should be acting. I really didn't like to be told what or who I was by someone else, and I told them so. Nonetheless, they were determined to fit me into their mold.

For me, their form of protection and better knowing just boxed me in, and I felt trapped. I pulled away. I felt lost. I didn't have the community that I needed. And I was even more confused. Who

was I, if I wasn't like them? We liked the same things—lipstick, high heels, skirts. I just didn't like them in the same ways.

So like any good schoolgirl, I turned to my studies. I was about to start a master's degree in gender studies, and I thought academia was where I could begin to explore my gender identity. I turned up bright and early to my first lecture still not out, but fit to burst. I was ready to study and learn about myself and the community of trans people that was out there. However, what the lecturer said that day, in response to a question by another student, put me back into the closet for another eight months. "Trans? Well some things are just too far out there for me. Why don't you ask [OLD NAME] Wilson over there? He studied psychology and probably knows about these *things*."

I hadn't studied feminism or gender studies very much prior to doing this course. I had studied psychology and philosophy and liked the idea of moving into gender studies when I had learned that it existed in my final year of my bachelor's degree. I thought it could help me discover something about myself. I mean, what could be better for me at the time? *Gender* studies. What I hadn't counted on was hostility from the Gender World I would enter.

Fortunately the majority of my teachers and fellow students didn't feel the same way as my first lecturer, who left not long after this first encounter. Still, at that time, I didn't feel confident enough to come out as trans, and I needed to learn more. I read books and carefully asked around (I thought I was so stealthy—I was reliably informed years later that "everyone knew"). From my reading, I learned that there was quite a raging battle in feminist and gender theory about whether trans people were the spawn of Satan or not. The crux of the issue was that trans women (they always focused on the women) were seen by some as reproducing the patriarchal stereotype, reinforcing the gender binary, and being at best unwitting pawns of the pernicious inequalities perpetuated by our misogynistic culture, and at worst were complicit gender oppressors themselves.

Sound familiar?

In this view, trans women's "traditional" understandings of gender identity and their insistence on wearing skirts and lipstick, meant that they were anti–feminist and regressive by nature in terms of gender politics.

Furthermore, through my schoolgirlery, I discovered that this perspective didn't appear only in academic theory, but also appeared in political and social practice within feminist and lesbian and gay communities. Trans women (and men) were excluded from certain social spaces, support networks and political groups on the bases of these arguments.

I decided to study trans for my final dissertation (subtle, huh?…stealthy like a cat). I found that there were alternative perspectives, written by trans academics and feminist and queer theorists. Some of them argued that trans people actually challenged gender norms by showing that "gender" is something that can be altered, changed and transitioned. Trans people can challenge gender norms by existing between or "beyond" gender. However, often, the problem of gender was laid at the feet of those who were perceived as "reproducing" traditional gender. Even in this perspective, those who looked "traditionally" gendered were not regarded positively in the fight against gender oppression.

I argued strenuously against both positions in my paper. It's never so simple as to say one identity "is bad," and another is "good." Everyone has a problem with gender, I said, trans and non-trans alike, and we all try to solve those problems in our own different ways. Granted, some strategies can be better than others at certain times and for certain people—but to simply dismiss some people's identities out of hand is theoretically and practically problematic. And not very nice to boot.

Of course, that is what I "said." I wasn't quite able to follow through in my own life. At the end of my master's degree, I came out as "trans." Surprise, surprise. But rather than transitioning and choosing the name and pronoun I have now, I stuck with my old name and "he." I wore skirts, dresses, heels and makeup but made sure I didn't pass for female. I told myself at the time that my radical politic was to be male and to dress this way. The truth was that I hadn't found the courage yet to take a chance and to become who I knew that I had been ever since I could remember.

I found that courage finally in "femme," and more specifically in *The Femme Guide to the Universe* by Shar Rednour. Wandering around the bookstore one day, still "sans queer community," I happened across this brightly colored, illustrated book with the fabulous title. I picked it up, being attracted to such things as I am, and immediately became engrossed in the material. Here on these fabulously decorated pages, I found a description of experience that so very closely matched my own. Shar recounts a story of trying to "come out" in a society that is hostile to the "femme-inine." She tells of power that is stifled by this hostility and of the bliss of finally realizing the self in an open and honest way. Furthermore, she said that anyone could do it.

I was immediately smitten, and I devoured the book. When I had finished, I had realized who I was. I was "femme." And I could be as complicated a "femme" as I wanted to be. More importantly, I realized I could be a *trans* femme if I wanted to be. It was Shar's unapologetic reclaiming of the femme-inine that did it. She showed me personally (something I had already figured out academically) that the truly radical act is to be oneself: if one is a femme trans woman, then the only politic I had to worry about is being true to myself. And everything else would follow.

It didn't take long to change my name after that.

I had the knowledge that there were others like me. Sure, most of the femmes whom I read about didn't start off as trans. But I loved their power and their determination to be themselves despite conflict with their own community. I felt such affinity not only because I felt like I was in fact femme, but also because being femme and being trans were so closely related for me.

And so it was by defining myself as femme that I finally call myself trans in the way that I do now.

After changing my name and fully claiming my trans-ness and femme-ininity, I realized I still hadn't found a community for myself. Finding real people who shared my experiences, values and realities in the big, scary real world was something of a daunting task: I had always worried about coming out in my community. I had never met other trans people at that time. I knew very few lesbians, and now that I was a woman, I was pretty sure I was one of those too.

As luck would have it, I finally managed to meet some trans people and lesbians (and other fabulous queers) very shortly after having my revelation. I was invited to the first–ever Club Wotever in London in 2003. It was billed as a completely open queer space (anyone could come: trans, lesbian, gay, straight, bi…wotever). I went and was blown away. There they were. All the people that I had only read about up until then. Butches and femmes, drag kings, trans and non–trans, queers and genderqueers and more. I was smitten again. I felt like I had graduated. I loved it, and I loved how everyone came together. I was welcomed with literally open arms from the organizer, Ingo, and I haven't left since.

What I love about Wotever, and the ethos it represents, is the mixing of everything and everyone. I found there, and in the people I met through it, that identity is an ever fluid thing. There are so many similarities between groups that are often rigidly defined as different, and it is such a shame that we keep each other apart so much.

Over the years, I have thought more about these issues, and have come to the conclusion that identities can be very useful if used in a calm and controlled manner. They give us a sense of who we are and a sense of common experience. The problem is that our culture is too often based on the emphasis of difference and rigidity when it comes to identity. In the LGBTQ community, we are often burned by society telling us that we don't exist, or that we are an abomination of some sort, and so we hunker down and fight back by reinstating and revaluing our own identity. It's a good thing to revalue and reclaim ourselves, but sometimes we do it at the expense of others by accident. As I look at femme and I look at trans, I see two groups who have experienced this phenomenon often. And I see two groups who have a hell of a lot in common. Well, they have me in common for a start.

For me, it was through accepting a femme identity that I finally was able to come to terms with my trans identity. Then I could be out, proud and visible as both. I finally stopped worrying about presenting a "self" that fit into what others might think it *should* be. I stopped worrying that if I wore a pencil skirt or bright red lipstick that people would think I was just a "traditional" tranny or some patriarchal dupe of a femme. I knew who I was, and I know who I am.

As a result, I became more relaxed with my identities, and they became looser. The notion of femme and trans became looser for me too, as they started to flow into one another. The lines became blurred for me between the identities "trans" and "femme" and among other group identities for which I have felt an affinity, such as "drag king," a group that I always loved for their playfulness with gender.

Overall, my borders faded. Now I find that the terms I used to use to describe myself are having to adjust too. Basically, I use trans femme for short, but if we are going to be accurate, perhaps it would be more like "stopped–pretending–to–be–male–to–queer–femme–female." And of course we could pop in "occasional drag king"…and "genderqueer"…and a few other things too.

Oh come on, I am just your basic modern woman, trying to have everything.

The Joy of Looking: Resisting the Couple Fetish
by J.C. Yu

As a single femme, I have received a lot of solicited and unsolicited advice about What To Do over the years about—you know—being Single. It seems that the first and most important question to ask single people is whether you are dating, what you are doing not to be single, or to talk of the day you will not be single. When being interrogated, lectured, or reassured about being single, I find it hard to know how to respond. Truthfully, depending on the day or the season, I have different responses.

These responses include shame (*Oh god, what IS wrong with me? Why aren't I dating anyone right now or married and adopting a child from China or Africa?*); defensive irritation (*Yeah, I'm not dating, and I haven't had sex in months. So what?*); smugness (*Oh, look at you trapped in your loveless heteronormative relationship of convenience, so weak and dependent*); the well–therapized voice (*I feel sad about being single, and like there is something wrong with me, but it's OK to have this feeling. It will not consume me; it comes from my lonely childhood as the daughter of immigrants who was queer but had no words for it*); and the socio–political response (*Why no, I have not assimilated with the masses of queers who agitate for marriage while selling out the most vulnerable members of our community who cannot and will not conform to white, middle–class, mainstream values. But thank you for asking*). Sometimes my response is a mix–and–match of the above. But mostly I either say, "Yes, I'm dating," or "No, not right now," and try to move the conversation along.

The pressure to couple up has always been intense, particularly for women. It goes without saying that society privileges marriage both economically and culturally. Moreover, a woman's sense of self is often tied to relationship status because of this pressure. But there is a particular fetishism of relationships that happens in the butch–femme communities I have been involved with that repels, fascinates, and entertains me, particularly in online venues. For many years, I have belonged to a website for butches and femmes. When I was first coming out as femme, I went there for edification, eye candy, and eventually entertainment.

There have been discussions and people on this particular site who helped shape in constructive and meaningful ways my sense of myself as a femme. That said, when I peruse the discussion forum, I hear more talk about the butch providing visibility to the invisible femme, the mandatory yoking of yin to yang, and a rosy, soft–focus idealization of domesticity vis–à–vis butch/femme relationships (wherein domesticity mostly is a stand–in for femme) that feels fundamentalist at times. It shouldn't surprise me; it dovetails with the current larger lesbian, gay, bisexual, and transgender community's focus on marriage as *the* way to gain equality and civil rights.

I no longer participate as actively on this particular site, but as I approach close to ten years of readership, I am equal parts amused and irritated by the heavy–handed focus on The Couple there. In some ways, it makes sense: the site is for butches and femmes, and there is a rich, often moving history of butch–femme desire and sex as a central organizing and community-building component of our subculture.

There is still something bizarre to me though about scrolling through the gallery and witnessing the Carousel of Couples in which Jo and Ann post pictures of themselves after having just met one week ago, followed by a rush of comments. *Your energy is amazing! You two look so good together! What a beautiful couple!* Six months to a year later, Ann and Jo photos are gone, replaced by Ann and Carmen, and hyperbolic comments follow again. Meanwhile Jo has just vanished completely after posting angst-ridden, thinly veiled poems about a woman who shattered her ribcage to pull out her heart, whole and beating.

I find so much of our representation of ourselves on that website is heightened performance, at times bordering on parody. Without the cues of mannerisms, touch, and tone, people are forced to exaggerate their identities in ways that don't happen offline. People are also able to choose which aspects of themselves to highlight and exhibit on the internet.

One of the biggest ways to gain legitimacy and currency on the site is to partner up and post The Couple picture to accrue as many comments as possible. I have dated members of the site, although only two were as a result of directly meeting on the site, and none of my dating experiences involved months of emails and instant messages before taking an airplane to consummate the relationship with sex and a photo for the galleries. In fact, I have never posted The Couple picture ever out of equal parts shyness, superstition, and a sense of imminent catastrophe I inherited from my parents who grew up during wartime.

One stonebutch I met through this site, Jay, lived several hours from me by car. Charmingly handsome, smart, and old school, he wrote eloquent and witty emails. He lived in a queer resort town; he was well-read and an engaging conversationalist both on and off the page. He was also, as I discovered on our second date, deeply enmeshed with his ex, Jane, with whom he had an almost famous on-again-off-again relationship for close to ten years. The vast majority of our conversation on the second date centered on how she had wronged him, wronged the daughter he was co-parenting with another ex, and how all his friends had been hurt by Jane. It became clear to me that this was someone with *I Still Love You, Jane* tattooed across his broken heart.

It also became clear to me that there were many ways in which we were not compatible, not the least of which was his pervasive romanticizing of aspects of domesticity that did not interest me in the slightest. I am a mediocre cook who would rather eat take-out; I hate doing laundry and often pay to have it done; and I am not a mother. My apartment is not full of the sounds of dogs barking, children playing, me hollering at the butch to take out the trash while I am at the stove stirring pots simmering with hearty stews made from root vegetables, and a pile of button-down shirts from my butch partner in the corner waiting to be ironed. This is pretty much what Jay wanted in a femme, and he spoke of it multiple times and in multiple places, a dreamy look in his eyes. When I confessed my domestic ineptitude to him, he reassured me that it was fine, but did I iron shirts? While there is nothing wrong with his desires for a particular kind of femme, I would not have fit into that pretty, white picket-fence picture. I have always had an uneasy relationship with the domestic. Maybe this is because I grew up watching my mother perform domesticity as part of an enforced femininity. Ultimately she found ways to enjoy domestic tasks and not just endure them. Still, I knew she never made a conscious choice around domesticity, but did the ironing, the cooking, and other tasks because it was expected.

Jay is but one butch, and the website through which we met is certainly teeming with all stripes of butches, transmen, transwomen, femmes, genderqueers, etc. But like all communities, online and offline, certain voices, ideas, and concepts dominate; there are cultural norms and rules. Jay's version of femme was a fairly common one, although he often expressed feeling like an alien in a sea of gender-bending children. Jay also had certain ideas about the topics appropriate to discuss with femmes (girls) and the topics you discuss with butches (boys). He said he couldn't even understand when a femme once wrote him an "emotional" email that involved feelings and maybe even a menstrual cycle. He and Jane inevitably reconciled. I was fascinated by their online gallery at the website where they each posted endless photos of themselves as The Couple, with their dogs, their children. They wrote endlessly about their relationship; no domestic detail was too small to be exhibited. Both of them participated in a thread about the role and meaning of "chivalry" that I found revealing.

I love an old-school butch, but I have come to think of chivalry as part of this fetishism of couples: chivalry is to butch what domesticity is to femme. Both are fundamental markers of what comprise a "true-blue" (Jay's term that he used with me as a compliment, as in "you are a true-blue femme" before he found out that I didn't iron shirts) femme and butch. According to Jay and Jane, if you want to be a chivalrous butch, you must always walk right beside your femme. Should you speed up so that you are in front of your femme, a righteous and true-blue femme will turn around and go the other way, click-clacking away on her stilettos. That's your cue to chase after her and beg forgiveness. You better bring your wallet too because a chivalrous butch pays for everything apparently.

If you, the chivalrous butch, drowned in a puddle in which you had lain your body for your femme to step on your back as a bridge, protecting her stiletto-clad feet, then the righteous femme would be shit out of luck—no butch to protect the righteous femme from puddles or to pay for a cab. Hopefully this femme would have her cell phone and could call 911 to report you, a dead but chivalrous butch, but perhaps a righteous femme has no need for a cell phone, leaving it behind with her wallet, because maybe a chivalrous butch has a microchip implanted in the brain that automatically makes reservations at restaurants, buys movie and theater tickets, and calls 911 in emergencies.

It seems that for all our talk about femme as its own empowered independent identity, standing apart from butch, a gendered identity not dependent on a desire or attraction for butches, it is difficult to imagine and live femme outside desire, domesticity, and codes of chivalry. This is not just a phenomenon on the internet, although it is more pronounced online. My very first image of a femme was in a butch-femme relationship context, when people were just starting to learn about the internet. I was spending New Year's Eve in 1992 with my first girlfriend, having come out after spending my sophomore year devouring feminist texts at the women's college. At the time, I was ready to dismantle the patriarchy under the tutelage of the women's studies professor revered by all the young dykes on campus: a pale, thin woman with buzzed hair and bright lipstick who liked to wear a SILENCE=DEATH button as an earring along with a motorcycle jacket, mesh tops, skirts or leather shorts, and high-heeled, purple cowboy boots to class. My girlfriend at the time was dutifully androgynous like me, short hair, jeans, boxy cotton shirts or button-downs, no makeup, simple earrings.

I spent New Year's with her in her very queer hometown of San Francisco. In a picture of myself from that time, my hair is appropriately short, but resembling a sea urchin, with cowlicks I had not bargained for when I went to get it buzzed as a ritual induction into the white lesbian world at this women's college. I dutifully underwent all the rites in white, mostly middle-class, mainstream, educated dyke space: shaving my head and discarding the long, flowing, floral skirt I had worn out onto the lawn of our campus one day, only to be told that I was "totally femme"—and this was not a compliment. Any vestiges of femininity were suspicious and possibly toxic, as I was reminded many years later when a self-identified boy dyke, who worked as a social work intern at the agency where I was employed, asked for a drag of my cigarette and then expressed alarm that my lipstick might besmirch her radical masculine lips.

And so on New Year's Eve, attired in the appropriate androgynous uniform, my girlfriend and I went to Josie's Juice Joint to hear Marga Gomez perform. That's where I saw them. The butch was in a suit and tie; the femme was all curves and cleavage in a tight, black gown, no motorcycle jackets and jeans for her. Her long, black hair was swept in a dramatic updo studded with bits of sequin and rhinestone. Her lips were a deep red; in fact, she had more makeup on her face than I had seen among my lesbian circle at college. She had one well-manicured hand on her butch the whole time. They were sophisticated, stylish, and sex. Not sexy. In that moment they were Sex.

I stared, repelled and intrigued, as if they were extra terrestrials in a UFO who had landed right in front of me. *Greetings, we come in peace from another planet, dowdily repressed andro girl.* All I could do then was tuck this image of a butch-femme couple away deep in the layers of my cotton shirts, and focus instead on more immediate objects, like Rachel and her girlfriend Maggie.

Rachel was a burly butch dyke at college who favored suspenders and who was routinely mistaken for a man. She was the only one who became upset when I cut my hair, her brow furrowing with disapproval. Her partners were all former straight women she "turned gay"—and whenever I heard this phrase, I had an image of her spinning an unsuspecting lady like a top, faster and faster, until the lady shed her hetero suit in an explosion of light and emerged, *POW*! like Wonder Woman, from the Amazon. At social gatherings, I furtively stared at them while listening eagerly for the morsels of gossip whispered about them. The biggest scandal: Rachel had a *dildo*, and she strapped on a *harness*. I was a naïve nineteen-year-old; I hadn't had sex, and my only kiss had been with the pimply-faced, much maligned Joshua Stewart in the school play when I was fifteen. Thus, I was both intrigued and deeply confused by references to a harness during sex. I pictured her flying in the air in a harness, swooping and diving toward Maggie, aiming the dildo like a missile.

So for a long time when I thought about femme, it was a straight woman being turned gay by the butch with her heat-seeking dildo, or the luscious woman with her hand on her butch's leg, shoulder, arm, tethered. It was in the context of butch-femme romance that I first really felt in a tangible and bodily way what it meant for me to claim femme, not just an abstraction I turned over in my head, ideas from books, websites, films, although that was a start.

I understood femme thanks to a cocky, hot butch dyke, my first butch, who terrified and fascinated me. She kissed me in a Brooklyn subway station in the middle of the night, told me I was "dangerous," and I swooned. She then jumped on the subway and rode it back to my stop. She walked me to my door, kissed me again, and I could feel her looking at me, at my ass, as I fumbled

for the keys at my door, dizzy and flushed. Only when I opened the door and waved to her, did she turn and make her way back to her home. There's chivalry for you. I rushed to report breathlessly to my friend that I had never been called "dangerous." What a femme friend of mine once said to me when I was puzzling in a very cerebral way about this thing called "femme" suddenly made sense: *femme is where I feel a sense of my power in my body.*

But, to tell you the truth, this thirty–six year–old body has not been feeling much power lately. I write to you, dear reader, from the desert, in a proverbial dry spell. Because I have been rather parched and dusty, I've thought about all the advice I've received about being a single femme. I've also recalled the not-so-subtle digs, such as my encounter at Pride with a femme friend from college with whom I've always had a charged relationship. Newly reconciled with her butch, she smugly said in response to learning I was single, "Oh, I am so grateful to have my Sarah. There is nothing out there for femmes. Nothing. You *poor* thing."

It ain't always fun or easy to be a single femme in a smaller subculture that valorizes butch–femme relationships and sees butches as exotic rare breeds in a larger gay world that is single–mindedly focused on marriage as the magic bullet. (And before I sound like some bitter single femme who can't get a date, let me assure you that the tears flowed aplenty from my jaded tear ducts when I saw the pictures of Del Lyon and Phyllis Martin getting married—both times). It's even less fun to be a single femme in a whole wide world that promotes the notion that you need to be part of a Legal We to be Somebody (not to mention get tax breaks and start a real family).

Here is all the advice I've gotten:
- Be more open–minded.
- Be more discerning.
- Go online.
- Go offline.
- Take more risks.
- Investigate your childhood and what you learned subconsciously from your primary relationships as a four-year-old so you can identify the barriers you have erected for true love as an adult.
- Read *The Secret* and visualize your butch and pray and she will come.
- Stop looking because only when you stop looking love will come to you.

This last one I've always found the most galling. How does one stop looking after hearing that counsel? It only leads to internal wars in my already neurotic brain: no, I am not supposed to be looking, so stop thinking about that butch over there and wondering if she is single because now I will never meet her and go on a date with her. Oh no, now I am thinking too much about it, and I am *looking*, oh god I will never date again! Stop looking!

I did conscientiously attempt to use some of the principles of *The Secret* and its laws of attraction. Here is a prayer of sorts that I wrote to attract to me the butch of my dreams:

> O Universe, hear my plea:
> make me an instrument of your peace.
> Where there is scarcity let me sow butch bounty;

Where there is bad etiquette, Old School manners;
Where there is false arrogance, humility;
Where there is utter oblivion, self-awareness;
Where there is inconsistency, steady devotion;
Where there is misogynist posturing, real self-confidence;
Where there is pretension, goofiness;
Where there is hollowness, creative passion; and where there is big dumb poopyheaded-
ness, smart critical thinking.
O, Universe
grant that I may not so much seek
the-you-do-me-I-do-you-50/50-lesbian mutuality;
for it is in receiving that I also give;
it is in bottoming that I am empowered;
and it is in hot sane butch cock that I am born to eternal life.
Amen.

During this particularly vulnerable moment of single life, somewhat discouraged that all that praying didn't work, and unable to master the art of Not Looking, I became determined to get laid. I was adamant that I would not reach the six-month mark of no sex (a personal and randomly set benchmark of shame). I was moved to write to someone whom I always thought of as my butch foil-not the shiny stuff for your food, but that literary device we wrote papers on in high school, a secondary character in a book whose actions and deeds sharpen the focus on the protagonist's foibles.

Without fail, this butch foil posted her personal ad on two of the same sites I frequented, one for butches and femmes looking for each other, and the other, the ubiquitous Craigslist. She had been using the same picture since the late nineties when I first saw her online, and generally the same text, although she moved to work from my city to work at an animal rescue shelter. It was a shot of her with sunglasses on, looking off to the side, tattoos galore.

I often felt contempt for her and her constant ad. God, what's *wrong* with her? She's always single. There were periods when all traces of her disappeared from the internet, and depending on how I was feeling, I would either think about how lovely it was that she had found love, or I would be full of bitter self-remonstrations about how pathetic I was—even the perpetually Single Butch Dyke Zookeeper had found love! But during my dry spell there she was, as constant as the North Star. I thought that writing to her and seeking out a date would kill many birds with one stone: I was keeping an open mind, taking risks, and going both online and offline. And I'd get to satisfy my curiosity: I'd investigate this creature and discover what made her churn out ads so steadily and prolifically.

In fact I noticed that SBDZ had employed a new strategy of simultaneously posting a sex ad on Craigslist, and a Looking for a Kind, Smart, Vegetarian Femme for a Long-Term Relationship ad on the other, more specialized personals site. While this strategy may suggest mixed intentions on her part (surely the writers of *The Secret* would be displeased with her fuzzy signal to the universe), I took it as yet more evidence of SBDZ's tenacity. So I responded to SBDZ's sex ad, the one

that did not seek a vegetarian, the one that did not require this highly allergic carnivore femme to breathe in pet dander and to endure a life of meatless meals.

We exchanged about four unmemorable, short emails that led to an awkward phone conversation where, at one point, SBDZ abruptly asked me if I were gay. Before I became insulted, I remembered that while I had been involved in a meaningful long-term relationship of sorts with her over the years, following her ads, to her I was just a girl who replied to her anonymous sex ad on Craigslist w4w, where the pussy shots roam, and the men and the crazy girls play.

I assured her of my gayness and decided to show her I meant business, moving right into setting up a sex date *(Go offline! Be proactive!)*. I suggested to her that I take the train to New Jersey where she lived—with her house full of animals to which I was allergic—to show her just how gay I was. It was spring: the birds and the bees were buzzing; life was renewing itself as green shoots rose from the earth. And I sneezed and coughed constantly, eyes burning and watering, as the pollen rained down. Yet I was going to amplify this suffering by placing myself in the middle of a zoo to ensure I would not be sexless for a year.

I dosed up on my allergy meds, put on my best lace panties, and took the New Jersey Transit one Sunday morning to the Garden State to meet the SBDZ for sex amongst the dander and pollen. I had told only two friends of this sex date, and they very kindly humored me. "It's hot and exciting!" I didn't feel hot or excited. My eyes felt hot from the pollen though. I tried to remain open-minded as advised, to be not so picky and difficult.

My heart sank to my bowels when I got out of the train and looked across the parking lot. There she was, leaning against a dark SUV—in high-waisted, faded jeans. In other words, the SBDZ who looked promising with her sunglasses and her tattoos, was wearing "mom jeans." There was no escape now; she had spotted me across the expanse. I girded my decidedly un-aroused loins and marched forth.

What cannot come through on the webpage are mannerisms, voice, fashion sense, and chemistry. My SBDZ was utterly charmless, slow, and dull-witted.

Did I mention that she was wearing mom jeans?

At the exceptionally mediocre restaurant, I struggled to eat my runny scrambled eggs. My jokes fell on the table between us like a sad soufflé whisked too quickly from the oven and exposed to a burst of cold air. At one point she asked me if I watched *Law and Order: SVU*, and did I know that Mariska Hargitay's mother was Jayne Mansfield. She told me that when she learned that fact, she understood why Mariska had such a "great rack." In that moment, I knew I needed to find a way to escape, a polite way to say "no thank you," to leave with my feminist dignity intact. Instead I found myself in some trance, ending up at her house, where three birds aggressively bobbed their sharp beaks at me ("Don't try to pet them," she cautioned, "They bite anyone who is not me"); a shaved cat with a terminal illness, his hairless skin an obscene pink, lay curled in a corner gasping for air; two other cats twitched their tails at me indignantly; and a sweet, three-legged dog hobbled about panting.

I perched on the edge of a wooden chair gingerly and tried not to breathe deeply. SBDZ sat on the couch surrounded by her furry brood. When she noted that I was "very far away," I found a way to the couch through the mass of dying and disabled animals; the indignant birds became increasingly vocal the closer I was to their beloved.

All through the sex for the sake of sex, sex I had with no real desire—far away from any sense or source of power—sex to prove obstinately and foolishly some hollow point to myself, with *Law and Order: SVU* playing on the TV, I heard the cacophony of her birds, loudly cackling, beating their wings impatiently as if to usher us along. I said a silent prayer that I would not end up starring in my own Hitchcock thriller. Mostly I was bored, which may very well have been mutual.

It is a testament to this thing called Getting Older that after this comical disaster of a sex date, I didn't, as I would have a few years ago, fall into despair that I was somehow a defective femme, not a wife ironing shirts for my butch and not even a good slut. Because it often seems like those are the only choices: that if you are not going to be a serial monogamist or married for life, you better at the very least play an empowered slut. While I've had my share of hot fun casual sex, it's not something at which I excel like some of my friends, and it's gotten less interesting and fulfilling over the years. But after my tryst with SBDZ, I felt more amused by my femme folly than shame or despair.

Later as I looked through the latest pictures on the butch/femme website of happy couples with their poodles and tiramisu, or femmes in lace and lipstick (no puffy eyes) posing sexily for their future butch partners, I wondered why there couldn't be a gallery where you posted pictures of yourself in the most abject dating situations. It is a very beautiful thing that there are places on the web, in homes, bars, community spaces, where butches, femmes, and other queers on the margins can find each other, find love and even post the minutiae of that love, the accretion of the quotidian of which are lives our made—be it ironing shirts, cooking, walking the dog, or sex dates gone awry.

But in that moment as I gazed upon the glowing shots of domesticity, I fantasized about taking a photograph of myself at SBDZ's zoo, surrounded by the dying cat, the tripod dog, the angry birds, my eyes red and puffy. In an ultimate chivalrous gesture, our photos could exist side by side: the domestic bliss and the occasional pitfalls of single femme life. I dreamed up the comments that could be posted to legitimize my single femme identity. *Girl, you look so miserable! Good for you for putting yourself out there—what a beautiful portrait! I love the energy of mediocre, dissatisfying sex in this picture!*

But, this will also do: the telling of this wonderful, terrible, sometimes abject, sometimes hot, occasionally lonely, always interesting, and not–so–domestic femme life of mine.

A Decade Later—Still Femme?
by Sharon Wachsler

Introduction

In 1997, when I had been chronically ill for just over a year, I wrote a short essay about my struggle to maintain my femme identity despite my new disability. "Still, Femme" appeared first in a feminist newspaper. A longer version was published in the anthologies *Restricted Access: Lesbians on Disability* (Victoria Brownworth, Susan Raffo, eds., Seal Press, 1999, pp. 109–114) and *Pinned Down by Pronouns* (Toni Amato, Mary Davies, eds., Conviction Books, 2003, pp. 182–185). *Restricted Access* is still in print and is often used in disability and gender studies classes or cited in articles about disability and sexuality. After more than a decade, the time has come to reexamine those issues to see what has changed and what holds true about disability and femmehood, both in my life and in the larger world. A slightly revised version of the original essay is followed by my new thoughts on the topic.

Still, Femme

Autumn 1994. We sit in a conference room at the gay and lesbian health center, among salmon- and beige-toned chairs, walls and carpet: we are ten or so women, tentatively beginning a discussion of what it means to be butch, to be femme, how we arrived at these self–designations. We are all, in varying degrees, nervous—afraid to offend, steeled to be challenged.

For me, this group, the monthly Femme/Butch Rap, is a realization of a dream. Or, at least, the road to a dream. After several years of searching for my sexual and gender identity and shuffling through many costumes, labels, and sexual partners, I'd finally come home to femme. Femme dyke. Femme woman who loves butch women. Political, capable, comfortable—and femme.

But once I'd unearthed my femme identity, I didn't know where to go with it. I wasn't in a relationship, and it was hard to meet other "out" femmes or butches to talk with or to date. Connecting proved difficult, as the taboo on butch/femme identity made most discussions on the topic turn into heated debates in which political positions and secret desires inevitably collided, resulting in hurt feelings, confusion, and more battle lines. Tired of my role as champion and educator of butch/femme identity, I sought community with several like–minded women. We began a regular discussion group for femmes and butches that we named the Femme/Butch Rap.

At our first meeting, we were getting acquainted. I don't remember most of what we said, but I remember one woman with soft red hair. She said she had a disability, and it made her question her identity as butch. Wasn't the butch supposed to be the doer, the protector, the one who says, "Let me get that for you, honey?" Wasn't she supposed to be strong, independent, and self-sufficient? Yet, she admitted, living with chronic pain and fatigue, it was she who often sought comfort, who asked her nondisabled femme partner for help, who even appreciated it when a man held the door open for her. She wondered how to maintain her butch identity in the wake of disability.

I remember thinking, "But you're still butch; it's part of your essence. It doesn't matter what you do." I remember thinking, "I guess that's not a problem if you're femme." I remember the silence after she spoke. I don't remember anyone else saying that they struggled with the same issue.

Outside of that small, buffered circle of the Femme/Butch Rap, I didn't refer to myself simply as "femme." Instead, I called myself a "power femme." Adding that modifier entitled me to wear thick lipstick and tight miniskirts and to dance close with a butch partner, while allowing other lesbians to perceive me as strong and capable. Calling myself a power femme silenced my fears about being seen as a will–less trinket and satisfied others' curiosity about how I could be a self–defense instructor in the afternoon, yet go out in heels at night.

Falling into the Depths
When I was a child, I had a poster of a cartoon frog in midair, leaping from one lily pad to another. His eyes bulged with shock: the second lily pad was too far away for him to reach. The caption read, "Just when you think you can make both ends meet, somebody moves one of the ends."

My journey to sexual/gender identity seems to have been a series of shifting lily pads. Fortunately, the water has been warm, and I've been a good swimmer. When I was eighteen, I came out as bisexual, at twenty, as lesbian. In between, I fluctuated between flannel with fatigues and neon miniskirts with leggings. I'd tried to be butch, yearned to be femme, and finally struggled my way into an identity: from 1991 through most of 1995, I was a power femme. Then, in October 1995, the lily pads were pulled clean away, and I fell into the deep, murky waters of illness and disability.

I was diagnosed with severe chronic fatigue immune dysfunction syndrome (CFIDS) and multiple chemical sensitivity (MCS). Lying in bed day after day, I watched the trees outside my window turn gold, then thin–limbed and spare, and finally become glazed in city snow, wondering what would become of me. I'd lost the control and independence I'd enjoyed when I was healthy. I could no longer work or go to school, do my own shopping or cleaning, go to restaurants or parties, nor even visit friends. As the cornerstones of my identity were ground under the relentless wheel of long–term illness, I sifted through the sands for the pieces of myself I could recognize, trying to pull myself together. My identities as worker, writer, lesbian (or any kind of sexual being) all had to be either discarded or reimagined. Among these self–definitions was "femme."

The process of building identity can be so gradual and organic that the elemental building blocks may be invisible. But when a radical shift shakes the foundations of identity, those individual pieces fall into the light and beg to be examined. This is one of the gifts of sudden disability—the chance to discover parts of yourself that were hidden in the flurry of "normal" activity. I had never given much thought to what exactly made me femme. But when I lost the markers of femme identity, I missed them terribly and wondered if I *was* still femme.

One of the most upsetting losses was makeup, specifically lipstick. Due to MCS, I had to discard all my personal–care products, including perfumes, hairstyling aids, and cosmetics. Applying makeup had been the finishing touch of my beloved ritual of getting dressed up to go dancing; I'd "femme out" in clingy club clothes, made up and bejeweled.

Since becoming ill, that entire experience remains inaccessible to me. I cannot wear my club clothes because they retain chemical odors. I cannot wear some of my boots or dress shoes because of dizziness and coordination problems. I often cannot comply with many normal social expectations because of the physical exertion required to stand, make conversation, or sometimes even sit up. In fact, because of environmental barriers, I cannot attend any "normal" events, be they meetings, political actions, or parties.

I realized that most of my femme identity was bound up in those narrow social contexts—getting dressed up, going out, being among other queer women—and in the "props" of those contexts. Now that I could no longer enter those surroundings or wear the clothing, makeup, and accessories that went with them, was I still femme? Where is the meaning in being femme if I am absent from the queer women's community? My hair tangled, my body limp and sore, my skin splotchy, I wondered if I would ever look *good* again. Was there any point in being femme if I were unattractive and inert?

With the flashier, sexier aspects of my femme role buried, I found myself grasping for any active role that could help me define—and value—myself. Yet, I discovered that some of the more subtle "domestic" aspects of my femmeness were lost to me as well—caretaking tasks like driving a friend to the doctor or cooking dinner for a lover were simply not possible anymore.

Ironically, while scrambling for evidence of femmehood, I was also mourning the devastating loss of those traits that, before my illness, had kept me from being "too femme." Where I had previously seen myself as tough and self-sufficient, I was now physically and mentally weakened, as well as dependent on others for money, food, transportation, and household help. As a nondisabled woman I had used the redeeming qualities of strong will and body to make femme identity acceptable. Left with the choice of being a non–power femme or nothing at all, I knew that I was—and must find evidence of my being—a femme. Yet how, or whether, I could find my femme self, I did not know.

I was certainly not alone in this search. In their book *Women with Disabilities: Essays in Psychology, Culture and Politics*, Adrienne Asch and Michelle Fine describe the phenomenon I struggled with as "rolelessness." They explain that nondisabled women attain social power or status by excelling in the traditionally masculine realms of workplace or academia or in the traditionally feminine (and less valued) realms of relationships and the home. While disabled men may be able to retain the benefits of maleness, disabled women who are unable to fulfill either gender role are left in a state of rolelessness, a psychosocial netherworld. Asch and Fine have found that disabled women tend to respond by becoming ultrafeminine, but they add, "Why this is true is left to speculation." Although I can't speak for all women with disabilities, to me the answer's obvious: extreme femininity is the only role left for some of us. After all, needing assistance—whether physical or fiscal—is perceived as ultimately girlie.

Yet, as a lesbian, the solution of being ultrafeminine is even more complicated. I don't get the kudos granted by mainstream society for attracting a man. Nor do I win the admiration or recognition of my lesbian sisters—I am not the strong, athletic, independent woman our subculture says we are all supposed to be. Additionally, as I am single and unable to be in public or to meet new people (except in the doctor's office)—my sexuality is almost entirely theoretical—there can be little sexual reward for my femmeness.

Coming to Rest

How then have I reclaimed my femme identity? One important step has been to organize social events that I can participate in—low-key soirées I hold in my home or the one other MCS-accessible location in my vicinity. These are enforced fragrance-free events in places with couches, where I can rest. I have also discovered catalogs with safer makeup and clothing. The untreated organic cotton clothes are dull and uniform, but at least they're new. The makeup, while less toxic than most commercial cosmetics, still aggravates my symptoms, but for special occasions I endure the discomfort for the pleasure of looking the way I want. Thus, every six months or so, I can play a version of the "party femme" I used to be.

I've also learned that it's possible to be a nurturer to my loved ones—as long as I plan more, use less energy, and lower my standards. I can't drive anyone to a dreaded doctor's appointment, but I can talk to them on the phone when they get home. I can't cook dinner for the holidays, but given enough advanced planning, I can usually bake a great dessert.

Still, these are solutions for special occasions. They cannot feed and sustain an identity over the long haul of solitude and inactivity. It's a truism for any person newly disabled by chronic illness that constructing a new life means learning how to become a *human being* rather than a *human doing.* As I lost the transformative powers of places and objects that made me feel femme, I had to find the essential femmeness within me.

With so much stripped away, I became driven to hold onto what is meaningful and indestructible: my values, thoughts, and feelings. When I am in deep pain or illness, or simply wending through the endless solitary days, I cling to myself as my best and truest resource. I've had to become the essential me—pleasing myself with my own jokes, conversations, and ideas. I've learned that I'm great company!

One shocking discovery of my adaptive femme nature is that I now embrace some of the very aspects of femme identity I'd once found demeaning or irrelevant. Accepting, and even asking for, help, taking care of myself, and moving and speaking more softly have all become important parts of my life. I tickle myself that I've become the ultimate feminine stereotype of a bored, lazy housewife: I lie around all day talking on the phone and watching TV.

In the end, I cannot say what really makes me femme; certainly there's little enough outward proof aside from my long hair. I only know that I am; I feel that I have a femme essence or spirit. In the way I move, my sense of style, the way I speak and interact with others, it's always there. Even when I can't express this energy as I'd like—those times when I have no energy—I understand it's only submerged. I carry my femmeness inside me like a red satin cushion. It comforts me. It gives me a place to rest. It sets me aglow with color. And I know that when it can, my femme flare will emerge glittering. Maybe not as brightly as before, but in certain ways the more precious for its survival and my transformation.

And Still…"Still, Femme"…

"Still, Femme," as its title implies, possesses lasting power. I continue to receive the occasional note from colleagues, fans, or other writers that this essay has stayed with them, that it's "a classic." Certainly it's tremendously rewarding that my writing continues to resonate with readers.

However, I squirm at the implications: after more than a decade, my essay appears to be one of just a handful that touch on the junction of disability and femmeness.[1] With butch/femme playing a central role in today's lesbian culture, and with disability studies a growing and respected discipline, how has this subject not garnered more attention? The answer lies in the hiddenness of both femmes and people with disabilities (PWDs), and the synergistic impact of both on disabled femmes.

On a Scale of One to Femme

Before delving into a discussion of how femmeness and disability interrelate, it's necessary to delineate femmeness from "feminine," "lesbian," or "disabled" behavior. My form of femme must be understood as an identity that's grown from the intersection of two specific subcultures: femme and disabled. To clarify "femme," I've divided it into three components:

> First is the elemental, what I referred to in "Still, Femme" as what's essential and resides inside. This is the energy or essence I perceive when I automatically respond to someone as a sister femme.

> Second is the performative component, fueled by queer awareness of the conventions and trappings of femininity and womanhood. Examples may be makeup, clothing or a way of moving—and the process of putting those props to use in queer ways: for other women, queers, and/or gender deviants. Performative femmes may be queens, seductresses, fabulous tramps, or warriors painting ourselves for battle. I've embraced the theatrics of femmehood by stripping for my partner, from my powerchair.

> Finally, the relational component is how a femme interacts with her lovers, friends, and community. This includes not just butch/femme partnerships, but also femme/femme pairings and, as discussed in "Still, Femme," a femme way of being with friends or community. One example is the queer tendency to create families of choice that are formed of partners, exes, and other close friends, with femmes often providing the home—literal or figurative—for the group. Because I'm homebound, I've happily provided my house as the gathering place for my chosen family.

Femme Hiddenness

Femmes (with or without disabilities) have historically suffered from both homophobic and sexist violence in the straight world and invisibility in the queer community. While often jeered by our lesbian sisters for passing as straight or not being "real" lesbians, some accounts show that femmes are actually at greater risk than butches for stranger assault. In fact, the Fenway Community Health Center of Boston, Massachusetts, reported in the early 1990s that more lesbians with a feminine appearance were sexually assaulted than those who looked more masculine.[2] Advocates found that perpetrators who harassed women frequently used terms like "dyke" or "lesbo"— regardless of the perceived orientation of their target—along with other gendered slurs ("bitch,"

1. One excellent essay that address the topic is Ellen Samuels' "My Body, My Closet: Invisible Disability and the Limits of Coming-Out Discourse," *GLQ: A Journal of Lesbian and Gay Studies* (2003, pp. 233–255).

2. Based on reports, conversation, and research in my role as an activist, instructor, and consultant on gay bashing and violence against women (Boston, 1991–1995).

"cunt," "slut"). However, while a straight woman might laugh off "lesbo" and a butch might expect "dyke," a femme who believes she's passing is likely to react with confusion and terror at being "read." Her response triggers escalation from harassment to assault. Thus, the myth of femme passing is not only dangerous; the fact of femmes believing the myth increases our risk.

Nonetheless, among other lesbians, femmes are usually only recognized as queer at a queer event or in the company of androgynous or butch lesbians. Especially during the second wave of feminism—from the 1970s through (depending on demographics) the last decade—femmes stuck out like sore thumbs. In the late 1980s through the mid–1990s in Boston, the taboo against finding femmes attractive meant that I garnered stares as the only one at the dance or bar wearing lipstick or a skirt. Paradoxically, these stares were invisibilizing. I was suspect, *seen* as a fake—a usurper of lesbian energy. Thus, the stares told me, I didn't exist as a real lesbian.

Eventually I became confident in my femmehood, and I discerned, behind some of the sneers, the hungry stare. More significantly, when I became lovers with a very obvious butch, the stares intensified, and while some malignant looks persisted, more often the gazes held curiosity and admiration. Women approached my partner and me just to tell us how much they enjoyed watching us dance.

This approbation owed something to changing times (an increased acceptance of butch/femme), however it was also a result of my visibility as a *partnered* femme. Clearly the sexual property of a "real" lesbian, I was no longer suspected of being "straight–but–experimenting," or a threat to anyone else's girlfriend. The latter fear points to one of the biggest sources of femme ostracization: fear of our blatant, potent sexuality. Femmes are revered or feared because of our willingness to express ourselves, and thus, to be vulnerable, as sexual partners. If femmes are sirens, drawing in lovers against their will, we're dangerous. Contrariwise, a partnered femme is tamed, subsumed by a "real" lesbian's sexual authority. At least, the femme is already occupied spending her sexual currency, allowing others to appreciate her from a safe distance.

Disability Hiddenness
Worldwide, PWDs have been a severely hidden class. For many, this invisibility takes a literal form: those locked in institutions (mental hospitals, nursing homes, residential schools), stuck at home (because areas of egress aren't accessible), or stuck in the homes of caregivers (who may be abusive or neglectful). Other PWDs exist as virtual prisoners either because the outside world is not environmentally, physically, attitudinally, or communicatively accessible or because they're anchored to home by pain or fatigue.

PWDs who venture out continue to experience erasure. Most disabilities are not "visible," including many psychiatric, cognitive, and sensory disabilities, even physical disabilities—heart and lung conditions, amputations, and the most common disability in America, back injuries—are frequently not obvious. Nevertheless, the malevolent myth of the malingerer or faker who tries to cheat the system to reap the "rewards" of disability is ubiquitous. This fiction particularly harms those with hidden disabilities who not only must contend with the disability itself, but also fight both public opinion and the "service" bureaucracies for every "benefit" to which they're entitled.

PWDs who *don't* pass bear the brunt of a different form of erasure. Again, while being stared at might seem to be the opposite of invisibility, it is actually a pernicious effacement; when a PWD's personhood isn't apparent, others see only our difference, our freakishness, and subject us to scorn and condescension. Indeed, a universal experience for those with obvious disabilities is to being treated as literally invisible; this occurs when a stranger (e.g., a nurse, waiter or clerk) addresses comments to and about us to our companion: "Why is she here today?" "She's so courageous!" "How should we pack her bags?" Even when we have answered the previous questions ourselves, the asker continues to ignore our attempts to represent ourselves.

When I became much more disabled nine months ago, my degree of hiddenness quadrupled. Continuous migraines and aura (extreme sensitivity to light, sound, touch, or movement); pain, weakness, and fatigue so severe that it sometimes causes functional paralysis; and frequent aphasia—the inability to speak intelligibly or at all—have had a global effect on my life. This increased disability prevents me from leaving home unless I absolutely must go to the doctor or hospital. Not only am I now hidden ninety-five percent of the time, but my former lifelines to the external world—telephone and email—have become difficult or impossible to use. I literally have no voice of my own. To make calls, I rely on relay operators who voice what I type on my TTY.[3] Often they may mispronounce my words or misrepresent my tone, or the technology falters, garbling my message. When strangers who don't know about my disability call, they can't understand me. Sometimes they don't even understand that I have a speech disability. "Speak up!" I've been commanded. One woman mistook my speech disorder for a cell phone reception problem and glibly repeated, "You're breaking up," until I practically was.

When I emerge from my house, the estrangement continues. My full-time wheelchair use, combined with my speech disorder and use of American Sign Language (ASL), cause strangers as well as family, neighbors, and healthcare providers to avoid looking at or interacting with me.

One Plus One Equals a Thousand

As a person with MCS, I'm aware that the admixture of two elements does not always produce the simple combination of both chemicals. Because of synergy, two plus two can equal four, but it can also equal two, six hundred, or banana. Disabled femmes experience exponential invisibility due to the synergy of combined identities. Thus, the fascinating topic of femme disability remains buried—*due to the factors that cause our hiddenness, as well as to the hiddenness itself.* Likewise, instead of the respect and understanding disabled femmes might receive as a result of such interest, we have been shut down, shut up, and shut away.

A case in point occurred in April 2007, when a disabled femme was shut up by the queer community. Peggy Munson's Lambda Literary Award–nominated novel, *Origami Striptease* (Suspect Thoughts Press, 2006), was censored due to ableism and femmephobia.[4] Munson's disabilities, which include MCS, prevented her from attending the Lambda reading in person, to which she had been invited. Instead, Munson sent a DVD of her reading. The sex scenes in

3. TTY stands for teletypewriter. Sometimes referred to as TDDs (telecommunication device for the deaf), TTYs are increasingly used by those with speech disabilities.

4. Information/links about these events, including Munson's blog and interviews, are available at peggymunson.com.

the excerpt were between the book's femme narrator and a transman and between the narrator and a person of unspecified gender. Although Munson was nominated in the category of Lesbian Debut Fiction, organizers decided not to show the DVD because it was deemed "straight." When Suspect Thoughts publishers argued that Munson's work should be shown, they were told that, because Munson was not there in person, she couldn't make sound judgments about the "audience response"—apparently to the graphic sexual content of the reading. However, it's not entirely clear what the organizers meant, since they changed their position several times and since an earlier reading was given by an author (nominated in the erotica category) whose work was equally, if not more, sexually explicit. Certainly nobody involved could imagine any reader there, nor an audience member or organizer, interrupting a reader because of raciness.

Personal conversations and published interviews with Munson indicate that she and many others felt "femmephobia" was a key ingredient to the censorship—that if she were butch, or if the characters had been transgendered or butch, their queerness wouldn't have been challenged. All agree that if Munson weren't disabled and had been there in the flesh, the issue would never have arisen; a sadly typical problem since ableism commonly involves not allowing PWDs through the door.

Munson's experience typifies the insurmountable barriers to being a public queer writer. In fact, the Lambda censorship controversy was unique only in one way: that it became a controversy. Actually, while angered by Lambda's censorship, Munson wasn't surprised by it, for disabled queer writers are routinely denied access in promoting our work. Rather, she was surprised that, members of the queer community expressed shock and outrage. Taking advantage of the rare groundswell of support, Munson and other disability rights activists pressured the queer literary establishment to attend to its ableism. With egg on its face, Lambda promised to implement deaf and disability access, yet no long-term change took place.

Munson noted that most who rallied to her defense were the community's "fringe"—PWDs, transgendered and genderqueer people, femmes, and bisexuals. Why did PWDs and genderqueers—including femmes—recognize Lambda's censorship as a common cause? Because both suffer erasure inside and outside our subculture(s). Munson's censorship and "Still, Femme's" lonely placeholder on disabled femmedom exemplify the hiddenness of disabled femmes.

The Cruel Irony of Femmes and Rolessness
The unique situation of women with disabilities and the continuing problem of rolelessness is addressed by Sue Suter, then president of World Institute on Disability Services, in her speech at the Ethics In Rehabilitation Conference in New Zealand, ("Gifts of Speech," gos.sbc.edu/s/suter3. html):

> William John Hamma and Betsy Rogovsky noted in their research that there's a special treatment meted out when [disability and femaleness] intersect....130 undergraduate students were asked to describe what they saw in two photographs. One showed a...man in a wheelchair. Most students imagined the cause of his disability as related to war, or job- or sports-related injuries—highly admirable. When they were shown a picture of a woman in a wheelchair, no one mentioned wars or jobs or sports. Instead, their answers centered on carelessness, like falling down stairs, or diseases—perhaps, by implication,

diseases that were contagious. In other words, signs of weakness.…Women with disabilities [are labeled as] passive, childlike, lacking of minimal skills.

These stereotypes present a triple whammy for femmes with disabilities. Lesbian culture in particular places a premium on being strong, independent, and aware. Even *nondisabled* femmes must go the extra yard to counteract stereotypes that they're incapable (i.e., weak and passive), the very labels associated with disabled women in general. Too many times I've heard a woman say, after "coming out" as femme, "But I know how to change a tire!"

Disabled femmes, then, are saddled with these labels from every direction—sex, gender expression, disability—and their potent combinations. We often feel required to perform amazing feats of household mastery, sexual prowess, and/or self-sufficiency at the first moment we introduce ourselves to prove our femme *bona fides*, i.e., that we are *not* needy, pathetic shells. Peggy Munson and I discuss this pressure to negate stereotypes "at first strike" in *Pinned Down by Pronouns* ("Crip Queer Chat," p. 72).

> **Peggy Munson:** I feel like I always have to find a way to compensate for people's perceptions of me as asexual or worthless. I need to turn up the volume on my sex charm so much higher, be so much more neon about my gender identity so that people can be distracted from their fears of disability.
>
> **Sharon Wachsler:** Yes, I feel like I have to be so much sexier, more witty, more charming, funnier to compensate for ableism.
>
> **PM:** Being a femme is so much about seduction anyway, drawing butches in. I have to do it times twenty, because not only do I have to draw them in, but I have to decontaminate them on the way here, nurse their ableism, and teach them how to function in a private sphere…removed from a queer culture that will validate who we are.
>
> **SW:** I have [focused on] snuggling, making little meals, being a hot lover inside my home, and…emotional nurturing. I feel like I have to make up for my physical limitations by being unbelievably with-it emotionally.

Suter adds a crucial element as it pertains to hiddenness: "Even the absence of labels takes its toll. Women with disabilities are seen neither as mothers and nurturers, nor as professionals.… [T]his [is] rolelessness!…Overcoming rolelessness means revealing that we are ordinary." Suter's conclusion might work for straight women, but it's a bad fit for femmes.

Suter describes the breadth and depth of the mainstream's obsession with fitting in, and argues that women with disabilities must exemplify ordinariness by showing that we fill the same roles as nondisabled women. However, for queers with disabilities, demonstrating ordinariness is more than a tall order. First, some—particularly butches and queens—might not be able to blend in. Second, while some gay people wish they were straight, many of us are proud and happy to be different. Finally, for the femme in particular, part of the joy of our role is being extraordinary. We work at being distinctive.

As Munson points out in our chat, and as my earlier delineation of femmedom outlines, femmes' beauty, seductiveness, and emotional strength are our unique power. Moreover, to be femme is

to intentionally bend stereotypic ideas of femininity and womanhood to our queer purposes. I haven't met a femme whose aim it is to blend into the woodwork. To be femme is to expect—and usually to hope—to be seen, which makes disabled femmes' hiddenness all the more painful.

All Made Up and Nowhere to Go
When I first thought about updating "Still, Femme," I was flooded by realizations of how I've changed since the late 1990s. I emailed a friend, another disabled femme. "I've just started plucking my eyebrows, something I've never done before," I told her. "I don't know why, I just feel like I have to. I'm also wearing red lip gloss every day, even though I never go out."

Right away, she replied, "I've started plucking my eyebrows, too. As I'm typing this I'm wearing *blue eyeliner*, and I'm completely alone." I think we both felt a little silly and perplexed at our own behavior, yet we knew that we were safe, one crip femme to another. As I made a list of all the behaviors and sensibilities that were swinging my compass toward True North of the Femme Pole, I noticed that they formed a pattern. They all emerged within the last few years. The most "extreme" arose within the past nine months. Yet none of my past triggers for "femming out" were present: I wasn't dating someone new, going out to see or be seen, or performing. I wasn't even trying to beguile my butch lover. In fact, she was away when I started plucking and puckering, and when she returned, she told me she liked my eyebrows better before. She's also leery of lipstick— what if some gets on *her*? I'm not snazzying up for my personal care assistants (PCAs)—the people who bathe me and wash my dishes—and my friends prefer me to spend my limited energy on interacting with them, not on looking presentable.

Furthermore, it's not just my eyebrows and lips that have captured my attention. My "refemmifying" process started a year ago, when I got Lyme disease. To verify my diagnosis, I shaved the back of my head around my nape where a tick had bitten me to get a clear view of the characteristic Lyme rash. Since that first shave (and the others that have followed to check on the rash), it's felt important to have a flattering hairstyle, particularly something that complements the stubbly slope in back. It's as if this mark of intrusion and destruction in my life—the tick bite that spawned the rash—must be defied and reclaimed by keeping my hair short, but stylish. It's one of the few acts of rebellion I can muster. Before Lyme, my best friend gave me free haircuts when she deemed my split ends disgraceful. Now a professional hair genius gives me seasonal cuts.

I've made other changes that seem more "girlie" than I used to be. I started wearing my current pair of pink, rhinestone eyeglasses before the nose pads and earpieces had finished outgassing[5] because I wanted so badly to have those sparkles around my eyes. Lately, I also wear a loose cotton dress every day, instead of my habitual t-shirts or sweats. I've become more covetous of my privacy and less tolerant of "tastelessness," which contrasts with my previous mellowness about the body and its sounds, smells, and functions. An unembarrassed attitude toward belching, farting, drooling, and body odors is actually part of disability rights culture. I'd always taken pride in this relaxed approach to bodiness, associating it with my earthy, queer, and feminist identity. These days, however, I like my lover to brush her teeth before kissing me, to be left in silence when I'm using the toilet (even through a closed door), and to make love only after I've bathed. Have I returned to acting like a self-conscious tween? I don't think it's that simple.

5. Outgassing is the release of (toxic) gases or vapors by a material over time.

Rolelessness Steals (into) My Life Again

These small changes have emerged as a reaction to the enormous change in the rest of my life, specifically how my disability has worsened. Whereas a few years ago I rarely went out, nowadays I *never* do, except for medical appointments. There, the combination of my obvious physical disabilities—as evinced by mask, wheelchair, and oxygen—as well as the presence of a sign language interpreter, mean I'm hit with both ableism and audism and am frequently dealt with roughly and rudely, as if not sentient. My diminished functioning has radically altered life inside my home as well.

My new speech disability, and the severely worsened exhaustion and weakness that usually prevent me from sitting at the computer, mean that presently I rely on a range of communication methods, depending on what is least tiring or painful, the degree to which I can vocalize, and the skills of the person with whom I'm communicating. With interpreters and Deaf friends or PCAs, I use ASL. With my partner and hearing PCAs, I use a combination of sign, gesture/pantomime, vocalization when possible, lip-reading, typing, notes, a TTY, and a communication board.[6] However, these methods can be extremely limiting and exhausting. Combined with the loss of easy phone and email use, they've compelled me to be much quieter and more internal than is natural for me. Thus, my isolation has increased tenfold. I've needed help with cooking, cleaning, and errands since 1996, but only within the last nine months have I required assistance to brush my teeth, bathe, eat, or get in or out of bed, or on or off the toilet.

I've also developed a speech disorder, which means that most of the time, my voice is absent or unintelligible. This radical shift in the nature of my disability has necessitated huge changes in my life. This has meant that my partner, PCAs, and certain friends and family see me naked, touch me, dress or undress me, and perform additional tasks I'd much rather take care of myself. *I did not go willingly into this twilight of the body.* I initially bitterly resisted such assistance, then succumbed to it with humiliation, then gratitude, and finally accepted it as commonplace. The independent life I had so painstakingly constructed around my illness up until now has been blown apart. The way I found to cope snuck up on me, slyly and unexpectedly.

Plucking Out Plumage: The Caged Femme

I didn't just reshape my eyebrows once and leave it at that or smear on the occasional gloss. Such whims could be explained away as something to help with the boredom and loneliness of hours of nothing to do but wait to feel better. My eyebrow obsession started when I made a DVD of myself for a reading—an exciting, though exhausting opportunity to put on flattering clothes, dangly earrings, nontoxic makeup, and be "virtually" in public.[7] When I replayed the video to check that it had recorded correctly, my appearance jarred me. For weeks, I hadn't seen myself in a mirror; they are all mounted too high above my sightline in my chair. My eyebrows seemed to bushily overshadow the rest of my face.

6. A communication board has numbers, the alphabet, and frequently used words, pictures, or names. The user indicates the relevant character, word, or icon to form words, phrases, or sentences.

7. The DVD was never shown.

Since then, almost every night that I'm physically able, I lie in bed, propped on pillows to minimize pain and fatigue, my pocket mirror in hand, plucking out every stray mustache, chin, or eyebrow hair I can. My original goal was sculpting perfect brow symmetry. The other plucking just grew out of seeing my face up close so much. I even decided, after wearing mineral makeup for the DVD reading, that from then on I would apply makeup every day to conceal skin problems and draw attention to my eyes. I've been too sick to use makeup again even once, but I wish I could.

My partner asked me why, when I hate that I can't maintain proper oral hygiene, I use precious energy plucking stray hairs. I think it's partly because, in using ASL and lip-reading to communicate, unconsciously I became more aware of my face, especially my eyes and lips. In fact, facial expression, including mouth and eyebrow shape and position, are crucial parts of the vocabulary, grammar, and syntax of ASL, so having a nice frame to my eyes, whether hair or metal, provides a greater sense of control over my ability to communicate. All these reasons to focus on my appearance were likely exacerbated by the fact that I can't generally look in mirrors except my hand mirror, which only allows me to see small portions of my face at a time.

But there are other reasons why—reasons that go much deeper than language use—I've become engaged in the minutiae of certain aspects of high-femme grooming. In essence, her question is the answer: it's *because* I can't take proper care of my body that I'm fixated on the areas I *can* manage. It's my way of claiming ownership of a body that has, sometimes literally, fallen into the hands of others.

This is very common for people with disabilities, regardless of sexuality or gender expression. Men whose legs are paralyzed or amputated may tattoo their upper bodies and/or build incredible strength and definition in the muscles of their arms and torsos. A newly disabled heterosexual woman I spoke to years ago felt terribly ashamed that, because she was unable to shave her legs, her doctors were seeing her with stubble. At the time I was not disabled myself, and I couldn't understand how, when facing dire financial, medical, and housing problems, she could waste energy on a triviality like shaving. Today, I can see that like me, she focused on grooming as something that felt marginally within her grasp because everything else had spiraled far beyond her control. However, the social underpinnings that motivated us in similar directions were very different, which is also exemplified by the outcomes we sought. Her primary concern was fitting in with mores of straight society. She feared appearing unwomanly, and therefore not respectable. She might well have been glad to have someone else shave her legs because the end result was what mattered.

On the other hand, I believe the way I blend bodily autonomy with practicality and a disregard for greater cultural standards is typical of my earthy-crunchy and feminist femmeness. I tend to be a furry femme. Before I got sick, I never shaved, even when wearing miniskirts or halter tops. I enjoyed some genderfuck, keeping the *dyke* visible in *femme dyke*. However, after I became disabled, because most other femme markers ceased to be options, I occasionally shaved my legs or underarms to reaffirm my femme sexiness. Today I'm unable to shave myself, but I would never allow a PCA to do it because, for me, the act (and to a lesser degree, the result) is a form of sexual expression. This is another distinction between femme and feminine, since femmes can

never expect (and often don't wish) to fit in with straight culture (or sometimes even with lesbian culture).

Indeed, the act of shaving is sexy for me (and my partner shaving me even sexier) because we're sharing a femme ritual of beautification or seduction. So maybe someday I'll ask my partner to shave me, not as a caretaking task or a way for me to look "correct," but to enjoy each other: she, the gentleman butch, playing a part in my femme ritual; me, the femme seductress, being vulnerable to her blade against my skin.

My hair plucking is also not as much about the end result as it is about the ritual; it's become compulsive, a form of displacement behavior. Displacement behavior (sometimes called self-directed behavior or SDB) is when an animal or person touches or grooms herself because of stress or anxiety, particularly when there are two competing impetuses (an "approach–avoidance conflict"), such as nearing something that arouses both curiosity and fear. SDB not only expresses nerves, it soothes them; the *act* of self-grooming is calming. As a service–dog trainer, I recognize that if my dog suddenly sits down and scratches during training, he's feeling anxious, and I need to alter course.

Unfortunately, there is no beneficent, omnipotent being who can do that for me—relieve the monotony, stress, and pain, and let me play. Indeed, one of the most brutal aspects of both CFIDS and MCS is that what is good for mental health is almost always bad for physical health; I'm socially isolated and sick of lying still, stuck inside, but a visit, exercise, or going out inevitably means an exposure or exertion, either of which causes relapse. Further, even though I've had more people in my home in the last nine months than probably the previous twelve years combined, I feel *more* isolated. Why? Most of these people are PCAs, of whom I'm very fond, yet with whom I usually try to interact as little as possible because thinking, listening, and even being around a person's energy makes me ill; I try to preserve my limited physical resources for my partner and close friends. Additionally, due to my speech impairment, often my PCAs (and sometimes my partner or friends) can't understand me. The disappointment of trying to communicate and not succeeding is so crushing that I've mostly given up. I find unrelenting loneliness in others' presence a special form of hell.

Even nondisabled queers tend to grow up with isolation, fear, and social distress. When I came out, social acceptance in my queer enclave practically required engaging in at least two of three of the displacement behaviors of choice: drinking, drugging, or smoking. Twenty years ago, smoking provided the same sense of calm and control that plucking currently offers. Both release endorphins—one stimulated by the chemical it delivers, the other by minute amounts of pain. While I could no longer smoke, even if I wanted to, many PWDs rely on self–medicating with tobacco, alcohol, or other chemicals; medical equipment companies sell a lot of ashtrays and cupholders for wheelchairs. And just like in prison, cigarettes can work as tokens of power, friendship, or currency in nursing homes and other institutions that incarcerate PWDs.

Some of us who grew up in the pressure cooker of queerdom and then were further scalded by an isolating disability become like a single parrot in a small cage, yanking out its own feathers and rocking repetitively on its perch. Intelligent and gregarious, it uses SDB to deal with the ravages of boredom and isolation. This comparison might seem extreme, but the depths of social deprivation

I've suffered, due to my disabilities themselves as well as others' ableism, cause damage that's hard to convey without seeming hyperbolic. Just as living in poverty is a form of violence, so is living without control of oneself, human interaction, and relief from pain.

In fact, I believe my plucking belongs at the mildest end of the continuum of self-injury behavior (SIB) because it carries a similar sense of compulsion and relief as do other forms of SIB. Also like SIB, I sometimes have trouble stopping, and it's a means for coping with overwhelming feelings. However, while most who practice SIB start young, before I became severely disabled, I never engaged in SIB. Since then, I have (in addition to plucking), and I've discovered other femmes who also started SIB only as adults with acquired disabilities.

Studies agree that conditions that lead to SIB always involve "invalidating environments" (selfharm.net/injury.html—"Why do people deliberately injure themselves?"), with a history of neglect as the most powerful predictor of SIB (selfharm.net/injury.html—"Etiology [history and causes]"). Most think of "neglect" as inaction of individuals toward those who are under their care. However, I believe the multiple layers of hiddenness disabled femmes suffer—whether the paradoxical hiddenness of stares or condescension or the literal hiddenness of physical or communication isolation—are a form of cultural neglect. In essence, the world is our invalidating environment.

Explicit in My Desire

Given this harsh internal and external landscape, how have I found creative, ultimately femme ways to survive? And what makes them "femme" versus simply "disabled"?

First, I rely on my true power as a femme: the strength that both creates and grows from vulnerability and openness, the toughness born of softness. Second, as a queer, I'm familiar with diversity of sexual expression and know how to rewrite the laws of the body. Queers have always known there are many ways to make love, and as a femme who experimented to find my sexual home, I've learned from men (straight and queer), women (femmes, butches, and nonaffiliated), genderqueers, vanilla mavens and kinky kings. Now that my body puts so many constraints on how, whether, or when I'm able to be sexual, I'm grateful that I can fall back on the flexibility of my brain and my membership in a subset of the community that accepts differences in bodies and expression as part of queer love.

The result is that despite social deprivation and reduced bodily autonomy, my femme nature is steering me toward ways in which I still feel some measure of control, some "me-ness" in the painful, inert, and voiceless body I currently inhabit. One very important way has been to draw lines around what is or isn't sexual (including that which portrays my gender expression), and to keep the boundaries very distinct: what my partner and I do with my body must be separate from what my PCAs do. I think that's one reason why I've generally been the most comfortable with straight women or trans (especially gay) men conducting my intimate care, as opposed to queer women (or straight men, with whom I'm definitely not comfortable).

In other words, while I accept that others must touch me, bathe me, or help me shed my clothes, I aim for those not to be my lover's tasks. Instead, they're *jobs* that I endeavor to keep scrupulously

asexual. I also try to avoid nonsexual nudity (bathing, using the toilet, etcetera) with my lover so that when I do want to be sexual, the lines are clear, and I can be explicit in my desire.

Similarly, my switch to dresses without underwear as my everyday clothing has been a way to be femme, sexy, independent, and myself, whether or not it adheres to mainstream norms. When I started needing help transferring onto the toilet, I quickly discovered that panties were just one more layer to be wrestled off. Over time, I was often been able to toilet myself by using a commode. However, pulling down my pants while transferring solo proved challenging. The solution was obvious: with dresses and no underwear, all I have to do is flip up the back, and I'm good to go. It also affords a modicum of privacy if a PCA walks by.

While wearing dresses around the house might seem traditionally feminine, as opposed to femme, these are very non-frilly, comfortable organic cotton dresses that are accruing a lot of food stains. Rather than feel ashamed of this look, I call them my Jackson Pollock dresses. Further, a choice that was initially made for simple practicality and greater independence also makes me feel more femme around my butch partner. No matter that my garb's not particularly flattering—the fact that it shows off my curves and that they *are* dresses highlights our butch–femmeness, for my partner wouldn't even wear a dress for Halloween.

Conclusion: The Role of Lily Pads
I began this essay describing the challenges of being "out" as femme fifteen or twenty years ago, when I was told repeatedly that identifying as butch or femme meant "being into roles." Playing a role meant engaging in fakery and pretense, as well as being weak willed (for supposedly mimicking heteropatriarchy). Defending butch–femme, I'd proclaim, "I'm not playing a role! This is just who I am!"

Yet, identity is multilayered, fluid, and more complex than embracing or rejecting one term. Being shunted into rolelessness has made me rethink my former righteous anger at being accused of role playing.

Further, "role" has many definitions. Roles are relational, and as discussed earlier, and relationships–based, which includes whom we're attracted to as well as how we relate to our queer families/communities. Being unable to interact with others thus shoots holes in identity, and therefore, in our role as femmes. To fill a role also means to fulfill a capacity, function, or occupation—in other words, to be of use, achieve, or fit in. As one of many disabled women who can't work; who look, sound, or move differently; who will never receive validation for embodying the nondisabled norm, I've learned there's a lot to be said for having a role (or several).

In essence, having a role means *having a purpose, a sense of meaning.* Indeed, that's been my goal, credo, and source of sanity and emotional growth for the past thirteen years. When I got sick, I told myself, whatever I can or cannot do, my life must have meaning. Whenever I'm rocked off center, I ask, "In the face of this fresh hardship, how do I live the most meaningful life?" The answer has varied—from writing to meditating to being a better dog owner. Sometimes it's simply been to survive.

A year ago, I would likely have derided the suggestion that wearing dresses, plucking my eyebrows, and sporting glitzy glasses were a way to live meaningfully. Yet these minutiae add up to exerting governance over parts of my body and life where other options are beyond me.

I'm in awe of the true power and beauty of my femme spirit's ability—when the rising tide of debility and loss threaten to engulf me—to keep my psyche afloat. It comes back to those shifting lily pads again: physically, I may be unable to swim, but psychologically, my femme nature has kept my head above water. In ways I never could have expected—in ways I couldn't understand, myself, until I started writing this essay—my inner femme has been reaching towards drifting water lilies within my grasp, and I've grabbed ahold, usually without knowing why. Often I shiver. I keep looking for a boat that hasn't yet come. Sometimes I think about just letting go and slipping below the surface. But femmes are fighters. Every once in a while, when I'm truly lucky, the light glints off the water, and I feel the sun on my face.

Femme Queening—An Identity in Several Acts
By Kpoene' Kofi-Bruce

1. Zamis of My Own

I've been thinking a lot about femininity lately.

As a Black woman, femininity is on my mind constantly, a low-level humming in my brain. Black women have always had to struggle to maintain control of the way our bodies are perceived. The polarities of mammy and prostitute constantly dog my steps.

My identities as a Black woman, a radical feminist, and a high femme are so intertwined that I can't think or talk about one without bringing in the other two.

I come from a long line of Black femmes. In the 1940s, my grandmother was voted "Favorite Pinup" by an all-Black Army regiment stationed overseas. My mother was a beauty with huge eyes that turned up at the corners and loooong lashes. She taught me how to make beautiful things with my hands. We are very similar, the three of us—comically short women who love makeup and dresses. We play the femme role to the hilt: when my girlfriend and I met her for brunch recently, Grandma was wearing high-heeled cowboy boots. She counseled me always to wear stilettos because they make your butt look sexier. Heels are also a good conversation starter for any butch brave enough to comment on them, which is probably not what Grandma had in mind when she was teaching me how to walk in them.

2. Post-Binary Gender (and Race, and Class) Chores

I'm rapidly approaching thirty, old enough to start being my own role model. My identity is a crystalline kernel in the center of my being, a tight little knot that sits in my chest. Lately I've been checking in on who I want to be as a visible queer presence, and I've been coming up short.

Just when I've found a woman with whom I can see building a life, a lot of my femme friends have begun seriously dating men. I'm not sure why this leaves me feeling betrayed. I guess it's because it is so hard for femmes to find each other that it feels like you've lost a piece of yourself when someone's identity changes. I've got a lot to work out in my head.

I wasn't always this rigid.

When my girlfriend and I broke up after seven years, I told myself that I should go on dates with every non-sketchy person who seemed interesting, including men. Dating men was a shock to the system after nearly a decade of having my Black female experience reflected back at me in the form of my ex-girlfriend. Though I thought it would be cool to add another layer onto my dyke persona, I quickly went back to women, falling hard for an incredibly intelligent White woman who routinely gets called "sir" and enjoys working with her hands and her brain. Many of our disagreements center around the assumptions we've internalized about masculine and feminine. I'm not that excited by the idea of her growing her hair long; she constantly bugs me

to wear flat shoes, or maybe even, God forbid, a pair of pants when it's cold out. We often find ourselves straining against the spaces we inhabit. This much access to another person's experience is thrilling, and terrifying.

Though we routinely have the kind of race/class/gender discussions that would make freshman Women's Studies classes shit their pants, what I can't quite explain to her is that, as a Black woman, I have to do everything I can to assert my femininity because every single day, I hear the phrase, "Blacks and women," as though they are mutually exclusive.

My identity exists in the forgotten space between the two.

3. "R" for "Revolution, "E" for "Evolution"

I grew up shuttling between LA and Washington, DC, but my femme awakening didn't happen until I moved to New York. Everywhere I looked, there were femmes to emulate. Some worked the political angle; others just wanted to have a good time, but all were about social change: Rebecca Walker, the Gloss Girls at Meow Mix, The World Famous Bob. My femme persona shifted from strident college student into bratty, sex–positive scenester activist. I lectured about community-building through zines and joined every feminist group I could keep up with, juggling my activism with the rest of the roles I needed to occupy: devoted girlfriend, dedicated employee, newly budding adult. For the first time in my adult life, I started to think about what kind of identity I wanted to shape, and after trying so many on, I started to lose control of my brown body in the name of various movements.

As a Radical Cheerleader, I wore combat boots and lacy underwear and cheered at Critical Mass rallies. This got a picture of me, complete with Doc Martens and a jailbait–length pleated skirt, into *Newsweek*. I joined TRAXX, an offshoot of Pink Bloque, and rocked the No RNC march with an Anti–Bush hip–hop dance routine. We were good dancers, and being cute and cuddly didn't hurt (neither did our finale, when everyone raised their skirts to reveal "NO RNC" on our matching underpants). We were a big hit at the march. I joined the New York Drag Squad and perfected my femme queening in a miniskirt and a push–up bra. We were welcomed at some pretty big NYC clubs and not just on the off nights.

We femmes offered up our objectified bodies, adorable in rebellion and seemingly desirous of the attention. The problem was that I didn't enjoy being lusted after by supposedly enlightened men, and I liked it even less from the women in the audience.

Five years later, my underwear has little part to play in my identity as an activist, and I look back in confusion at the way we femmes set ourselves up to be viewed: why do women, and especially brown women, expect to have to show off our bodies, even while protesting? Though everyone was about healthy sexuality and not giving a damn, the butches and bois among us rarely crossed the line of offering up their bodies for appreciation or inspection.

A butch friend suggested that it was the femmes' way of being taken seriously, because society perceives men's voices as more authentic. I'm not sure what I believe.

4. The Nod, or Lack Thereof

At some point in every queer friendship I've ever had, there comes a discussion about "the nod"—the casual acknowledgment that two people with a shared identity give each other upon meeting.

The nod is a powerful thing. It's about belonging and comfort and safety.

Femmes rarely if ever get the nod, and femmes of color are doubly excluded. I worked at a gay high school with an almost entirely gay staff for five months before my White coworkers realized I was gay. Maybe they thought I just really liked teenage drag queens.

The nod is something that femmes hunger for—I find myself searching the faces of women on the street to see if they have that *something* in their eyes that would let me know they were like me. Generally we just pass each other by, we invisible girly girls.

Though San Francisco congratulates itself on being a Mecca for gender exploration, the hardcore butch/femme dichotomy is alive and well here. I recently went to a femme friend's birthday party, and one of the other guests, a hardcore butch in a tie and motorcycle boots, kept talking about another party that promised to have lots of femmes but eventually didn't deliver. It was dehumanizing to realize that femmes could be a commodity, and interchangeable at that.

Butches want to date us, but we'll never be part of the brotherhood.

I worry that I'm missing my femme sisters. Cheryl Clarke once said that she called herself a lesbian to make herself known to other Black lesbians. I call myself one to make myself known to other lesbians in general.

A friend told me that a few years ago on Craigslist, there was a fake guide on how femmes can recognize each other, complete with hand signals. I laughed about it, but secretly I wish it existed.

5. Taking Yourself Seriously

Thinking about my role as a Black femme in relation to the world has been keeping me up at night. As I get older, I'm enjoying playing around with the fluid, sticky mess that is gender. As a femme, and more importantly as a woman of color, I have to balance my deep-seated need to take care of everyone's problems with my obligation to take care of myself. I'm so grateful that there are femmes of all colors, but especially Black ones, who have given me blueprints for living from which I can pick and choose: I borrow liberally from June Jordan, Pauli Murray, even Letta Neely, in my recipe for personal fulfillment. I think about my mother, who started an MBA program at sixty, or my friend Hanna who teaches fundamentals of union organizing to factory workers.

I have my work cut out for me in figuring out how to negotiate my femme identity. These high heels *are* my running shoes, and I can use them to walk all over anyone making assumptions about me. The thick skin I've been developing is slowly stretching, letting in more light and air and ideas, preparing itself for the next phase of my personal evolution.

Femme Is as Femme Does:
On Being a Queer Southern Femme
by Brook Bolen

I have a deep and enduring love affair with femmes. Not sexually or romantically, usually, but with their ways, looks, and stories. As a femme myself, I am especially fascinated with other femmes' stories of how they came to identify as such. I find these stories interesting because of my difficulties adopting this identity. Through sharing stories with other femmes and reading about them, I've seen many shared parallels, but few, if any, that have seriously addressed the biggest themes affecting sexuality and identity in my life: namely, the relationship among queer femininity, a working-class background, and rural and social isolation.

Because of these elements, I've frequently experienced some confusion and discomfort in my adulthood over my sexual identity. I began my dating and romantic life with biological men, and in college, I slowly transitioned to biological women. Before college, I never gave any real thought to my sexual identity. I had always assumed I was heterosexual because I had no reason to think otherwise; I was attracted to masculinity, and I was very feminine. I was definitely drawn to that difference and dynamic, and I saw this way of being reflected in mainstream society. Typical adolescent angst aside, I felt normal.

When I got to college, however, it was a whole other story. I saw and met my first butch women, and they astounded me and made me reconsider everything. During this time, while still with my bio-boyfriend (but growing increasingly aware of my attraction to butch women), I began to identify strongly as bisexual. I felt it to be fairly accurate as far as my sexual interests.

I identified as bisexual also because I felt it was important in terms of challenging false dichotomies (e.g., heterosexual versus homosexual), upon which so much of my life had been predicated. For example, my parents took pause when in high school, I began a successful stint as a competitive powerlifter. My parents mused about how unusual it was for such a pretty girl to lift heavy weights; powerlifting was a sport for males. Their worry escalated until, over fear that I would damage my reproductive system, I was forbidden to continue powerlifting. Similarly, my comely mother's intellect and competent demeanor were often questioned; the fact that she was neither stupid nor a shrinking violet meant the outside world frequently did not quite know how to deal with her. I saw her navigate many interactions by downplaying her intelligence; doing so made her appear more deferential and less threatening. My mother's beauty and brains were ostensibly incongruous. The same was true of my femininity and powerlifting. False dichotomies meant neither of us were able to present our whole selves openly. Adopting a bisexual identity felt like a step toward being whole.

Yet I wasn't completely comfortable with this identity, either. I felt it gave too much verbal lip service to men. At this point, they were falling off my sexual radar. After I broke up with my boyfriend and started seeing women exclusively, I began identifying as lesbian. I didn't hate men, but I wanted my identity to reflect my choice to live a woman-centric life. I liked its exclusivity and

what I felt to be its explicitly political nature. But while I enjoyed these aspects of the label, I never felt like it truly fit me—more appropriately, that I never truly fit *it*. When I thought of lesbians, I thought of women who dressed and presented in ways that were more androgynous or masculine than feminine. A huge part of what hindered my adoption of this identity was my ignorance regarding femmes: their presence and their fundamental place in queer history and culture. I simply did not know they existed.

In the past, I felt invisible as a lesbian because I didn't "look" like one. I fell victim, as have countless others, to the ridiculous notion that cultural signifiers of femininity represent heterosexuality and therefore do not and could not translate as lesbian. According to this "logic," variations of masculinity and/or androgyny equaled lesbian; variations of femininity, particularly of the flagrant variety, were considered suspect, oppressive, and definitely not queer. Reactions to my femininity have often been negative; in lesbian bars, clubs, and some circles, my femininity has caused me to be questioned, snubbed, and sometimes harassed. As I've gone around the queer block, however, I've learned that this reaction is not universal but contingent, at least in part, on the racial and class makeup of the community.

Looking back, I see there was no real way for me to know much of anything about queer history or the existence of femmes. I grew up in rural western North Carolina, the youngest child of two overbearing and overprotective parents, both of whom were the children of generations–old, poor, farming Southerners. Not only was our neck of the woods small and fairly geographically isolated, it was socially isolated as well. As a child, my only sustained interaction with people who weren't relatives was inside the classroom. Unlike most other families in our community, we didn't go to church, but read the Bible at home. Similarly, my parents never went out socially, and with few friends, never entertained. I wasn't allowed to go to other kids' houses, and while I was never forbidden to bring friends home, it was never encouraged. My parents were rabidly successful in their mission to keep me away from anything they deemed immoral, the two worst instances being dating/marrying outside your own race and being queer. I was told that if I ever did either of these things, I would be forever disowned.

I am sure there were queers in my hometown, but I never knew of any. At that time, during the eighties, there were no real representations of queers in the media past the exploitative and sensationalized accounts on *Donahue* and *Sally Jesse Raphael*. These limited representations overwhelmingly featured conflicted, tortured souls: weak, effeminate men and brusque, manly women. As a result, I grew up thinking queers were strangely gendered people who existed "out there" in the metropolis; that queers might be gender normative or rural never even once crossed my mind.

Situated within the isolated rural and social context of my upbringing, and coupled with negative and homogeneous queer media representation, my parents' threatening, hateful rhetoric literally did scare me straight. I can now see how profoundly this shaped my life and what I perceived to be my life's choices, because being queer was something I never, even for an instant, considered to be a viable option.

Compounding my ignorance and confusion about queers in general and my own queer sexuality, specifically, was the fact that I was the girliest of gender–normative little girls. My recollections and pictures of me as a child corroborate this truth. I had no misgivings about wearing dresses,

lace, pink, and patent leather—I only wanted more of these things in my life! Not only did I adore traditional trappings of femininity such as these, I thought being a girl was infinitely better than being a boy. I liked playing with girls I met at school much more than the boys. Yet while I preferred the company of girls, I knew my fate was to get married and to have children; my entire life at home, and my life as a feminine, biological female in the world at large, groomed me for this expected reality.

A fundamental aspect of this training meant living by a completely different set of rules than my older brother. Despite being seven years younger, I had to do all his chores. The logic, according to my parents, was that girls were naturally neater than boys, and thus chores were girls' work. His male privilege (though I didn't know to call it that at the time) infuriated me.

Any aspirations I had straying from the traditionally feminine, such as sports, and later on, college, were disdainfully rejected. Any interest I expressed in a career was met by my family's reminder that my husband's and children's needs would come first. Seeing how my brother's interests were encouraged and mine were squashed made me furious, and I soon learned to keep these thoughts to myself.

As a girl, my voice was largely silenced, both literally and figuratively. I learned through the parental chastisement, "pretty is as pretty does," that "pretty" meant silent and dutiful. This lesson pained me, because it left me feeling as if I had no real choices; I wanted to be both pretty and boisterous. As I grew from a child to a teen—and especially from a teen to a young adult—this silencing message became increasingly more difficult to understand and to accept because it was stifling me completely. I didn't want to be passive and deferential; I wanted to express my unabashed femininity as well as my opinionated irreverence that had been suppressed since I was old enough to articulate it. In spite of the rampant inequality I experienced, I genuinely enjoyed creating femininity for myself through makeup, clothing, and the skills I was learning at home, such as cooking, canning vegetables, and decorating.

After graduating high school, I went to college against my parents' wishes. Living away from my parents and in a college setting, I saw and met more types of people than I ever knew existed. These were the types of unlimited social interaction and experience I had always longed for but had been denied. I drank it down like it was my daddy's homemade muscadine wine. I maintained my sobriety until, in my first semester, I met my first butch in class. She literally made me feel drunk. She was thick, with wide hips, strong hands, and a British accent. After half a semester of eyeing each other, we slowly began to make small talk about our class, until one day she asked me to go to a pub with her for a bite to eat. She did little things for me, like holding the door open and pulling my seat out for me at dinner, that I had found irritating when performed by men. With men, I found these types of behaviors troublesome because I felt they highlighted the inequality between the sexes. With her, a masculine woman, I found them to be charming and endearing.

Even though the two biological men I dated long–term were both kind and egalitarian, there was a power differential I never felt able to overcome in those relationships, which made me profoundly uncomfortable and unhappy. Even when I felt there was equality between us as just two *people*, that feeling was always fleeting because our relationship didn't take place in a vacuum; it took place within a social context built on, and sustained by, profound inequality. I could never fully escape the feeling that these relationships were inherently inequitable.

I do not want to suggest or to imply, however, that same–sex relationships are necessarily or inherently equal; nor do I wish to claim equality between the sexes is impossible. I can only speak to my experience, which has been that while my relationships with women haven't been perfect, I have experienced them as more egalitarian than those with men. I am sure this reality relates to the fact that my female partners have deeply understood and shared certain core truths of mine, especially regarding the impact of class, region, and sexual abuse. My male partners lacked this understanding in large part because they lacked those actual experiences. Moreover, my male partners had male privilege in a rampantly misogynistic world. Together, this combination threw the balance out of whack for me.

I had always been attracted to masculinity, which is why it didn't feel weird or anathematic to me to date men. I felt I was always searching for the elusive "right fit" and equality in my relationships with men, and this was a fairly typical path relative to dating; conventional wisdom held that you usually searched for a while before finding the right one. I considered this quest part of the dating/relationship journey.

Similarly, I never consciously remember feeling physically attracted to another woman, but I do remember being utterly captivated by the idea of queer people. I, of course, kept this feeling to myself. My silent fascination speaks volumes about the influence my isolated and repressed upbringing had on my choices. The only way I could conceive of a non–heterosexual life was in my most private contemplations. The idea that I could be queer made no sense to me in terms of what I understood and "knew" of queers as urban gender inverts; it never dawned on me consciously that I could be one of *them*.

The path I navigated to make sense of my sexual identity is not uniquely mine; it mirrors those of many femmes I have read about or personally know. In my efforts to assimilate into my newly chosen lesbian community, I cut my long hair, stashed my makeup under the sink, wore so–called sensible shoes, pushed my skirts to the back of my closet, and buried all my fishnets in a drawer. But this shift in presentation made me miserable. I like comfortable shoes as much as the next girl, but I also know that nothing compares to the way I feel when I slip on a pair of sky–high stilettos. And though I love the utility of my overalls, I don't feel like my most authentic, powerful, genuine self unless I'm in some tight jeans or a fabulous skirt.

While I felt more accepted in lesbian spaces after I adopted a more androgynous style, it negatively affected my self–esteem. I didn't feel very pretty or desirable without my feminine clothing or accessories. It didn't take too long for me to figure out that when it comes to my wardrobe, flannel is best for sheets. Although returning to my femme roots was sometimes alienating, it was necessary in order for me to live happily and authentically.

I don't feel that external accoutrements are the sole, or even primary, aspects that comprise femininity or femme identity; that's a classist and wildly stunted viewpoint. I do, however, feel they are a crucial element of the theater of feminine gender; they are part of the process of creating and crafting a visible and recognizably gendered self. Similarly, for me, items such as clothes, heels, and makeup are what I love and enjoy, and as a result, they bring me pleasure, an increased sense of self, and a feeling of empowerment.

While second-wave feminists such as Betty Friedan widely argued that femininity and its afore-mentioned trappings are disempowering, even oppressive, I vehemently disagree. Heels, mani-cured nails, and makeup are what I arm myself with when I meet the world; they are the armor that helps enable me to feel capable of making my way in a wildly unequal world. The unequivocal sense of power I derive from my femininity is significant because the world disempowers, silences, and oppresses those of us with feminine self-presentations; I feel this power even more strongly because I, as a femme, actively select my femininity rather than accept it as a natural or necessary corollary to my female biology.

The key to this sense of power is that I consciously choose to present myself in feminine ways. My femininity is my choice and construction; it is not a dutiful response or reaction to a social mandate that dictates that female equals feminine. Moreover, it feels empowering because I use my consciously crafted femininity to attract and entice the objects of my affection, who are over-whelmingly gentlemanly butch women. Now, make no mistake about it: I adore the attention my gender presentation garners from chivalrous admirers. However, I find the most significant and empowering aspects of my femmeness lie in relation to myself.

Perhaps principally, I feel empowered because of the pleasure I derive from its creation. When I am getting dressed for a date or doing my makeup and nails, I am saturating myself with simple feminine joys. I enjoy these activities not only for the indulgent delight I feel from them, but from the connection I feel to countless femmes before me, including my mother, who utilized the pow-erfully transformative powers of makeup, perfume, and clothing.

To say that I, as a child, loved watching my mother get ready to face the world would be a gross understatement. I absolutely adored it. I looked forward daily to watching her emerge from the bathroom to sit at her vanity, flanked on either side by mirrors, and line her eyes deftly and per-fectly with liquid liner, apply rouge and mascara, and, after finishing her cigarette, slick her lips with lipstick. Through this ritual, I saw her metamorphose into an even more unspeakably beauti-ful and powerful woman: one who, in spite of her class disadvantage and lack of education, felt stronger, more confident, and better able to make it through her day in a man's world.

Similarly, getting dressed and made up for the outside world helps remind me to contextualize and historicize my life and queer community daily. Through something as apparently simple as a bold nail color, I am reminded not to be complacent in my life and to work to effect the changes I want to see. This can be particularly helpful on days I experience as especially bleak; if and when I feel hopeless or powerless with the state of the world, I am comforted, however minimally, by my glossy nails or lips.

Perhaps most importantly, my femininity empowers me because it allows me to feel more like myself; it makes me feel more authentic. Thinking about how to articulate this sense of authentic-ity reminds me particularly of adolescence, a time characterized largely by the collective struggle to find ourselves and our places in the world. When I am immersed in femmeness, I can breathe freely, even if, ironically, I am corseted so tightly as to make that endeavor challenging. I can relax and ease into myself more.

Whereas some women experience femininity as gender conformity, it actually makes me feel less susceptible to the homogenizing effects of socialization on gender and otherwise. I am not suggesting I am immune to the stifling ubiquity of norms; however, because it is something I have interrogated and crafted largely to my own specifications, femininity feels genuinely empowering. As a result, I feel better about myself and better able to accomplish what I set out to do—which, for me, means constantly striving for the elusive: social justice and the perfect shade of red lipstick.

Creating my queer femininity involves agency, interrogation, and intention. As a result, I find it to be an incredibly pleasurable source of power, one that helps me to live a more empowered and powerful life. And while my background as a white, rural, Southern, working class, feminine female initially was a hindrance for me and my queer femme identity, it has nonetheless provided me with an ineluctably unique vantage point; I am better able to see the complications and layers of life and identity because of my own struggles with labeling my sexuality. My insights fuel my abiding fascination with, and dedication to, femmes.

My history also propels me to be explicit and intentional in my efforts to divorce femininity from its requisite heterosexuality. In doing so, my fellow femmes and I are creating new visual markers for queerness, ones that include, but are not limited to, lip gloss and stilettos. While we are all certainly more than our looks, self–presentation remains important because it acts as the basis of how we perceive each other. Moreover, it is particularly important in a subculture that, in many ways, perpetuates itself based on the messages we send to others through and by our self–presentations. As the queer community rejects the false dichotomies that function to repress agency and self–actualization, accepted notions of what "looks" queer will be broadened. This more nuanced, expansive view can engender a more holistic, and preferably fashion–forward, knowledge of queer lives and sexuality.

Femme Fuck Revolution
by Hadassah Hill

This is my dream of revolution. An all–gender, glammed–up conspiracy of femmes.

The Fourth of July makes me feel a little jealous. All those people running around real excited, eating barbeque, setting shit on fire, shooting guns and celebrating the so–called Independence Day. Whether they have real independence while celebrating that cheating lying rapist plunderer revolution isn't the point. They're happy, and they get to feel free for a day.

I want that too.

I want a revolution to start now, with the femmes, and with all the people who love femmes, and with all the people who have yet to realize that they love femmes. Because I am tired of femmes getting the short end of the dick.

"This is a man's world," James Brown said. Maybe he's right, but somehow, that belief has crept into queer culture. And the conspiracy of men is nothing new.

It's true: with or without gentleman callers, some people keep up with that old way of thinking that those who represent as feminine must be inherently emotive and therefore deceptive and conniving, flaky or malicious, or oversensitive, full–time relationship mechanics. Then there's the delicacy, the nesting, and don't forget the fingernails that render hands useless—and of course feminine connotes a flatbacked, sexual black hole. Taking always matched with a big toothy hopeful legspreading, wrapped up with the same old gossip about who took whom. It's tied up with twine for the femmes, and then it's dismissed. And aren't we all a little tired of prepackaging?

Vagina dentata is not limited to femme, my friends, nor is it necessarily part of the equation. I want the person who gets fucked the most to be exalted. I want the people who feel extremely to be given their due. And I want none of these things to be tied to femme identity. Because if these traits are only and necessarily for femmes, then what do we do with sometimes–stone femme tops, like me? What of the femmes who feel tough, hate decorating, cut their nails, don't want to process, and still know in their guts that there's nothing but femme blood in their hot veins? Of course, these are trick questions: the answer is, we give femme more than just a curt nod and a place at the far end of the genderqueer table.

I love that the queer community is full of progressives and perverts, and that lots of realities have normalized themselves. For example, when boys get together to fuck, for them it's seen as fun, and everybody understands that bois will be boys and rubbing their shit against each other is perfectly cool. But when a femme wants to play, it's suddenly discussion–and–feelings time, it's got to be serious if a girl's up in it; her sexuality is a problem because of her representation. What the fuck does that mean for femmes?

It means: put–together femmes are shallow narcissists, and aggressive ones are still masculinity–chasers; tough femmes are witchy ball–breakers, and pretty ones must be stupid—unless they're

pretty enough to be well-paid sex workers, in which case they're exploited; demanding femmes are plain old high-maintenance, and those who just want to fuck, well, they must be breaking up with their boyfriends, or they don't get it, or maybe they're sluts.

Yeah, that's it.

I know whom I'm writing to in this essay, and I'm certain we can all agree that of course femmes are not necessarily any of the traits listed above, and that these are not even bad traits to cultivate.

For the record: femmes simply know what we want, and some of us would like glitter with our boy toys to match our one long hand of nails.

Some people still think that femmes get down only for love, commitment, and emotional content—you know, the Girl Needs. Femmes aren't supposed to get hot for hard things or to spread for softness without feeling something about it. And this is where this assault on the feminine gets confusing: why can't I just spend a long, sweaty night with a stimulating person without it having to read as an extension of my inner gender and a function of my emotion?

Femme motivation can be so much simpler than people think: my motives range from sweaty to mathematical; are controlling during, or are for making someone ask for it. My motives are to fuck, and those motives are there to help me succeed. What in the world makes that complicated? My eyeliner? Garter Belts? Maybe…using lipstick?

When I was gay camping in the woods this summer, I saw hotness all around me, and you better believe that I joined in. In front of me, three boys making out so hard I figured someone would be bleeding soon; later I invited one to kiss me, and it was so softly I thought something was wrong. Was it my dress? Truthfully, it may have been.

My femme siblings all around me have mirrors of this experience. While I, and we, have definitely gotten our share of rough trade when we want it, it's the occasional introductions of the assumption that we need it slow that's disjointing. I'll ask for it how I need it; that's femme for you. And you out there—the current and future femme lovers: it's your job to pay attention.

I say it's time for a femme fuck revolution. It's time for femmes to consistently have the status, make-outs, and hot dates we deserve without any unwanted assumptions. A great place to start is by giving respect to each other—and this will be so much fun! Where are my femme lovers in the house? If you love a femme, if you have femme friends, if you sleep with femmes, if you hold doors for us or support our shit, smile on yourself for a moment. We are brilliant, gregarious, kick-ass queers, and the more love and respect we give each other, the more we can shoot back out into the shit that matters to us. And besides, once femmes achieve mass multiple orgasms—intellectual and otherwise—we can collectively take on the world.

Now, I am a busy girl, I get tired of chasing people down, and I am not about waiting for my turn. Lord knows, I LOVE the masculine front-line folks, they're so sexy, so tough, and so complex. And there's just something really fucking hot about fucking butches that makes me shiver all over.

But the masculine genders are just so in vogue right now, and that's fucking with the femme game.

In our revolution, if there aren't enough boys willing to come around, it won't matter: because we got ours, and ours is revolution femme style. We are not waiting for the boys to come around. We're coming. We're cumming. And we're getting around.

See, we femmes are multifunctional creatures, and since I know for a fact there are tons of hot femme tops out there, this revolution is going to work. Whether the femme who seduces you is a rocker babe or a classy lady, a cowgirl or a biker, a pet owner, a student, or a schoolmistress, a daddy or a mommy, it's pretty much endless and girls—it gets revved up now.

This is going to cause more ruckus and surprise than my upstairs neighbors' previously docile, bongo–playing, white Rasta boyfriend tearing the door frame out at 2 am. "What are you capable of," she said to him, and to me, "I never saw it coming." Yeah, that's what they'll be saying about us, soon enough. Waves of smart, stylish, bossy women storming the streets, demanding what we want from life by day, and fucking our stone out by night. Now. That's revolution femme style.

Our revolution will not be broadcast live: it will be contextualized, randomized and feminized. (And for some of you, if you're good, it'll be force–feminized.)

So go ahead: tell a femme she's beautiful! Hit on her with fruity liquor, a zine, or an outstretched hand. Tell her femmes are your favorite, and mean it. The better it feels to be femme…the more likely we will consider making others feel good, too. Get your love lines flowing, cuz we're going to have a hot bitch revolution. For every hard–working, no bullshit (snap), fetch–me–my–robe lady in the house, I want to give my respect and love, because I know we are all moving into better and brighter days. Now holla if you hear what I'm talking about, because Femmes are too tough and hard, even when we're nice and soft.

Subverting Normalcy: Living a Femme Identity
by Ann Tweedy

If I had to sum it up in a sentence, I would say being femme denotes conscious, empowered adoption of one's femininity.[1] In other words, while feeling feminine expressing oneself in feminine ways—in terms of dress, speaking style, and general mannerisms—may not be voluntary or chosen,[2] I think of femme identity as an intentional celebration of the feminine against the background of a personal understanding of historical oppression of women that extends to all things feminine.[3] In other words, although there is quite a lot of baggage around the term "feminist" these days, it would be fair to say that the femme is a feminine feminist. Because the femme celebrates femininity with full knowledge of, and rejection of, the oppression that has historically been tied to femininity, the femme both reclaims and subverts femininity so that it becomes something positive and empowering for the femme and, eventually, for other feminine people as well.

The femme is rebellious in that she refuses the dichotomous/binary choice with which mainstream culture attempts to saddle women. For feminists of my mother's generation and even for many feminists today, to present oneself as a feminine person meant and means acceding to one's own oppression, as well as giving up important opportunities for academic and career success.[4] This had to be so, according to the popular wisdom, both because femininity is itself the product and symbol of oppression and because those in power (mainly white males) perceive success and competency to be diametrically opposed to femininity. (Indeed, my mother, who is a feminist of sorts, rarely dressed in feminine clothing and tended to make disparaging comments whenever she saw me dressing femininely, clearly believing that my femininity would harm my chances for success in the world. This was a subject of repeated disagreement between her and my father, a Born Again Christian who uses and needs his binary, non–blurry gender concepts to help him make sense of the world.)

1. I think of the core attributes of femininity as being those expressed in speaking styles, dress styles, and mannerisms. However, I recognize that femininity is an extensive concept that also includes career choices and value systems. See Mary Anne C. Case, "Disaggregating Gender from Sex and Sexual Orientation: The Effeminate Man in the Law and Feminist Jurisprudence," *Yale Law Journal,* vol. 105 (10/05): 20–21. When I speak of someone as celebrating their femininity, I refer to someone who, at a minimum, subjectively embraces the core attributes. I say "subjectively" because whether a person embraces these attributes and identifies as a femme is ultimately a question only she or he can answer. Moreover, while I recognize that what I'm referring to as the core attributes could well be deemed the most superficial, *id.* at 21, the essence of being femme is appearing femme in terms of how one looks and moves in the world.

2. By saying that such modes of being are not voluntary or chosen, I don't mean to imply that we have no control over them. To the contrary, we can always choose to suppress how we feel inside and to attempt to alter how we move in the world. The feelings themselves, however, and the tendency to express oneself in a feminine way are not things that I would consider to be chosen, although they may well be, at least partially, learned.

3. See Case, *supra* note 1 at 33.

4. Catherine A. McKinnon, "Difference and Dominance," in Mary Becker, et al., *Feminist Jurisprudence: Cases and Materials* (St. Paul: West Publishing Co., 1994): 75.

The femme, however, rejects the popular wisdom and refuses to compromise her self–expression. Like many members of marginalized groups, she says she'll be who she is despite what anyone else has to say about it. She says she'll set whatever life goals she wants, and she'll achieve them. In effect, the femme sets out to have it all.

The fact that the femme is engaged in this subversive process, simply through her very existence, means that she is necessarily stealthy, at least in the sense that she appears to those who don't know her to be part of the very system she subverts. As Lisa Duggan and Kathleen McHugh explain in their essay, "A Fem(me)inist Manifesto," although "[s]eemingly 'normal,' [the femme] responds to 'normal' expectations with a sucker punch—she occupies normality abnormally."[5] The femme, like a member of an ethnic or racial minority who passes as white, is more likely to be directly privy to the goings on of more dominant, or in the case of traditional feminine women, mainstream culture. People who don't know her are likely to say sexist or homophobic things around her that they wouldn't say if they knew who she was. Not only is she thus given more opportunities to refute prejudicial comments, but she also subverts the mainstream ideas about what a feminist is or, if she is queer, what a queer woman is. She un–others those concepts just as she remakes or re–others traditional femininity.

In short, the femme confuses things. Confusion can be very powerful in blowing apart stereotypes and constrictive categories generally. Notably, the confusion is also likely to occur among members of the queer community who will be more likely to mistake her for a traditionally feminine (read: straight) woman. The femme is a shapeshifter of sorts, but rather than changing her own shape, she re–forms the concepts that are the building blocks of our culture.

While the queer femme, and more specifically the lesbian femme, is the paradigmatic femme, I am not one of those who thinks that queerness is prerequisite to femme–ness.[6] First and most obviously, my definition of femme—as someone who intentionally celebrates her femininity despite knowledge of, and rejection of, the oppressions culturally tied to femininity—is broader than that. But more importantly for me, when I think of someone as a femme, I've found that I apply the label to both queer and straight women. In fact, in formulating the definition, I tried to make sure it covered my own intuitive perceptions of femme–ness. For instance, one of the poems that epitomizes femme–ness for me is by a seemingly straight poet, Kim Addonizio's "What Do Women Want":[7]

> I want a red dress.
> I want it flimsy and cheap,
> I want it too tight, I want to wear it
> until someone tears it off me.
> I want it sleeveless and backless,

5. Lisa Duggan and Kathleen McHugh, "A Fem(me)inist Manifesto," in Chloe Brushwood Rose and Anna Camilleri, eds., *Brazen Femme: Queering Femininity* (Vancouver:Arsenal Pulp Press, 2003): 167.

6. While I believe that men can be femmes too, and in fact have male femme friends, what I am about to say would not apply to male femmes because they transgress "normal" conceptions of maleness by expressing their femininity.

7. Kim Addonizio, *Tell Me* (Rochester: BOA Editions Ltd., 2000): 74.

this dress, so no one has to guess
what's underneath. I want to walk down
the street past Thrifty's and the hardware store
with all those keys glittering in the window,
past Mr. and Mrs. Wong selling day-old
donuts in their café, past the Guerra brothers
slinging pigs from the truck and onto the dolly,
hoisting the slick snouts over their shoulders.
I want to walk like I'm the only
woman on earth and I can have my pick.
I want that red dress bad.
I want it to confirm
your worst fears about me,
to show you how little I care about you
or anything except what
I want. When I find it, I'll pull that garment
from its hanger like I'm choosing a body
to carry me into this world, through
the birth-cries and the love-cries too,
and I'll wear it like bones, like skin,
it'll be the goddamned
dress they bury me in.

Because the speaker in this poem derives power from her red dress, in other words by dressing in a provocative, feminine way, I consider this work to be a femme poem. When she talks of the dress "confirm[ing] your worst fears about [her]," she tells us she has rejected the patriarchal role of women as being disempowered sexually, as beings whose sexuality exists solely for the pleasure of men. Thus, while embracing many aspects of traditional femininity, such as wearing sexy dresses and childbearing, she at the same time takes back her sexuality in a fully empowered way. She stakes her claim as a femme.

However, I realize that any definition of femme–ness that does not include a prerequisite of queerness could be considered revolutionary in some circles. For instance, I was recently kicked off a butch–femme email list-serve for being married to a man. Under the moderator's definition of femme, not only was queerness a prerequisite, but queerness itself was measured by others' superficial perceptions of whether you were in fact queer rather than how you identified. Thus, the fact that my marriage led others to perceive me as straight meant that my personal identification as queer was somehow faulty and erroneous, or at least incomplete in her mind. Ironically, an ex-girlfriend who identifies as a lesbian but who sleeps with men occasionally is the one who appears to have brought my marital status to the moderator's attention. To me, this incident not only demonstrates biphobia in the queer community (although the list purported to be bi–inclusive) but also the extent to which the femme woman risks being labeled inauthentic as a queer person—even in groups built around butch–femme identities, she may be required to prove a monolithic lesbian identity.

Personally, I reject attempts to define objectively sexual orientation as well as femme-ness. Identification with such concepts is grounded first and foremost in one's perceptions of oneself. The idea that someone could come along with a tally sheet and overrule a person's deepest perceptions of herself on such issues is inimical to my whole conception of identity.

While, in my view, a woman can be both straight and femme, I think that queer, i.e., female femmes, take it up a notch in "occup[ying] normality abnormally." In other words, perhaps especially in the case of lesbian femmes, queer female femmes appear to be sexually "normal" but are not so (in terms of mainstream, heterosexual sexual orientation) at all. One could argue the point both ways with respect to bisexual femmes: is it "more normal" to be bisexual than lesbian because bisexuality includes a component of heterosexual attraction, or is it "more normal" to be lesbian and thus monosexual, though in a different way than the mainstream, heterosexual world? Similar questions might be raised with respect to male-to-female transgendered persons, who may be lesbian, straight, or bisexual in addition to being transgendered. Like every assessment of normalcy, the answers depend on the audience and the predominant definition of normalcy among audience members. At any rate, because she is "less normal" (or mainstream) in terms of sexual orientation, the queer femme is more subversive and in a sense more stealthy than the straight femme; she is certainly likely to be subject to more erroneous assumptions.[8]

In my own case, as a polyamorous queer femme who is married to a man, the erroneous assumptions are quite plentiful. When people hear I am married, for instance, they often put me into the straight, monogamous box, and it can sometimes take a very direct statement to disabuse them of this negative assumption. For example, a reference to "my girlfriend" is more likely to be read to refer to a platonic friend than it would be if uttered by a single person. For people who know that I am queer and married to a man, such a reference on my part may elicit discomfort and confusion on their part, presumably because it implicitly gives them unwelcome information about my "abnormal" sexual practices. Even straight people who do not know I am married tend to assume I'm straight, as do queer men, presumably in both cases because of my femininity. Queer women in my experience are less likely to make these erroneous assumptions, although they too are not immune.

Thus, to me, a femme is a feminine person who consciously celebrates her femininity while rejecting the oppression of women and the oppression of the feminine in all of us. Just by her very existence, she challenges traditional assumptions about femininity. While she can be queer or straight, the queer woman necessarily challenges more assumptions than the straight femme, at least in terms of femininity.

8. A funny recent example occurred when I was in a rural bar with live music. I was dancing with a friend (who is somewhat feminine) when another woman starting dancing with me. "Don't worry—I'm not gay," she said, by way of introduction. Surprised, I exclaimed, "Well, I am," and laughed. She laughed also and quickly danced away. Later, she asked me if I was serious or was just joking.

The above example is a great illustration of the invisibleness of queer femmes and how the possibility of their being gay is often not recognized at all by those who don't know them well. Of course, queer femmes derive privileges from this invisibility as well because they are less likely to be the targets of discrimination by strangers.

The King of Femmes
by Asha Leong

I've spent my whole life in the South, baking in hot Virginia summers that faded into cool winters. The South, the dirty dirty, where white nectarines summer on the tongue, wide witch trees ground future tellings, crooked creeks splash summer grass: all this held home a world away from where I came. I was born in the real south, about as south as you can get: Wellington, New Zealand.

New Zealand is like a figment of my imagination, amorphous but always there. My Chinese relatives in Wellington are like an army of ants always milling about, campaigning, driven. We left behind my grandmother at the head of the family like a queen ant, laying the plan, issuing orders, marching on. My Indian/Irish relatives, also in Wellington, came in much smaller numbers; they were less loud and more loving like my cousin, Maya, my complete opposite blond, blue-eyed, thin, foiled against my black, brown-eyed fatness. We traded our island home for landlocked Southern hotness. I wonder what it felt like for me to leave everyone I loved at five for America. I don't remember.

My mother was shocked by America as only a multiracial immigrant can be. My mom could not find clothes for me in stores that were not colored pink or purple, so she dressed me in boys' clothes. I was a terrible tomboy. I remember my first day of kindergarten when the boys were looking up the girls' skirts from underneath the jungle gym, but they couldn't look up mine because I was wearing shorts. My mother also couldn't find any action books with girls as the heroine. I remember my favorite childhood book, *Aktil's Big Swim*, about a mouse that swam the English channel and then had French fries with the French mice. I loved French fries, so maybe that's why it was my favorite, or maybe it was because my mom had given Aktil a sex change and made the boy mouse the girl heroine of my dreams.

I remember so much of my childhood involved battling my mother about what was considered normal for American children to do. We had long conversations about getting a bra, my ears pierced, being allowed to wear makeup, have enough of an allowance, and getting to hang out with my friends. I was the oldest, so I had to push in order to have the life my friends thought of as normal. My mother had no idea how to guide me into being an American woman. I thrived in American culture, while she never understood it enough to know what was right for me or why. I remember so clearly in eighth grade wearing puffy, off-the-shoulder shirts with just one color of green or blue eyeshadow smeared across my whole eyelid. It was not an auspicious start to the femme who I've grown to be today.

There was a way in which being a multiracial, immigrant woman in the South meant I was never going to fit into what was considered power in my teenage world. I looked in the magazines, watched the television and knew what held value was the blond, candy-floss, glossed, thin version of white beauty. I knew I never had the chips even to imagine playing in that system. I did what I could: I was the best friend of the beauty queens and popular girls. I was the dark twin, ignored and used. I couldn't be them, but I could be close by and feel the warmth of power I knew I could never have myself.

I was a late bloomer as a femme. In fact, I mistakenly thought my queerness required butchness, so I spent part of college in flannel, fatigues, and combat boots. My head was half-shaved with squares, many colors, and even the word *dyke* once shaved into the back. My journey to femmeness began in Atlanta on a trip to the twenty four-hour WalMart with my best friend, nikki. A pair of red strappy platform sandals found me. I was so excited about them that I fell asleep with them on my feet. It was that simple; I was done.

I was femme born of the white-trash superstore, with shiny red straps crisscrossing my feet. femme like my spit was glittering diamondique that could be used to accessorize anything. femme like the blisters and bleeding feet from flaunting impossibly high heels not actually meant for walking. femme like "fuck you" and "hell yeah," the kind of strut down the street that no one messes with. femme like sweet tea that washes down, leaving one feeling both satiated and full. I love the power my body has when I'm that perfect vessel for my perfect femme.

But there was also Al.

Al Schlong is a sleazy guy. He's not the guy you bring home to momma; rather, he's the one in the morning that made you feel like you stepped into a sleazy '70s movie as the judgment-challenged heroine. Al is my alter ego, my pied piper, my masculinity. Al is a little bit of a hip-shaking rock star. Every time I say I'm a drag king, I get a disbelieving look. Most people cannot fathom that the femme girly girl in front of them could ever possibly be a man. The sick part is that Al is more man than just about anyone can handle. I smile at their judgment and disbelief and say, "Al's a sexy guy." Al makes people nervous. How can this pink, glittery, rhinestone-encrusted femme be a guy?

I've had lovers who came early to pick me up for dates, only to find Al naked with only his eyebrows done. That experience was more than enough for one, who was so thoroughly distracted we almost didn't make the show on time. I've also had lovers who had an identity crisis, worried about meeting Al, or questioned their own gender because of my gender flexibility. There is something so damaging to me to put myself out there as Al and then feel judged, belittled, spit upon.

Al is a man of many talents: he's rocked out to Vaginal Crème Davis, Nine Inch Nails, Meatloaf, and Bollywood hits. Al loves to be a chameleon. He has as many sides as a rainbow Sporty Spice: debonair in a tux and full-length cape, preppy in button-downs, and strange in skin-tight unitards. Even my alter ego has alter ego. Al cuts an extremely compelling high-class vampire: just look into his eyes and be captured. This personality vies with a pirate dying of the scurvy, of course. Al's not afraid of his feminine side. Al is especially into the feminine accessories of masculine fashion. He loves bankers cuffs and thinks they're just like garter belts but for men. Suspenders bring his soft member to attention; the urge to snap them is overwhelming. As for cuff links, Al would love nothing more than a bank vault full of the shiny, matching baubles. While Al may be a faggot, he still loves the ladies and will win their hearts through any means necessary, including a battle of the accessories.

People treat me completely differently when I'm Al Schlong. My femme friends fawn over me and do dirty things that get them in trouble with their daddys. The daddys who know me quite well in both guises treat me like another butch, even though they know underneath the drag, I am a

femme. They play butch–out games and actually include me. In my head, it's totally dysphoric because I know I don't belong in this masculine world. I'm a little disappointed to learn that these butch–out games exist at all. I don't feel the need to compete: my masculinity is completely constructed, and I feel secure in the man that I am. I know the strength in Al's hip movements and pelvic thrusts. I have the screams and molten desire of pretty ladies to remember as I fall asleep at night. I don't have to be king of the mountain as well.

My gender becomes even more complicated in terms of relationships. While queer through and through, I'm attracted to both the femme and masculine side of the queer gender spectrum. Have I mentioned that I'm a slut? I like to fuck and play, and I don't apologize for it. Living in the South, it's hard to escape the boxes of butch/femme relationships, which often feel straight and overdone in this region. As a result, this dedicated dynamic makes it especially hard to score with the other girly girls.

I struggle with what to do when I am authentically myself in two completely different gender presentations. For example, when I once held a barbeque in honor of femme–on–femme action, countless butches asked whether it was okay if they could come. If I had held a butch–on–butch barbeque, everyone would have known they were included. Why not femmes? Our queer community prioritizes and idealizes masculinity over femininity so deeply that a celebration of femme–on–femme action is not genuinely understood. Why is the reality of femme–on–femme action such a golden holy grail? Does it count if I'm dressed as a boy, and they want me for my cock? I must admit that in my mind, it counts.

I'm secretly pleased at the reality of femme–on–femme even when knowing that I'm cheating (i.e., is it really femme–on–femme action if I'm Al or butch at the time, and femmes want me for my masculinity?). There are those glorious moments though when femme–on–femme happens in "real" life without any assistance from Al. Those times give me faith that one can be truly seen despite the trappings of masculinity.

Hot southern nights, the humidity dripping down my back, this girl struts in stilettos, skipping holes in the pavement; this man struts through dark alleys looking for trouble. I am a culmination of all of my parts, the feminine, the masculine, a total genderfuck. This southern girl struggles with being seen, recognized, identified. The people who can see through my various selves can understand the whole of my gender-bending parts, wholeness engaged with the ebb and flow of gender as it crosses the landscape of my body. Those are the people I count as family, who live in the beating of my heart.

The Conversation
by Mette Bach

When most people move, they give notice to their landlords in the form of a phone call or possibly a letter. My landlord doesn't operate that way. For one thing, he asked my partner and I to stay forever and promised us that he would never raise our rent. He's about seventy-five, and while his English is rusty, I'm told his Cantonese is even harder to understand. After my partner and I broke up, I stayed for nearly half a year, in part so that I would not have to disappoint him. When I finally decided to give notice, I budgeted an afternoon and drove to his house where he insisted that I drink cola and eat unfolded fortune cookies with him.

He ushered me into his office, which is also his bedroom and is about the size of a walk-in closet. I sat on his bed, and he took the wheely office chair and put on his reading glasses. We spent the first hour talking about the parking ticket he got last week and how difficult it would be for him to show up in person to pay the fine. He could send a check in the mail, he told me, but how would he know if they got it? Who could trust mailmen these days? City Hall had canceled the telephone payment option, so he would have to go in person or pay online. That's when he gestured for us to switch seats such that I was in front of his 386 PC. His kids were too busy to give him a tutorial on the internet, he said, so the duty fell to me. I figured out his dial-up connection. He reconciled his reluctance to send his credit card number into cyberspace. The lesson was over before my cola was even warm.

A little more small talk about his cab-driving days and his mah jong friends, and I knew I had to execute. I was blunt. I said we broke up, and she had already moved, and now I had to, too. We sat in silence for a while, Mr. Gee not being the type of person who feels the need to speak in order to alleviate awkward quiet moments.

"I'll miss you," he said.

"I'll miss you, too, Mr. Gee."

We switched seats again. He poured more cola despite my objection. He pushed his chair back from the computer desk and looked at me, inquisitive. "This woman-woman thing . . . is this something you always do?"

I understood his confusion. My ex is not much of a lady. She can use the women's washroom, but she often has an easier time in the men's. We had lived together in his house for the past two years and had spent many evenings with him, drinking cheap wine and listening to his stories about coming to Vancouver with nothing when he was only sixteen, and how he had been a house boy, then had driven a taxi, and how he had bought real estate and put five kids through university. He told us about his failed marriages, his affinity for gambling and his good-for-nothing daughter who didn't understand hard work. Invariably, by the end of these encounters, he'd tell me that I was beautiful, like a movie star, and he'd pat my ex on the back and tell her he'd never known a woman so good at fixing things.

"Yes, Mr. Gee. The woman-woman thing is something I do," I said.

He told me it was okay. He said that when he was young, it wasn't okay to be woman-woman or man-man, but things were different now and better. He hesitated for a moment, then started rifling through his files. Usually, when I visit him, he pulls out the family album and tells me stories about his younger days. He shows me his kids and talks about the importance of family and sticking together. I had a feeling that was what I had coming. I know Mr. Gee doesn't approve of the bachelor apartment lifestyle. I was pretty sure he was going to suggest that I move back in with my parents.

Instead, he pulled out a photo of his dentist son, the one he's always boasting about. He was in a cap and gown on graduation day, looking like he was posing for the kind of photo that he knew his parents would show to everyone. He too apparently lives alone in a small condo in the west end and doesn't aspire to the kind of family life that Mr. Gee wants for him.

"My son," he paused, "I think maybe he's man-man. He's a dentist. Very handsome."

"Oh."

"He's very smart," Mr. Gee insisted, "Maybe you should try."

And that was when I realized I was being set up. I couldn't help but laugh.

"I *have* tried," I said, "I'll bet your son has tried, too."

"You're beautiful," he said, "You could have a very rich husband." Then he told me that I was a good girl for choosing my ex who, even though she wasn't a rich man, had skills and talent and was smart. She had put in a new floor and installed our gas stove and rewired the house for him. Mr. Gee and I were both impressed with her abilities.

"I loved her," I told him.

"I loved my ex-wife, too," he said, "and now she has my houses. That's okay. Women. You can't keep them. They stay until they don't want to no more, and then they go. It's okay."

Mr. Gee has always made me feel that way, that things would be okay. We drank our colas in silence and then chatted a bit about the pain of parking tickets. He insisted I take his son's business card anyway, "just in case," and said that no matter what, I should at least get twenty percent off any dental work I needed. As I left his house, I realized that even though he never fixed the plumbing or the rotting planks in our porch, he was the best landlord I've ever had.

The Shimmy Shake Protest: Queer Femme Burlesque as Sex Positive Activism
by Maura Ryan

You probably already know what burlesque is because, since its revival in the 1990s, many cities have been inundated with various incarnations of the striptease art form. Those incarnations can vary from bachelor party entertainment to political art. Queer scenes have not been immune to the trend. In fact, queer women have been at the cutting edge of burlesque's popularity. While individual burlesque dancers may have been queer since the dawning of the pasty and the g-string, the last ten to fifteen years have birthed the emergence of queer burlesque. Queer burlesque (i.e., queer–identified people burlesquing in queer venues for mostly queer audiences) has emerged for different purposes than general neo–burlesque, and it produces unique effects.

We all have questions about the phenomenon that's become part of our lives (or at least part of our queer outings). Questions like, how do they open their eyes with such heavy fake eyelashes? How do glitter and gems stay put? Where do they get the nerve to perform like that? Although this essay doesn't offer practical advice about eyelashes and glitter, it does attempt to answer some tougher questions about where queer burlesque dancers get the nerve to demand celebration of femininity from queer people.

My dissertation focuses on femme social movement activity in queer communities and how femmes attempt to make queer people fonder of femininity through a variety of methods. One of the methods is the use of burlesque. In this essay, I offer examples from my repeated observations of queer burlesque performances in Seattle and Portland to point out the significance of why queer femmes use burlesque, why it's important that femmes do it, and why it's political.

Burlesque: The Historical Context

Burlesque is a vaudevillian–inspired striptease that employs extravagant costumes, dramatic makeup, and humorous skits to entertain audiences through a merging of erotic display and wit. In classic form, it emerged in the 1870s and remained popular throughout the 1930s (Wilson 2008). Classic burlesque performers offered an alternative to a conventional womanhood that emphasized fragility and purity by reveling in "unladylikeness" and "overtly sexualized, loud, and feminized" erotic performances (Wilson 2008: 81). By the 1960s, the availability of stripping and live sex shows had completely replaced classic burlesque performance. Thus, the art form stayed dormant for nearly half a century.

In the 1990s, burlesque was simultaneously revived by counterculture performance artists primarily in New York City and Seattle and is now generally referred to as "neo–burlesque." Neo–burlesque, like classic burlesque, eroticizes a variety of body types and makes use of humor and bodies to create sex–positive displays. Its "newness" refers more to its revival in the current cultural context than differences between new and old performances (Baldwin 2004).

While the classic burlesque of the 1920s and '30s enjoyed mainstream popularity, neo-burlesque tends to be subcultural, or even countercultural. In today's sexual culture where nude shows are commonly available in major cities, the popularity of burlesque comes from something more than a desire to see nude or almost-nude women. Today's burlesque is a nostalgic portrait of feminine sexual iconography. Neo-burlesque performers, like classic performers, use burlesque to provide erotic performances while making statements about sexuality (Allen 1991; Baldwin 2008). However, because today's sexual culture is different from classic burlesque's sexual culture, the sexual statements of the dancers are different, and their performances are received differently by their audiences.

Why Burlesque? Queer Women's Political Context

To answer the question, "Why burlesque," I first explain why queer women's cultures value visible eroticism. Briefly, my answer is that such valuing directly results from feminist and queer conversations about the ethics of sexual representation since the 1980s.

Even though feminists have always argued over the meaning of sexuality, the feminist "sex wars" refer to a set of specific debates in the 1980s. The mounting friction over questions of pleasure, power, violence, consent, representation, and autonomy erupted at Barnard College's 1982 conference on "Pleasure and Danger" in women's sexuality. Feminist activist group Women Against Pornography protested the conference wearing t-shirts that said, "For Feminist Sexuality" on the front and "Against S/M" on the back. The Lesbian Sex Mafia, a New York City organization dedicated to "politically incorrect sex," responded with a speak-out the next day. The feminist magazine *Off Our Backs* covered letters to the editor on both sides of the debate for months following the conference (Hunter 1994). Although the debate between anti-pornography feminists and anti-censorship feminists became the most memorable throw-down during the sex wars (Duggan 1994), the decade-long rumbles also featured discussions on prostitution, lesbian/queer sexuality, sadomasochism, and even style/fashion aesthetics (Queen 1999).

Some queer feminists claim that the sex wars created new erotic opportunities for queer women and changed the ways that queer feminists theorize about subjects like erotic oppression, sexual domination, and gender relations (Queen 1999). For some "pro-sex feminists," the journey through the sex wars meant that they valued queer erotic identities over what had come to be seen as a judgmental feminism (Rubin 1981).

Similar debates around erotic representation emerged within GLBT communities with the onslaught of the AIDS epidemic. Because the government's inattention to the AIDS epidemic rested on a homophobic fear of queer sex, part of the radical response of AIDS activists was a celebration of queer sex and a direct action politic dedicated to the visibility of queer sex (Schulman 1994). I'm talking making out in malls filled with straight folks. I'm talking people dressed as giant condoms marching in protest. I'm talking demanding information about transmission rather than punitive measures. However, not all gays and lesbians agreed that their communities should promote a visible sexuality as a tactic pursued to end the AIDS crisis. For instance, some gays and lesbians agreed with the state that gay baths should be closed to help stop HIV transmission while other gay activists argued that closing the baths would be a homophobic punitive measure (Hollibaugh 1996). The GLBT debates around sexual representation following

the onset of the AIDS epidemic were the beginning of the political divide between mainstream gay and lesbian reformists who wished to sanitize gay and lesbian identity from its association with gay sex and queers who celebrated the unique political potential of queer sex and its representations (Warner 1999).

Whereas the gay and lesbian ethnic identity model of political organizing tends to be rights-based, queer politics tends to be ideologically and culturally based (Gamson 1995). For this reason, while a defining characteristic of mainstream gay and lesbian politics is their disassociation from queer sex (so that elites will believe their movement slogan that they are "just like everyone else") (Warner 1999), a defining characteristic of queer deconstructivist politics is the goal of creating a sex–radical culture in which queer sex is more visible and less sanctioned (Califia 2001; Warner 1999). Deconstructionist queer political philosophies reject the privileges of sexual normalcy, and as such, its political maneuvers do not include lobbying the state for inclusion in its institutions; instead, queer political action takes place at the level of *cultural* change (Berlant & Freeman 1992), with a great deal of emphasis on the empowering potential of queer eroticism (Califia 2001; Warner 1999).

The investment in a politic dedicated to queer sex visibility is particularly instrumental in understanding queer women's communities. Since the 1970s, feminism has deeply characterized lesbian cultures (Taylor & Rupp 1993), and (while we recognize that our communities are not made up of just lesbians anymore) modern queer women's communities are a manifestation of feminist *and* GLBT political debates. Queer women today exist in a community that has experienced the feminist sex wars of the 1980s and the pro–sex politic that emerged from it, the AIDS epidemic and the queer sex debates of the 1990s, and the temporary merging of queer men and women in activist communities where we learned erotic lessons from each other.

The importance placed on non–state–directed activism, the feminist sex wars, and queer sexuality debates since the onset of the AIDS epidemic have created an atmosphere in which young queer women can enter into political discourse through the erotic use of their bodies. For a whole lot of feminists and queers (and feminist queers) in this political generation, sex is understood to be inherently political. Burlesque is one avenue through which young queer people challenge hegemonic, heterosexist, and patriarchal mandates about sex, sexual visibility, sexual bodies, and women's sexuality; it is an important avenue, especially given the historical development of burlesque and its uses of feminine queer bodies to produce it.

Why Femmes?
All neo–burlesque performers subvert sexual prescriptions for feminine women. However, the queer context of queer burlesque allows for unique sexual statements and a unique subversion of feminine scripts. It's rad that some queer women are choosing to articulate erotic performances through neo–burlesque, particularly because of the way that femininity has been stigmatized within lesbian communities.

We know that story by now. Throughout the 1930s, 1940s, and 1950s, the predominant lesbian gender dynamic was that of butch (masculine women) and femme (feminine women) (Kennedy & Davis 1994). The prevalence of butch/femme gendering began to change in the 1970s when a

lesbian feminist political sentiment emerged, seeking to redefine the parameters of appropriate lesbian behavior by criticizing the existent lesbian culture of butch/femme (Case 1999; Nestle 2003). Butch/femme couples were accused of unwittingly aping heterosexual roles (Nestle 2003). Butches were painted to be uncivilized brutes who attempted to garner power by dominating their feminine partners; femmes were assumed to be fallen heterosexual women who forced their partners to be masculine as substitutes for men (Case 1999). Consequently, it became politically and socially difficult to assert a butch or femme identity for decades following this gender intervention (Nestle 2003).

Although butches and femmes were both criticized through this kind of feminism, there was a particular feminist stigma reserved for femininity and feminine–identified people. Harris and Crocker (1997) explain:

> Femmes—like other groups of women—were not always welcomed into a mainstream feminist movement that had as its primary constituency middle–class white women. For femmes in particular, feminism's failure was its pejorative understanding of femme as equivalent to patriarchally imposed femininity, rather than alternatively a positive understanding of femme as a critical approach to femininity. In its (mis)recognition of femme, feminism denied femme its radical and critical nature (3).

The feminist vilification of butch and femme (and particularly of femme) were part of a "political lesbian" construction that emphasized lesbianism's link to a political feminist identity more than an erotic interest in women (Queen 1999).

There is an important parallel between the way that lesbian feminists purported to practice lesbianism for feminist ends and the ways in which queer people today express a belief in visible queer eroticism as a path to political empowerment: both merge the concepts of sexuality and politics, though they have totally different ideas about sex and politics. Carol Queen (1999) thinks that the claims of political lesbianism were less radical than lesbianism had been before its feminist intervention. This new brand of feminism was less challenging than lesbian culture had previously been to essentialist assumptions about male and female bodies, the naturalness of heterosexuality, and gendered relations of power. Although the activists who formulated "the political lesbian" believed their construction to be quite radical, the desexualization of woman–identified lesbians served the patriarchally–defined mandates of female sexuality.

The connection between queer femme presentation and erotic visibility is evidenced by their simultaneous suppression by lesbian feminists; the connection is made clearer by their simultaneous re–emergence in sex radical culture. For instance, Queen (1999) asserts that the sex radical culture that resulted from the sex wars has allowed queer women to rebuild their communities after mainstream feminism had stifled their erotic potential. She says:

> In many ways, the latter part of the 1980s and '90s have been a time of recovery as the lesbian community grapples with sexual issues, producing its own erotic materials, rehabilitating butch/femme and dildos, struggling to accommodate gender variant women and transgender people, and revisiting the issue of lesbian and bisexual erotic diversity (186–187).

She goes on to say:

> Increasingly, transsexual and transgendered women and men (including female–to–males), bisexual women and bi–dykes, butch and femme identified women, S/M dykes, and others on the gender spectrum can find each other and also some space within the lesbian community—if not always enough space, or easily enough won (187).

Part of this "rehabilitation" is occurring through the queer feminine labor of burlesque. Femmes are key figures in the political work of making queer erotic space because they have been marginalized in queer communities; because their gender identities are often grouped with other gender/sexual outlaws like butches, trans people, and S/M dykes; and because their sex/gender presentations of female femininity have a history of eroticization in dominant culture. They use burlesque because it is an historically significant erotic performance and because it celebrates a sexually extravagant female femininity.

Queer Burlesque's Political Statements
Burlesque is a nuanced political tool precisely because of its use of the body. Burlesque performers follow the political orientation that all bodies can be sexual and that queer sexuality should be public. They create those spaces with their bodies. Spaces where queer burlesque is performed are transformed into spaces where the celebration of (near) naked bodies is normalized and where queer audience members have the opportunity to display lust for other queer bodies.

Because lustful sexual exchanges between members of the same sex are typically sanctioned, the opportunity to display one's body for a queer audience (or to appreciate another queer person's body visually/vocally) is unique to that environment. In short, because queer sexuality is politicized by non–queer dominant others, queer sexual displays are by default political.

Queer burlesque dancers display their (near) naked bodies and perform erotic dances so that audience members can experience queer erotic exchanges that are not typically experienced by women. For instance, at one fundraiser event that offered burlesque dancing as part of the evening's performances, the announcer was attempting to gain the attention of the audience after The Von Foxies performed so that she could announce raffle prizes. She asked, "Are you awake out there?" to which someone answered, "We're mesmerized by boobies."

These kinds of exchanges illustrate how burlesque creates an atypical atmosphere of (queer) sexual appreciation. A similar exchange occurred between dancers and audience at the 2007 pride festival event in Portland where The Rose City Sirens performed a series of dances individually and then performed a group finale. In one of the individual performances, a troupe member—slender, with short, femininely styled hair and outrageous makeup, wearing a white ribbed tank top, suspenders and tight–fitting short skirt—ended her dance by standing on a speaker and pouring two bottles of vodka over her body. She shimmied and rolled her hips as the liquid poured over her body and made her white shirt sheer enough to see through it. The crowd roared, hooted and clapped. Next to me, a woman stood with her mouth agape, staring up at the performer. Another woman next to her—presumably a stranger—asked her, "Are you going to be alright?" She replied, "I think so. That's the hottest thing I've ever seen."

At Seattle's 2007 annual burlesque performance during Pride celebration week, the prominent burlesque performer, Muchacha Extravaganza, hosted and performed one dance routine. Before she entered the stage, music with a salsa beat and Spanish lyrics boomed in the club speakers. Muchacha Extravaganza blasted into the room by running through the main room's entrance and around the tables with dramatic twists of her body and sweeping motions of her limbs. Wearing a leotard, a cape, and a Zorro mask, she jumped onto the stage midway through the song and began to dance around the prop set up for her: a donkey piñata on a table. She flirtingly gestured to the donkey, leaning into it and pursing her lips. Standing behind it, she began caressing the cavity of the piñata with one finger and then penetrated its opening. She held up two fingers to the audience with one hand and waved her other hand frantically up and down, calling for the audience to shout out, "Two!" After penetrating its cavity with two fingers, she held up three fingers to the audience, and they shouted, "Three!" It went on this way until her hand, in the shape of a fist, was inside the piñata. Nearly everyone in the audience stood at that point; everyone was clapping, and many people were shouting and slapping high fives to each other.

Although the piñata was an inanimate and supposedly genderless prop, Muchacha Extravaganza performed the popular and popularly derided lesbian sex act of "fisting" (Hollibaugh 1996) on it. In this case, to achieve a political message that challenges the impossibility of female people performing penetrative acts during sex, she uses her body—most notably her fingers, hands, and arms, body parts that are particularly erotic in lesbian sexuality (Bright 1999).

In addition to political commentary on sex acts, the potential to merge sexuality and politics purposefully after the sex wars has meant that some queer burlesque dancers can also use erotic performances to make political commentary about phenomena beyond sex acts. Importantly, Muchacha Extravaganza's choice of music (salsa) and costume (Zorro, a fictional superhero who fought the rich and served indigenous Mexicans) speak to the complexity of race, ethnicity and class in spaces that promote queer desire. During my ethnographic research in Seattle and Portland, I observed the performances of over thirty queer burlesque dancers. Muchacha Extravaganza was one of only three performers of color I observed. The 2000 census reported that Seattle's population is 70% white, and Portland's population is 77.9% white (U.S. Census Bureau, 2000 Census); thus, some of this lack of diversity can be explained by the racial dynamics of the Pacific Northwest, but their racial homogeneity also speaks to racial tensions in queer communities. That particular evening, through the humorous use of the piñata and her feminine Zorro costume, she forced the mostly white audience to contend with the ways in which she is racialized as a woman of color in queer sex–positive spaces.

Much like Muchacha Extravaganza's performance, some performers are able to make the audience laugh at painful topics because they are offered in humorous ways. During the same evening as Muchacha Extravaganza's performance, another prominent performer, Miss Rainbow, performed several times. In one of her performances, she came on stage wrapped in a rainbow boa with rainbow ribbons in her hair. The song "Love for Sale" played as she swayed back and forth. During her dance, she held up well–known advertisements of major corporations that target the gay community: a rainbow Bud Lite beer ad, a lesbian Subaru ad, and to end her dance, she turned around to show us a cardboard sign glued to her naked behind that read, "Your ad here."

During this time, Seattle's GLBT community was engaged in a debate over how commercial their pride celebration should be: the pride parade had been moved from what is warmly called "the gayborhood," the Capitol Hill district, to the downtown district, removing possible proceeds from locally gay–owned shops and restaurants and allowing a more corporate pride celebration to emerge. In response, two different pride festivals developed: the official corporate one held downtown, and one called "Queerfest" that was located in the Capitol Hill district. Thus, Miss Rainbow used the classic humor in burlesque to create a *queer* humor in the context of *queer* burlesque. The topic of a commodified queer culture is of particular interest (and is a particular source of pain) to queer people, and Miss Rainbow used her body to lament the conflict.

Humor is not always used to make light of difficult situations. Humor is most often used to talk frankly about sex and sexuality. The Von Foxies provide an example. At a fundraising event in which they were featured performers, two members of the troupe entered the stage wearing floral dresses, pearls, and white gloves. One of them sat in a white garden chair, while the other sang her the song that played on the speakers. The lyrics announced her love for the woman to whom she sang, "You're smart, you're funny, you're lovely, and you believe that human rights violations are wrong." The woman being sung to smiled and nodded enthusiastically. The woman who was singing paused with the music, "But there's just one thing I need to know…do you take it in the ass?"

The woman being sung to jumped out of her chair and shook her head from side to side, indicating that her answer was no. They followed each other around the stage, with the pursuer trying to convince the pursued to submit to her sexual request. Finally the pursued took the pursuer by the shoulders and turned her around; the pursued lifted her own skirt to reveal a dildo (i.e., a phallic–shaped instrument used for penetrative vaginal or anal sexual contact) strapped in by a harness around her hips. She motioned back and forth as if she were anally penetrating her. The audience laughed and clapped. The performer who had been requesting to be the penetrator, and was now the penetrated partner, turned her head toward the audience and smiled. Then she stood up, lifted her own skirt and turned the other dancer around, revealing her own dildo strapped in by the same method. She moved back and forth as if anally penetrating her, and the other one smiled to the audience. In creating a scene where two conventionally feminine women engaged in anal intercourse with each other, The Von Foxies sought more than just sexual interest from their audience; they also evoked a challenge to standard understandings of how feminine women can have sex. Feminine girls in dresses and pearls can be attracted to each other, and they can have sex that we might not expect them to have. In this case, the sex that we may not expect them to have is a penetrative act that is profoundly symbolic of a source of stigma for queer people in the AIDS era (Hollibaugh 1996; Schulman 1994).

Similarly, at a fundraiser event for a queer Jewish documentary, Miss Rainbow and another prominent performer, The Nude Folk Review, illustrated an example of humorous banter that demanded a broader understanding of who can be queer and how many sex acts are possible for them. In their skit, they performed what they called "comedic burlesque" in an act called, "Your Jewish Grandmothers." Both self–identified Jewish queer women, they dressed in stereotypical elderly women's style and talked with exaggerated New York accents. They sat on stage and answered questions from the audience. The following is their answer to the question, "What is your favorite sex act?"

The Nude Folk Review: None of your business!
Miss Rainbow: Why are you sticking your big Jewish snoz in my business?
The Nude Folk Review: See, as one gets older, you get stretchier, baggier, looser.
Miss Rainbow: Fisting! She's talking about fisting!
The Nude Folk Review: You use lots of oil.
Miss Rainbow: Like Hanukah.

In response, the audience exploded in laughter. Laughter from the audience was probably the goal when they designed this scene. However, offering a scene to an audience in which elderly women discuss same-sex attraction and an extreme form of penetration also begs the audience to expand their notion of who can be queer and to imagine the erotic potential of unconventional bodies.

As with the examples of Miss Rainbow's pride celebration commentary, the two Von Foxies' anal penetration inquiry, and the "Your Jewish Grandmothers" skit, the *context* of queer performance can also affect the actual *content* of the performance. Another example includes the political content of the ongoing theme of safer sex messages in the performances I observed. On one evening, The Queen Bees performed such a message at a fundraising event for a queer youth organization. The announcer, a drag queen, called out to the audience, "Wanna avoid the sting of sexually transmitted infections? Safer sex is sweet as honey when The Queen Bees whip it, whip it good." Four members of the troupe entered the stage: two of them wore very feminine outfits, and two of them were in masculine drag.

After entering the stage, the song "Whip It" began playing. The performance had two different segments. During the first, the two dancers in masculine drag engaged each other by looking intensely at each other. One of them dramatically pointed to the other, and they danced toward each other; their encounter culminated in mock anal sex. Behind the two engaged in the mock sex act, a tall blond troupe member dressed as a "safe sex super hero" with condoms, gloves, and dental dams of various colors hanging off her, danced around them with a wild look on her face. Another troupe member held a sign that read "boy meets boy." Before the end of this segment, she flipped the sign over to read, "That's a wrap," implying both that a condom was wrapped over a penis and that the sexual encounter had come to an end.

Both of the dancers in drag undressed until they were wearing black bras and gold hot pants. They walked up to each other with flirty looks on their faces, and the sign-holder displayed a sign that read "girl meets girl." Parodying lying in bed, one of them held up the corners of a large white sheet so that the audience could only see her head and shoulders; the other performer knelt in front of her and was lost behind the sheet. The safe sex super hero threw safer sex tools at the duo, and the performer we could see threw her head back in pleasure and silently contorted her face to make happy movements with her mouth. To conclude this act, the sign holder displayed a sign that read, "Hot Dam," a double entendre that remarked on the hot sex that had happened and the use of a dental dam.

To conclude the whole performance, all four members moved to the front of the stage, dancing. They snapped latex gloves on their wrists, snapped their fingers in unison, and walked off the stage. The political intent in this performance—that safer sex can be erotic in male-male or female-female encounters—was especially clear because its venue was a fundraiser for a queer youth organization.

Similarly one evening, two of the Von Foxies performed a safer sex message against an erotically charged dance to the song "Feel Like Makin' Love." Dressed in the same floral dresses and pearls that they wore during a previous performance, the two demonstrated interest in each other by smiling demurely and lifting the hems of their dresses. Using a giant notepad resting on an easel, one of them showed the other pre–drawn pictures of safer sex techniques. After a few examples of condom use and dental dam use, there was a cartoon of a hand and a latex glove. The next page showed a hand cupping itself upside down so that four of the hand's fingers were on top of each other and curved upward; it was labeled "the duck." The performer being shown the pictures enthusiastically nodded her head, clapped her hands, and jumped up and down. The one showing her the pictures took her hand and led her behind a sheet so that the audience could only see her head and shoulders. The one who led her there dramatically removed a latex glove from a box, snapped it on her wrist, and winked at the audience. She knelt under the sheet, and the standing performer threw her head back in pleasure. The kneeler reached her arm out from behind the sheet and held up two fingers and then disappeared behind the sheet again; the standing member of the troupe threw her head back dramatically. Then the kneeler showed the audience three fingers; and then four; and then "the duck." Like The Queen Bees' performance above, The Von Foxies used their performance to teach people about safer sex techniques and bragged about the erotic possibilities of queer sex.

The burlesque performances that had explicit safer sex messages derive from a queer political position that sexual activity is healthy, and that the way to avoid contracting infections is through careful sexual engagement. It is derived from an era in which the government attempted to keep gay men ignorant about safer sexual practices by denying information about contraction and from a queer community commitment to educating each other about such safety steps.

Toward a Future of Burlesque, Cultural Politics, and Femme Appreciation
Verta Taylor, Leila Rupp, and Joshua Gamson (2004) have argued that the performances of drag queens can be broadly understood as a form of social protest. Although their performances have long been understood as apolitical camp or as sexist attacks on women (see Newton 1979), they suggest that drag queen productions are better understood as a protest against the cultural prescription for heteronormative gender expressions.

Queer women's burlesque performances are similar in that they are a protest of the stigma that surrounds sex, queer sexualities, and femininity. Perhaps this is why Lady Lollipop's parting letter to fans proclaimed, "Performing feminine drag is political." She went on to say:

> I was a founding member who didn't have a lot of experience in performing and didn't truly value art as a legitimate form of social change organizing. Now I'm a poster child for the importance of political art as a tool for political, social, and institutional change. In fact, I feel no movement will be successful without the voice of artists, and I strive to bring the political artist movement to the forefront of a new generation of progressive activists.

As discussed throughout my research findings, burlesque is part of a wider movement that seeks to disrupt conventional ideologies surrounding femininity and norms surrounding sexuality.

Queer burlesque dancers mock the prescribed cultural investment in heteronormative femininity by utilizing femininity for non–heteronormative means. They choose an independent feminine sexuality instead of a demure passive female eroticization by a dominant active male gaze, and they choose queerness instead of heterosexuality.

Importantly, the pro(queer)sex consequences of burlesque are possible because of the performances of feminine female bodies. The performers make use of the larger cultural eroticization of the female body—breasts, hips, legs, buttocks—and use their bodies to create the previously described pro(queer)sex atmosphere. Scholars have noted that gender performance artists, such as drag queens (male people who do feminine drag) or drag kings (female people who do masculine drag), create a pro–sex message in their routines (Rupp & Taylor 2003; Shapiro 2007).

Queer burlesque dancers (female people who do feminine drag) achieve this message differently because female bodies are culturally eroticized differently than male bodies; because femininity is eroticized differently than masculinity; and because aligned gender performances are eroticized differently than the non–aligned performances of transgender artists. Outside of their performances, feminine female people experience particular gender and sexuality prescriptions; because of their bodies, gender identities, and gender expressions, their sexual autonomy is uniquely curtailed by patriarchal constraints (Ryan 2005).

Although some may argue that the erotic use of female feminine bodies furthers the mandate of patriarchal control of these bodies, I argue that their performances rearticulate female femininity. Through their performances, they redefine how female feminine bodies can be sexual (queer instead of just heterosexual), what uses they have (pleasure instead of just reproduction), and who defines their sexuality (them instead of someone else). Further, their performances utilize the eroticization of female femininity, but redirect it so that the audiences may *value* female bodies and femininity. Through these performances, the marginalized queer feminine woman is brought to the forefront of community sexuality debates and acts as an agent for pro–sex political action; because their erotic performances benefit queer people, queer burlesque dancers create a space where femininity is valued in queer contexts.

Many forms of protest may contribute to a realignment of femininity and sexuality norms, but burlesque contributes to this protest in a unique way. The performers use their bodies to produce an erotic performance that benefits queer people who do not choose to perform in this way. The benefit for queer people is both concrete in the immediate satisfaction of witnessing such an event and abstract in its long–term effects. Although the long–term effects are abstract, they are meaningful: burlesque performances create a space in which queer sexuality is visible, public, valorized, and unapologetic to repressive proscriptions against queer sex.

Queer neo–burlesque is a subcultural political erotic labor that is taken from an historical form of mainstream erotic labor. It makes use of the wider cultural production of stripteases for monetary reward and brings it to queer audiences for political purposes. In fact, many of the burlesque dancers I informally spoke with told me that they currently or previously had jobs as strippers in clubs that cater to heterosexual men; they wanted to do burlesque stripping for queer audiences in their spare time because they saw it as a way to use their talents for different ends. For example,

one burlesquer who works as a stripper told me, "[Stripping] is a talent I have. I have fun when I do it for queer people. Even though it's like [my full-time] work, it becomes not like [that] work. I get something else out of it, and [queer audience members] do too." In modern queer sex radical culture, her work as a stripper is not devalued as it may have been by lesbian feminist communities; instead, her labor is so valued that it is brought in smaller production to queer audiences.

The emergence of neo-burlesque in queer venues is the result of feminist and queer sexuality debates in multiple ways: it is part of sex radical culture produced by pro-sex factions of these debates. It is part of a new demand to value historically marginalized queer female femininity. It is possible because of the new feminist possibility to value sex work, and it illustrates the complexity of sex, labor, and politics post-sex wars.

As I finalize this essay for *Femmethology*, filled with hope that the epoch of queer burlesque is part of a burgeoning respect for femininity in queer communities, I am haunted by comments made in two separate interviews I conducted with femmes. Here, Edith, who is not a burlesque performer, retells a story that was told to her by a prominent burlesque performer; it is a conversation that occurred between the femme-identified burlesque performer and a non-femme-identified audience member:

> Someone came up to her after the fundraiser and said, 'I finally get it,' and she was like, 'What?' and they were like, 'I finally get what you can do for the cause. You can take your clothes off for the cause.' And she [the dancer] was just like, and 'fuck you.' Like, yeah, I distinctly remember her telling that story because, oh my god, I can't believe someone would say that.

Edith's comments remind me of U.S. 1960s left political causes in which men told women that their contribution to the revolution could be made on their backs. While the structural gender relations between this femme burlesque performer and the non-femme audience member were likely quite different, the exploitation of feminine sexuality is the same.

In another story of the possible non-reflective consumption of queer burlesque, Katrina, who performed with the Queen Bees in Seattle, reflects on how the popularity of burlesque has not necessarily translated into a celebration of everyday queer femme identities:

> There is this sense of a little bit of emotional violence that happens [to queer femmes] because it's not a valued position in queer culture. It's much used as something that can entertain other people, but not a way of being, right? I love the way that we can perform and we can entertain, but if you did the same thing racially, it would look really ugly and has looked really ugly in our nation's past. When you look in our own community, it's safe to get on a stage and perform queer femininity, but not as accepted when I just walk into a bar, when I walk into the Rose [a dyke bar in Seattle], when I go…there was some fucking…Melissa Ferrick was playing, and Lucy and I were in high-femme gear, like totally high-femme…walk into this concert of women who are part of our community, and nobody would make eye contact with us. Nobody would

look at us. Nobody would talk to us. It was really…we were quite disconcerting to this room of women who were there to see Melissa Ferrick. I was like, *Goddamn. I am in my own community right now, and I feel very other.* I laughed at it. I thought it was funny. There was no threat of violence to me, but it's a little like, hmm…I was hoping [the whole queer community would have] the same sort of shift [that burlesque has offered] in terms of [queer community] not continuing to other [femme] expression and make it so we're a valuable and viable part of the community and make it so that the stage is not the only safe place we get to express this [femme self] when it's to entertain people.

Although I have used this essay to argue that burlesque is a beautiful tool through which we can make statements about gender, sexuality, and the ethics of its representations, I want us to remember these cautionary tales provided by Edith and Katrina. The intentions of queer burlesque may always be to challenge the audience's assumptions about sex, gender, and sexuality, but we have to hold the audience accountable for how they use burlesque. Burlesque cannot reach its full political potential if femmes are told that they can "take their clothes off for the cause," or if it is only safe to express femininity on a stage. Burlesque is not an end; it is a means by which we may realize the unique contributions that queer femmes make to queer communities.

References
Allen, R. 1991. *Horrible prettiness: Burlesque and American culture.* Chapel Hill: University of North Carolina Press.

Baldwin, M. 2004. *Burlesque and the new bump-n-grind.* New York: Speck Press.

Berlant, L., & Freeman, E. 1992. Queer nationality, *Boundary,* 2: 149–180.

Bright, S. 1999. *Susie sexpert's lesbian sex world.* San Francisco: Cleis Press.

Califia, P. 2001. *Speaking sex to power: The politics of queer sex.* San Francisco: Cleis Press.

Case, S.E. 1999. Toward a butch–femme aesthetic In *Camp: Queer aesthetics and the performing subject: A reader,* ed. Cleto, Fabio, 185–99. Ann Arbor: University of Michigan Press.

Duggan, L. 1994. Censorship in the name of feminism In *Sex wars: Sexual dissent and political culture,* eds. Lisa Duggan and Nan Hunter, 30–42. New York: Routledge.

Gamson, J. 1994. Must identity movements self–destruct? A queer dilemma, *Social Problems,* 42: 390–407.

Harris, L., & Crocker, E. 1997. Introduction to sustaining femme gender In *Femme: Feminists, lesbians, and bad girls,* eds. Laura Harris and Elizabeth Crocker, 1–11. New York: Routledge.

Hollibaugh, A. 1996. Seducing women into a "lifestyle of vaginal fisting": Lesbian sex gets virtually dangerous In *Policing public sex,* ed. Dangerous Bedfellows, 321–336. Boston: South End Press.

Hunter, N. 1994. Contextualizing the sexuality debates In *Sex wars: Sexual dissent and political culture*, eds. Lisa Duggan and Nan Hunter, 16–29. New York: Routledge.

Lapovsky, E.K., & Davis, M. 1994. *Boots of leather, slippers of gold: The history of a lesbian community*. New York: Penguin Press.

Nestle, J. 2003. *A restricted country*. San Francisco: Cleis Press.

Newton, E. 1979. *Mother camp: Female impersonators in America*. Chicago: University of Chicago Press.

Queen, C. 1999. Lesbian/sex: About what we do and desire, and its relation to community and identity (or, how I learned to love the sex wars) In *This is what lesbian looks like*, ed. Kris Kleindienst, 182–191. San Francisco: Firebrand Press.

Rubin, G. 1981. The leather menace: Comments on politics and S/M In *Coming to Power,* ed. Samois, a lesbian/feminist S/M organization, 194–229. Boston: Alyson Publications.

Rupp, L., & Taylor, V. 2003. *Drag queens at the 801 cabaret*. New York: Routledge.

Ryan, M. 2005. You can't take this away from us, *Clamour: The Revolution of Everyday Life*, December.

Schulman, S. 1994. *My American history: Lesbian and gay life in the Reagan/Bush years*. New York: Routledge.

Shapiro, E. 2007. Drag kinging and the transformation of gender identities, *Gender & Society,* 21, 2: 250–271.

Taylor, V., & Rupp, L. 1993. Women's culture and lesbian feminist activism: A reconsideration of cultural feminism, *Signs*, 19: 32–61.

Taylor, V., Rupp, L., & Gamson, J. 2004. Performing protest: Drag shows as tactical repertoire of the gay and lesbian movement, *Research in Social Movements*, 25, 2.

U.S. Census Bureau, 2000 census, "Quickfacts: Portland, OR" Retrived on December 22, 2007 from quickfacts.census.gov/qfd/states/41/4159000.html.

U.S. Census Bureau, 2000 census, "Quickfacts: Seattle, WA" Retrieved on October 15, 2007 from ofm.wa.gov/census2000/profiles/place/1605363000.pdf.

Warner, M. 1999. *The trouble with normal: Sex, politics, and the ethics of queer life*. Cambridge: Harvard University Press.

Wilson, J. 2008. *The happy stripper: Pleasures and politics of the new burlesque*. New York: I.B. Tauris.

Femme the Sex of Me
by Jennifer Cross

0. Butch

I learned how to be a girl from Sesame Street, and I learned how to be a woman from a rapist stepfather. They both taught me that women could be anything, but he specified: You'll be powerful, a ball–breaker like your mother, yes, but only as long as you're under the control of at least one man *at least one man.* You've gotta be reigned in by somebody owned if you expect to be unleashed.

Here's the image that resides in me: I wear a long red sheath dress, legs and arms exposed, accessorized into glamour, my face ennobled with paint. I am strong and brazen and empowered as I cut down all the perfect, tuxedoed men around me with a laugh or a look or a well–wrought rebuttal until someone (*he, the alpha*) puts his hand on my neck and calls me back in: the pit bull always chained, the woman stripped, humiliated, revealed to be property, publicly forced to demonstrate how her power is only an extension of him before being removed to the kitchen and fucked over a counter and after, offered up like a door prize, or a party favor.

So listen: I'll admit it. We're not supposed to say this but Yes, butch was a cloak of choice, an identity I selected over weakness: *no one will tell me where I can and can't go safely. I have already stood up to death. I will walk through dark alleyways /behind drunken frathouses/ in the middle of the night. I will look through the garbage. I will be safe.* On isolated walks, jogging skinny blonde women crossed to the other side of the street upon mis/reading my silhouette. How protected am I, when men mostly read through, mistaking me for "sir" only when approaching me from behind?

I proclaimed myself "butch," and declared my independence from the straight feminine (a redundancy?), then ensnared myself within an erotic façade: the boy clothes, cropped hair, slight swagger (masculine only to the straight–laced eye). I wore the sheen of something that looked like sex in the right light, but was, in fact, pure lacquer and varnish. It all came off as a piece at night, when I was left with my girlbody again, confused and unprotected, belabored and at pains to explain why it was so hard to get fucked in this (or, absent any) persona.

With no angles, it was a struggle to bend butch to meet me. As an effeminate boy, I pranced and shone until I ran up against the wall of any butch I thought of as *real*—those women who knew butch in their bones and bodies from youth, endowed with grease under their nails, who pass even when they don't want to (but mostly they want to, at least a little bit, don't they?). At those moments, with some effort, while the well of me corpuscled and throbbed hot down my thighs, I pulled hips and ass into a swagger, bundled fancy hands into fists that got shoved into front pockets, wished to god I smoked: anything to excuse the cheeks that were not supposed to flush at the glance of another butch.

1. Femme

The slow tear of fabric loved for ten years, that protective sheath taken between the hands on a Sunday morning and pulled, length from length, until each thread separates from itself, that soft and

unremarkable, irreparable complaint. One may mend, a repair written off as purely motivated by economics, but the fabric is never the same after the damage is done. The seams show.

2. Butch
Girlhood's pathologized. I thought, if a girl existed, *he* must have made her: *he* did this to me. *He* made me this whore and this slut who'd danced naked, played dress-up in lace-panties and a leather jacket, was forced to fuck everyone over and over.

I didn't fathom myself as *of women*, and when I came out into *dyke*, it all made sense why, and I wrote myself a new story, and it didn't matter that I didn't know the word *femme* 'cause I knew the word *butch*. *Butch* I could *see—everyone* could see. Butch looked like safety to me. And so I climbed into the garments of the other—took on the boy clothes because I thought they would protect me. I took the butch I wanted onto me—into me—the only way I knew how, and... became what I wanted to fuck.

I tried to recant the way I'd been *woman*, been *sex* and *sexual: too much, all the time*. It all seemed to cause a lot of people a lot of problems, and therefore caused *me* a lot of problems. I became safety and apology, became years of folding inward, flattening my curves, excavating my sexuality, wanting to be something safe in myself, to finally become the big brother who would have protected if not herself at least her mother, at least her sister, from the sticky fingers, cock and mouth of her stepfather. But it didn't work. Revisionist butchness doesn't recourse to protect a past that's past.

3. Femme
Sometimes having words makes life easier, facilitates explanations, strengthens identity, helps us make sense—and sometimes language is a trap we can't find our way out of because it shapes, then comes to entail, all we know.

With each new piece of interpretation, of identity or language, the light on the world and the past changes. I see things anew, then trace back through the paths of my history to make some integrated sense of things. But there's no single unifying theory of identity or self, is there? No cosmic vision or equation that makes us make one, final sense to ourselves or those we hurt or maim on the way to ourselves—

I look back now and see *femme* along those same tracings of my childhood and adolescence that I'd once upon a time inscribed as *butch*. I rewrite the stories I used to defend and define myself, to justify a gender identity/a sexuality/a self.

We, all of us, at some point fold ourselves into the drawer of what we think we ought to be, and stay there until—to mix metaphors—someone starts to turn the crank of our box and we find ourselves squeezed tighter and tighter, more and more uncomfortable until the pressure is unbearable and we spring, explosively, from and into our lives, splattering everyone around us with agonizing song, blood, pus and tears—

4. Butch
They say it about your hymen, too, how it tears when you're fucked the first time. For me, that

implosion occurred before any boy my age could plunge his tiny dick into my overworked cunt. It might have been a finger or a tampon or a dildo: the tools my stepfather used instead of bloodying, implicating, his own cockflesh. So, when he finally pushed into me, no flesh tore from flesh. No. Instead, at that moment, sanity separated itself from my skin, from the surrounding tissues of my life—a scrim of safety pulled away from my face that afternoon he first fucked me, when he laid me down on my back and told me, with each thrust, *Trust me Trust me Trust me*

When I came out, I tied on a new cover, dove under boulders of oversized clothes, wiped the shiny color from my face, took the hair from down my back to reveal the butch I convinced myself was meant to be found there. I squared my shoulders and walked out armored in masculinity, moved away from all the feminine, and waited for men to stop seeing me. Waited for the magic (in)visibility to take shape along my frame.

5. Femme

Skin or clothes: linen scrim run round and round that girlbody, turned over and over her mummified form, that bolt of sheer, unbleached, cream-colored fabric pressing along round of thigh, filling in hip and waist, battening down breasts, thickening shoulders, bracing back—this was the undercore binding before I put on the straightleg jeans, the tanktops and short-sleeved men's shirts. Dammed up. Damned.

And when you found me, hadn't I begun to unravel? Like the scarecrow, I was pushing out here and there and there and there. I wore everything boy-right, down to the underwear. I stood right, and was convincing as long as I didn't move, walk or smile. If you looked closely (and you did), my seams were fraying: shreds of fabric hung from the sleeves of my shirt/thrust out of my jean cuffs and shoes/between the buttons of my shirt/bulging and throbbing/body parts I didn't remember owning restless inside my clothes, exhausted and just wanting to breathe

All this you tore through when you touched me with your vision (then with the fingers that fit just so at my hip), touched the girl you could see underneath all that spit and polish, under all that surface tension. Didn't you know I'd cut through at the most stifling places (wasn't I bursting already?) and just wanted you to take hold so I could unfit myself from myself?

Tearing is the metaphor: forceful revelation. Not a demand but clearly intentional and irreversible. What I wanted was the thrust and rend of a desire (yours as well as mine). My hands bloodied/pressing out to you, shoving first through the skin protecting me from me, through scabs and scars through the denial of history's history. The swollen owning: I am that girl. I was always this/girl.

Tearing happens when something can't be contained. The dam breaks, the dike dissolves—

I'm working too hard for this metaphor, for something more fierce and powerful and complex than the simple need to spread my legs beneath you. No tearing. There was no sound when the world around me split once more, besides the sigh and exhale of necessary damages. I knew it was right, I knew you felt me feeling you, the boy underneath the girl and the girl within the boy: all inside me, all aching with cold clammy need and sweat-moist palms, fingers shaking against simple insanity of mouthing yes to desire, to the solid surety of myself against you.

When you spoke to me of transition, a cold panic cut through me—Wait/Wait wait for me/Wait. I can be that girl. I can be the one who holds the cock you already have, who can cradle the all of your gendered self. Wait/(The slutty forceful tearing off my own clothes)/Wait, see? I can fold in and around you, explode myself. I can be that girl you want and I want. Wait—oh god—I haven't forgotten. Just. You. Wait.

6. Butch
In this colonization of a gender/whom did I fool besides myself? Of course I'm embarrassed, revealing myself as a fraud, and I hasten to apologize for my male impersonation. *Impersonation*, as though I knew I was lying. As though I took the freight of *femme* in my hands and tossed it overboard. The fact is, I had no language for that other option. Butch was supposed to save me, take me home, gain me entry: the secret code, the password to the clubhouse. I wanted to be seen and unseen, visible and empowered in my wounds, protected, protectable: safe from the swollen heat, the swampy mess of female. Girls are not protectable, and I wanted (to be) something safe.

Femme the sex of me. Femme is liar, storied in her truth: how can I now claim and defend this term, this name, except through the rightness and ease on my bones and skin? The shifting movement leaves me terrified with (un(speakable)) certainty.

7. Femme
What are the stories we choose from the stories we're offered? I mean, what do I resist when I resist being me: plain old white girl dyke shiksa/WASP and Midwestern catholic. Nothing radical here/ no postmodern queer/ the gender meshing with the sex specified at birth into quasi-traditional chords and folds, and I sink back down under the radar/ unseen and noticed/badly not visibly queer but visibly vulnerable. Available. Who sees me now besides the straight men who assume all women exist for their consumption?

8. Butch
A photograph of a moment, of an unfurling into the bodies of selves written into fantasies, into that girl between two butches: my own ostensibly masculine self compr(om)ised against a Butch lover unable not to see what she was looking into. I met something home in you, wet and full and inexcusably torrential—the voice in my throat pressing as hot as your tongue.

9. Femme
Desire is an insurrection: it never fits anywhere, does it? The things we go to for safety/the hard won, bone-dry protection of one particular philosophical interpretation will turn us away, do us in, in the end.

It was a revolt, an inside job, when I touched my need for what you offered, unspoken. The terror unexperienced when I came out the first time thrust itself into my heart: that sudden realization of loss at the claim of desire I understood all the agonizing stories of "oh my god, am I really this way? What will happen to me? What will people say?" I shattered upon the understanding that I wanted you to lift me, lay me down, hold me up. I wanted to let you do it, could not figure how to make myself not want the hard-and-soft of romance, your strong-bodied gentle one, my soft-bodied hard one, your butch to my femme.

10. Butch

And what did you see? You looked straight through the cracks, and did you see what I showed you? What I didn't know was in my hands? Was I the girl who turns her head and lifts her skirt so she is not responsible because she does not see?

The difference between fag and femme was one quick slip and shift of thigh up to hip muscle. Emasculated. En-femme-d: a chain reaction, the body's articulations sliding into a new chord Boy transformed into girl with one sharp step. The revelation's in the softness, not the longed-for hard stem of young fagboy but the round, the round, the girlflesh, the woman—

These are the things I told my private voices: how it excited me, the way my various bodies moved yours, the succulent way you pushed the meat of your energy at my body. The insatiable containment exploded, splattering and exposing the curves and edges of home.

11. Femme

Maybe butch was my cocoon, enabling something savory, undulant, viscous, and unguent to save itself under the surface. Transformation (meaning survival) takes lifetimes, and in the meantime we become so comfortable with our surfaces that we claim them as us. We forget the beginning and rush the end. Forget the intention of our mutability. The strategy becomes the end game, the costume becomes the self, becomes an identity we claim fiercely, defend with bared teeth and sharp nails while anxious need festers and hollows out our underneath and in-between. All our unfitting silenced selves live themselves anyway into our interstices, into the tears we embody, into the mess we become.

Run your fingers along the inside of the cocoon, that just-split shelter (if she'll let you in) and see what you don't find there: the sticky remnants left on your finger, the hot liquid possibility of her firmament. Look what she lets you into.

12. Femme

You kneel before me in your burgundy shirt and tie and although we may not fuck, you still slide your hands up from my heel-sculpted calves, up the outsides of my hard soft round thighs. You settle your hands like they belong on me, like it's still an honor to touch me, like it's a risk you run. Your hands under my skirt, you grip to my hips and curl your strong fingers around my ass. You cannot wait until later.

We are vagrants in the Twenties. You have removed your fedora and tossed it on the bed. I loosen your tie from itself, slip buttons from holes like promises while you liberate my heavy breasts from my bra without rumpling my blouse. Let me curl and twist my fingers into your hair, tiny braids laced together under my hands, let me grip your cheeks, sigh into your kiss. I want how it feels to unfurl and swell beneath and around you, how when you take me you take me open, press your cock into me even though I don't deserve it, even though I am afraid and dizzy, even though I am ugly and dirty. Still, you believe me: you shudder and adore your way through his infiltrations. We are in this together, this reclamation of loose-skirted dresses and round bodies and the hard hands that could hold them, the hands pressed firm to small of back, to hip, to thigh—claimant with a fierce tenderness, your *this is mine* that always acknowledges the giving the melting when I allow Yes, yours always remembering my own ownership The self literals back through the metaphor of bodies to desire, swooning. *Aren't you my girl?* makes way for *Yes. For yes, I am a girl.*

There and Back Again:
Revisiting the Femme Experience of Genderfucking
by Amy André and Sand Chang

Can "femme" be conceptualized as a fluid gender identity?

It's been three years since two friends, Amy and Sand, sat down to discuss their experiences of living as the combination of, and in the intersection between, genderqueer and femme identities, as well as the impact of their racial identities on their gender expressions. The co-interview, titled "And Then You Cut Your Hair: Genderfucking on the Femme Side of the Spectrum," was published in the anthology *Nobody Passes: Rejecting the Rules of Gender and Conformity* (Seal Press, 2007), which was released two years after Amy and Sand's actual conversation.

When the anthology was published, Amy and Sand were asked to speak about that conversation at a book launch. They both discovered that, because of changes in their lives and their gender identities in the time since publication, what they wrote seemed to be written by two different people! They had both been actively exploring masculinity in a much deeper sense. Since then, Sand and Amy have devoted more thought to the fluidity of identities. Now, three years after the original conversation—and a mutual shift back towards/around femininity again—Amy and Sand revisit the dialogue and their shifting conceptions of, and connections to, "femme."

Sand: Amy, I'm really glad to have the opportunity to continue this exchange about "femme" as an evolving and fluid identity. Since we first spoke, it appears that both of us have had a shift in gender identity. For me, it's been a subtle yet powerful shift in not only internal experience, but also in how I relate to the world around me. I'd been thinking for a while that I wanted to write a follow-up piece to reflect the changes that I've experienced as a female-bodied person who undergoes a full circle transition from feminine to masculine to feminine.

I still identify as a genderqueer Chinese American with no particular pronoun preference, but I am much more strongly identified as femme and genderfluid (and, as my friend Ben calls it, "the infinite loop" between masculine and feminine). I've also dropped the "y" at the end of my name, preferring the name "Sand" as a more gender-neutral alternative to my given name. I was surprised at how such a seemingly small change helped me feel more balanced. What about you? How have your identifications changed or stayed the same?

Amy: Interviewing each other for *Nobody Passes* was a turning point in the evolution of my understanding of my own gender identity—and a very unexpected one. I felt pretty secure in my femme identity, and I tended to resist the idea of fluidity because I think it gets pushed on people sometimes. Not everyone is fluid; some people are very static in their identity and happily so. Often, when I hear people talk about fluidity, it's to say, "Everybody is fluid in their (gender or sexuality)." I think this diminishes the experience of people who aren't, and even of people who are.

But sometimes, you can be ideologically one way and experientially another. I had settled on "I'm a bisexual femme, and that's it," and then things turned upside-down. Well, I'm still bisexual! Some

things never change. I've been out as bi since I was fourteen—almost twenty years now, oh my god—and it's always been the best word for me to use to describe my sexuality. And I *am* still femme-identified, too.

But now I'm so much more.

During that co-interview, I reached a place of giving myself permission to explore masculinity, which had previously been a really scary concept for me. For me as an African American, living in a violently racist society, the idea of being perceived as a black masculine person is fraught with danger. I grew up in the South and witnessed violence against black men. So, while my femme identity is and was authentic (to whatever extent an identity can be), it wasn't formed in a vacuum. At least a small part of being femme was a reaction to my own internalized racism and sexism around black masculinity. Writing with you freed me to acknowledge that, and to learn from that. And to find and create spaces where I could explore my own masculinity.

Sand: I totally agree with you about not wanting to throw around this concept of fluidity lightly. I think that this sort of "normalization" of a potentially different or challenging aspect of identity often serves to undermine the struggles of people who experience it, and it negates the need to actually pay attention to the experiences of those people. But for me, being fluid in gender is one of the only constants that I can rely on! Time and time again, every time I think I "know" exactly where I can pinpoint a static identity with regard to gender, I've been proven wrong by my own inner experience. But believe me, I've tried to pin it down. At times, I've really wished that I could just have an answer—an answer for myself, and an answer that would satisfy everyone else. But that answer would never stay true. I think there are aspects of my identity and personality that are relatively stable; traditional notions of gender and sexual orientation haven't really fit with those. However, despite the continual shifts between "masculine" and "feminine" or being perceived as a man or a woman or "other," I have felt anchored by my femme identity.

Isn't it interesting that sometimes certain aspects of us are better understood only after venturing away from them? Or by integrating that which is perceived as contrary to those parts? I'm fascinated by this dialectic.

Amy: Me too.

Sand: After our interview, I moved to New York. It was there that I really came to explore the more "masculine" aspects of my identity at a much deeper level. I was very out as a transmasculine person, yet still femme–identified. That "femme" part of me was often perceived as gay, and while I did identify as a "trannyfag" at that time (and to some extent still do), I was very clear that "femme" had more to do with my experience of my gender as distinct from my sexual attractions. I was perceived as flaming and flamboyant, and those are certainly parts of my personality and mannerisms that I embrace. In ways, I become more like my drag king character, Charleston Chu, and I felt what it was like to be perceived, at times, as an Asian American man. I certainly got "sir'd" a lot more in New York, which probably has something to do with my external appearance and also what I perceived as a more rigid gender binary in New York as opposed to the San Francisco Bay Area. Though I did find some fabulous genderqueer and gender–variant folks who also lived "in the middle" with respect to gender expression, I found that this gender expression and the concept of "genderfucking" in general was not nearly as celebrated as it is in a place like San Francisco.

So, I was more masculine–identified. One way of putting it is that I felt like a "femme–y boy." I realized how much being femme was a part of me, regardless of my assigned gender or identifying as a man, woman, neither, both, or in–between. Though I did bind my chest, wear men's clothing, and feel very in touch with my masculinity, I felt super–connected to being the femme that I still am today. I'm now back in the Bay Area, and my gender expression is much more stereotypically "feminine" than it's been in years. It's been a huge and scary transition. I couldn't believe how hard it was for me to wear a dress and makeup outside the context of drag or burlesque performance—it took me two years to own that part of me again! It's taken a great deal of searching and reflecting, as well as struggling with societal expectations, for me to embrace a different kind of femme identity today, one that is intricately connected to being socialized and perceived as a woman of color. I have to admit that sometimes I have felt scared to show my fluidity to the world for fear of being rejected or seen as a fake, hypocrite, or traitor. I've come to realize that the only way that I would be a fake, hypocrite, or traitor is if I don't honor the fluidity in me. As a result of all this exploration, I've come to find a greater sense of what I like to call "femmefidence."

Amy: Great word! I love it.

Sand: You spoke before of the fear, or feeling of danger, that you had about being perceived as a black masculine person. I'm really curious as to how that was challenged, changed, or expanded, as you gave yourself permission to further delve into the realm of masculinity.

Amy: After we wrote the first time, I felt tapped into a deep desire to dip my toe in the pool of masculinity, so to speak. My partner and I are polyamorous, and I started having sex with a friend of mine, a transman of color with whom I feel very safe and comfortable. One of the first times we played together, I asked him to refer to me as male. Something about our dynamic together let me know that he would just get it, and he totally did. It was an unbelievably hot experience. I had never played with gender that way before, but since then, when I'm with him, I don't want to play any other way. When we have sex, it's always with me identifying as a guy, or, more specifically as a boy. And as a boy, I'm pretty femme–y, so that's been consistent! (laughs)

The fact that he's a man of color, and trans, and a friend with whom I've had a lot of dialogue about race and gender politics, goes a long way towards creating the space for me to explore gender play. I haven't played as a boy with any white people, and I think that's in part because of my aversion to race play. Not that being a boy with a white lover would automatically have a racialized element to it, or that two people of color can't engage in race play with each other, or that race play is even necessarily a negative thing for two consenting people to do together. It's just not for everyone, and it's definitely not for me. Whether this is logical or not, when I'm in bed with another person of color, I feel more relaxed around the idea of sharing my black masculine self, compared to how I feel about sharing it with white people. That may change over time, and also could depend on the particular white person (or the person of color) I'm with.

I also have anxiety around the idea of being seen as a fake. This comes up because I haven't much changed my dressing style. On an everyday basis, I wear business suits and jeans, but all designed for women. I pass as female, and, relative to black men/masculine people and to people who don't pass as any gender recognized by mainstream society, probably get a certain amount of some types of privilege as a result. It's funny: I don't think I pass as femme, or, I should say, femme enough, in queer spaces, because I am nowhere near high femme. I never wear makeup, and heels and dresses

only come out of the closet on very rare occasions. But I don't pass in queer spaces as a boy or as male-identified in any way because those elements of my identity are only being expressed in bed, and I don't have sex in public (that often)! At the same time, I'm a grad student, at an extremely heterosexual, hyper-heteronormative school, and in that space, I think people just think that I'm this short-haired black lesbian (they don't get bi) who wears pants all the time.

What this all boils down to is: I *always* feel awkward in any bathroom I walk into! (laughter) Either because I feel it's the wrong one ("If I'm a femme who's also a boy, why am I going into the ladies room?"), or because I sense that other people do ("Why is that person coming in here? Oh wait, that's that girl I've seen around campus, the one with a girlfriend").

How have your friends and partners responded to the fluidity in your gender and sexuality?

Sand: I think that my projections about others' reactions have always been worse than what they are in reality. The people in my life have responded very differently, but for the most part, the visible changes in my gender expression seem to bring up curiosity. I've had a lot of people tell me that I do both "boy" and "girl" equally well and that they both seem like "me." The way these people say it conveys that they are somehow surprised. I take this as a compliment, but also as a sign that they don't think that this type of duality exists as evenly or obviously in a lot of people. I have had a lot of fears about being rejected by trans communities now that I am perceived as a woman the majority of the time and am not super high femme, but close. I love wearing dresses and skirts and jewelry and makeup, and I love feeling that I am very consciously presenting myself as femme and as feminine to the world. I still resist classifying myself as either a man or a woman, but I also think it's really important that I acknowledge the privileges that come along with passing as a gender-normative person in the world. I don't take that for granted because I know what it's like to be treated differently or looked at with bewilderment or even disgust for not fitting into those boxes. I know that because of fear and ignorance, there is a real threat to physical and emotional safety when you're a gender-variant person in the world.

But to return to your question, the friends who love and understand me best are ones who also embrace some degree of genderqueerness in themselves. The same goes for sexual or romantic partners. At the same time that my gender has come full circle again to a more feminine presentation, I have opened myself up to the possibility of dating non-trans and non-queer men again for the first time in several years. What a mindfuck! I've realized that the degree to which people accept my fluidity is more about their openness to new concepts in general than what boxes they fit into with regards to sexual or gender orientation. I've had trans and queer partners who really wanted me to be one or the other, and I respect that because many people do have a preference when it comes to the gender expression of the people they are attracted to. But this being "one or the other" was never something I wanted or was able to comply with. I've dated straight, non-trans men who really appreciated that complexity in me. So I've learned not to be quick to judge, which is what I would hope for from someone else.

With respect to sex and dating, I think what has been and continues to be trickiest for me is navigating racial power dynamics. I am keenly aware of the stereotypes of Asian American women as passive, submissive, exotic, and hypersexual. I don't want to be anyone's fetish on account of my skin. In ways, my identities as femme and as a person of color have been mutually reinforcing, giving me a lot more certainty about who I am in the world and how I want to relate to people. In

a world in which feminine bodies, dark bodies, and curvy bodies are often devalued, it feels like a radical act for me to love my body exactly as it is.

And then there's my sister, who loves it every time I "transition" back to masculine because it means she gets a whole new wardrobe of women's clothing! And then I have to fight with her to get some of those things back. I've gotten smarter, though, and now I know that I should hold on to this stuff because it will more than likely come in handy! (laughs)

Amy: My partner is butch, and I don't have any sisters. So all girly clothing stays mine! (laughs)

I wanted to touch on the idea of the relationship between genderqueer and femme identities. I don't define myself as genderqueer because I'm sometimes a boy. The genderqueer part is connected to femme–ness, and I think that femme is a radical and subversive queer gender, because it carries with it the potential to undress heterosexualized femininity. I feel that genderqueerness doesn't always have to be connected to some type of masculinity. I'd be genderqueer even if I wasn't ever a boy. In our queer community, I find that there's a hyper-attention paid to masculinity and male identity, and I think that is, in part, a reflection of internalized and externalized sexism. Queers are not immune from the effects of being socialized in a patriarchal world. One of the things that femme does is celebrate the queerness of gender itself, and the queer thing that gender can be, even feminine gender in female bodies. And I find that really exciting.

At the risk of boxing myself in, I have a feeling I'm going to stay this way gender–wise for a long time into the future. Famous last words, I know! (laughs) But I really do think this will be the case, because I feel very happy and comfortable fucking with gender in the way that I do. I think the only thing I would like to add to my gender experience is to find more people to do it with!

Last time we wrote, things changed greatly for me afterwards. But I think that was because they needed to change, because I needed to acknowledge my attraction to examining the edges and edginess of my gender(s). Now I'm feeling much more settled in myself. I still have qualms about how others might perceive me or might rate the authenticity of my boy–ness (or even my femme–ness), but, unless I'm having sex with those others, (and I won't be), it ultimately doesn't matter!

I know gender play, like age play or race play, isn't for everyone, but it's been very nurturing and healing for me. Not to mention incredibly exciting.

What about you? What do you think might happen next for you, in terms of your genders and your sexuality—and your femme identity? What's the future of femme for Sand?

Sand: I think there will only be more to learn and that my relationship to the concept of "femme" will become deeper and more nuanced over time. I intend to continue to use performance—drag, burlesque, and dance—as a medium of further exploration, as well as continue to work towards justice and equality for people of all genders. And hopefully to continue what you and I are doing right now—building community with other femme-identified people who want to push boundaries in radical, intentional, and, of course, queer ways.

Once a Femme, Always a Femme
by Katrina Fox

Snakepit

The first time it happened was when my best friend Mandy and I went to enter the then London Lesbian and Gay Centre in the UK, circa 1988. We'd just come out of the closet. There was a women–only tea dance, and we couldn't wait to shake our thang to high–energy tracks and to revel in our fabulousness. The "it" I mentioned is the moment I realized that my femme identity was not only not particularly popular among many lesbians, it was positively reviled.

Mandy and I had dressed to the nines in sexy gear: low–cut, skin–tight, skimpy vinyl tops, matching clinging micro–miniskirts, six–inch stiletto ankle boots, cheap but glitzy diamante jewelry dripping from our ears and wrists, and more makeup on our faces than a Revlon counter. We'd been to mixed gay events in similar attire as well as what we termed "femme fatale" outfits such as long ball gowns à la Marlene Dietrich and other Golden Age Hollywood stars whom we revered and who provided us with what we thought were worthy role models of womanhood.

At the mixed events, we had no problems—the gay boys, drag queens and trannies loved us. We'd put on little "shows" that comprised us dancing around in a camp fashion, touching each other seductively one minute, then hitting each other with a feather boa the next. Yes, it's true: we were exhibitionists of the highest order, and we loved the attention. If there was so much as a hint of a platform or stage to dance on, we'd be up on it, strutting our stuff with glee.

That Sunday evening, we decided to venture for the first time into a "women–only" party event. In what in hindsight can only be described as our naivete, we expected a similar reception to what we'd received elsewhere—only this time, it would be women (women–loving–women, no less) who would be admiring us, dancing with us, flirting with us and generally having a gay old time in celebration of this new word we'd discovered: *sisterhood*.

Our illusions of a safe space where women could express themselves in any way they wanted and not be judged (again in our naiveté, we thought that's what one of the tenets of feminism was supposed to be) were swiftly shattered. As we walked up the stairs, we came face to face with two punk dykes who eyed us up and down and then proclaimed: "What are *you* doing here? It's a lesbian event." After politely replying that we knew it was a lesbian event and we were lesbians, one of them growled aggressively: "You're not lesbians. Lesbians don't dress like that." Some other women came up the stairs behind us, and Aggressive Punk Dyke # 1 shoved me against a wall while her friend told us to "fuck off," before they waltzed down the stairs and—much to our relief—out of the centre. That exchange didn't augur well, and for the rest of the evening, we got dirty looks. A couple of women even came up to us, asked how much we'd been paid to dress "like that," and assumed we worked in the sex industry.

Red Lipstick in the Red Light

At that time, we weren't sex workers, but a couple of years later—tired of the anti-sex, anti-porn,

anti–femme rhetoric of radical feminists—we took jobs at the Sunset Strip Theatre in Soho. Now, of course, it's been turned into one of those boring lap–dance clubs where all the girls look the same, but in 1990, the Sunset was a lovely old–fashioned striptease theatre that employed girls of all shapes and sizes as well as talents (e.g., one girl juggled while she removed her clothes as she was in training to join the circus).

Tattooed punk girls, rock chicks and girls–next–door coexisted (mostly) peacefully in a tiny dressing room, taking turns to go on stage dancing and performing to anything we liked, from Abba and the Rolling Stones to Edith Piaf. Believe me when I say it's very liberating to swing naked in the air hanging onto a rope to "Non Je Ne Regrette Rien!"

While Mandy and I—still convinced we were feminists even though we'd been told a few weeks earlier by a woman from Campaign Against Pornography that we weren't and couldn't be because of our attire and the fact we weren't prepared to superglue the locks to the sex shops in Soho— knew that the guys in the audience couldn't see beyond the details of our pussies, we nevertheless felt a sense of empowerment. We were two young women exploring and enjoying our sexuality without any hang–ups about our bodies along with a mixed bunch of other women of varying sexualities. The straight rock–chick girl thought that the lesbian who did a strip–ballet to a classic French song she'd never heard of was eccentric, but she accepted me and we got on well.

This camaraderie was what we expected from consciousness–raising groups and feminist meetings. Instead I was told that coming to such a gathering wearing screaming red lipstick was a sign that the patriarchy still had a hold on me, and that I was colluding in my own oppression. Never mind that I was wearing sensible flat boots, dyke jewelry and a "Sisters Are Doing it for Themselves" t–shirt. There's just no pleasing some people!

Showdown
The following encounter solidified my break from mainstream feminism. Mandy and I were on one of our breaks at the Sunset, so we decided to walk down to Charing Cross Road to Silver Moon Women's Bookshop to hear a talk by Andrea Dworkin. We were all dollied up in our sexy clothes because we had to be back on stage in an hour. We stood at the back of a room full of lesbian feminists who cheered and applauded Andrea as she trashed the sex industry and criticized any woman who worked in it. I put my hand up and challenged Andrea's assumptions that all sex industry workers were victims. To her credit, she thanked me for my comments although she disagreed with me, but the reactions from the audience were not so polite. Every head swung around to stare at me, revealing scowling faces full of hatred. Some women boo-ed; others called us names. Eventually Andrea called the room to order and began to wind up her talk. Mandy and I looked at each other, and almost at the same time said, "Let's get out of here." We were both scared that these women—these lesbian feminists—would become physically violent towards us, so we ran out of the store (as best as one can run in stilettos) and back to the Sunset. The irony of escaping from a lesbian feminist environment, whose inhabitants had managed to instill fear in us, to the safety of a strip joint in the notorious red–light district was not lost on us.

This is how it was—and I suspect still is for many people—for the femme. Misunderstood by both the lesbian "community" and mainstream society, both refusing to see past the external trappings,

and both refusing to recognize that a painted lady can be every bit the strong warrior fighting for social justice as much as the butch or androgynous dyke who rejects the traditional garb associated with femininity.

The Femme Species

Is femme the same as femininity? I don't believe it is, but it's a form of femininity that deserves to be recognized and celebrated in its own right. Being a femme lesbian or femme dyke or queer femme is not the same as being a feminine straight woman. The former, simply by fucking, dating or setting up home with another woman in a still essentially homophobic world, is carrying out a political act, consciously or otherwise. Don't let the fact she wears lipstick fool you.

In the early days, I considered femme to be all about external appearances: femmes wore pretty dresses, high heels and makeup; butch dykes wore trousers, flat shoes, cut their hair short and kept their faces au naturel. My political and activist leanings were something apart from my femme-ness, or so I thought (ah, the naiveté of youth!). I remember going on a large animal rights demo in the mid '90s to protest a farm that bred cats for vivisection in Oxford, wearing sensible flat boots, plain black leggings, a black jumper and jacket, hair tied back and no makeup, and wondering, "Am I still a femme?" The question sounds silly now, but at least I was smart enough to realize that if riot police were going to chase protestors through acres of field (which they did on a regular basis), a chick with a miniskirt and heels wouldn't stand a chance.

Fast-forward to today: I describe myself on my Myspace site and to anyone who asks as a "high-femme lipstick lesbian, sex-positive vegan feminist." It pretty much covers everything, but not quite. Like many people, many femmes, I'm a maze of contradictions, and therein lies the challenge of defining "femme" and presenting it as a gender. There appears to be no one single definition of femme, let alone high femme, although the common theme is this thing called "femininity." During the day at work as a freelance journalist at various publishing houses in Sydney, Australia, I'm a strictly flared black yoga trousers, sneakers and t-shirt sort of girl. Hair tied back in a simple ponytail, no makeup or nail polish. I wear a bumbag (i.e., fanny pack) because it's convenient, and I carry a small backpack for the same reason. I don't care for men allowing me to enter an elevator before them, nor for opening a door for me (unless I'm carrying several bags of shopping, as I would do for someone else, so it's not a gender thing). In contrast, when I was younger, I would have questioned whether I was still "doing" femme; now I know better—of course I'm still femme. The bumbag contains, among other items, a flaming red lipstick, all-in-one foundation and powder, and a comb—all of which are pulled out and used in an instant should anyone even think of pointing a camera at me!

For special public events, such as going to a club or party, I will do the high-femme thing, which is, according to definition three of the online *Urban Dictionary*, "a lesbian who expresses the cultural norm for ultra-femininity." But even that's not exactly accurate, given that femininity is often associated with being weak or with passivity. Sure, I wear outrageously high-heeled stilettos or big platform boots and a ton of makeup and glitter. Sure, I will let someone carry my handbag (unless it's glitzy and is part of the outfit) and coat. Sure, I want someone else to go to the bar and to order drinks. Sure, I will let someone open a door for me or pull a chair out so I can sit. Heck, I'll even go in the elevator first on those occasions when I'm all dressed up. Why? Because it's all

part of being thoroughly fabulous. It's all about projecting an air of high glamour and camp, in the vein of my earlier Hollywood heroes—Marlene Dietrich, Bette Davis, Joan Crawford, Elizabeth Taylor. Why stand in a queue at a bar when you can be holding court and being seen in your full glory elsewhere? Why struggle with a door or chair that will undoubtedly ruin the line of your lovely frock?

Yes, I'll embrace those notions of ultra–femininity when I feel like it. But if anyone messes with me, the glamorous, camp vamp can turn into aggressive warrior woman in a second. No thought will be given to the nicely arranged hair or immaculate makeup; the heels become an instant weapon, and the words coming out of my mouth will be associated with anything but stereotypical concepts of femininity.

Part of my femme–ness is a performance, a bit like doing drag. It's also, ironically, about smashing stereotypes. While I'm out and about, mincing around the gay scene portraying a high–glam persona, I'm also known, via my columns and articles in a variety of queer publications, to be a militant animal rights activist and advocate for social justice and the environment. I once wore a t–shirt with "Militant Vegan Femme Lesbian" on it to a women–only striptease club. "That's a contradiction…They don't go together," was the most common response.

Oh yeah?

The combination of glamour and activism often confuses people, but I'm of the firm belief that it's not only possible, but preferable, to change the world while covered in glitter.

Not That Girl
by Margaret Price

I never had a sister. I grew up ragtag, dirty, climbing roofs and killing frogs, running after the boys. There were ten of them, and me, and we played Tackletown and Smear the Queer; we farted in each others' faces and danced to AC/DC on the living-room rug. I wore their jeans, their jackets, their stripe-top tube socks. I went weeks without a bath. I walked among them shirtless, tied my T-shirt around my head to catch the sweat.

I know how to whip an apple, how to tag a baserunner, how to say the alphabet while burping. I know how to bike no-handed, how to unhook a fish, how to shoot skeet. I know how to cruise in the car, whistling at girls, how to turn to the boys and say, "I'd eat the corn out of *her* shit." I can spit ten feet.

You are my best friend. Sweet, small man, hard-won chest and voice, soft hands. We share many loves. Gardens. Bears. Rabble-rousing. Cock. We like to walk in the park and cruise the big tough guys. We giggle.

You're a femme too, and for years, I fail to know this. One day I idly ask what you think of femmes, and you tell me, "Well, I am one."

I am agog, I never knew, how could I not know? I've seen your picture as a baby, just like me, your mother's only girl. But dressed the way I never was, pink ruffly dress with bows, lacy socks, rosettes. You are beautiful, that baby girl, but you are not a girl. Not that girl.

My mother and my aunt, soft voices, hard fingertips, they treasured me, they taught me all they could. I know how to knit a sweater, how to whip an egg white, how to fold a towel with the corners sharp and the monogram on the outside. I know how to pour the wine, clear the dishes, listen while the men speak. When a man drinks eleven beers and falls on the floor, I know how to help him up, comment gently on how tired he must be. I know how to be expendable. To disappear. Shrink to nothing but a pair of hands floating in the air, soothing, lifting, letting.

Nights at my cousins' house. My uncle, six foot four, whom I've lifted off the ground before. Drunk, dark, pipe smoke in his mustache. His hands were heavy and they handled me, my ass, my tiny cunt, my hair. I stopped breathing.

I stopped sleeping. Back home in my room, listening to my brothers' snores, I held my eyelids open and watched the sky. When it turned from darkest purple to blue, when the birds began to keen, I closed my eyes and slept.

I ate dirt. Also pennies. And small screws, and snot, and pages torn from books. I nibbled at my fingers, at my toes. I never ate enough to disappear.

You help me meet my boyfriend. I am thirty-eight, I don't trust this Internet dating thing, why can't anybody spell? You soothe me. "Just look," you say. "Just window-shop. Just try it out." You're an old hand, veteran of Manhunt and Bear411, genius of the coffee date. You can pick them up in bars, you can meet a man in a chat room and have his cock in your mouth forty-five minutes later. I don't know how you do it.

"Dating is a muscle," you say. "Just flex the muscle."

"Butches don't like me," I say. I mean my hair, almost military short, I mean my callused hands, my long determined stride. I wear dresses, but never ones I couldn't fight in. I stick my hands in dirt, in engine oil.

"The right ones do," you say.

I remember seventh grade. I knew nothing. I wore the same clothes every day: brown corduroys, blue button-down shirt, white turtleneck dotted with red hearts. Around me girls bloomed in fat curling-iron curls, jeans with names, shining blue mascara. They leaned into the bathroom mirror, their hips swayed to music I couldn't hear. They never picked their noses.

I took the bus home and a man sat on me. I didn't understand. An old lady sat up front with her grocery bags, people were behind us, didn't anyone see? Meaty thigh and square ass cheek, half in my lap, the two of us piled at angles like cordwood. I didn't move. He ground his ass. His hands lay quiet in his lap, his eyes gazed dully out the window. His left ear flushed and fleshy, swinging lobe trembling when the bus trembled. I weighed ninety pounds, his ass went in a circle, clockwise. I didn't understand. I didn't breathe.

At my stop I stirred, he moved, I rose, I left. He swung aside to let me out as if I hadn't sat beneath his khaki ass. What should I have done? I didn't know.

And the music played. Alicia danced with Ward, arms around his neck, feet shuffling in a slow circle to the sound of Foreigner. *I've been waiting for a girl like you.* On Monday, I teased her: "You love Ward!" Without embarrassment, without denying it, she smiled and glanced down, eyelids smeared with curves of Maybelline purple. Her face was pleased, smug. I had meant to embarrass her, but somehow I'd given her the upper hand.

My currency was worthless now. On the soccer field I hawked and spit, competently, a tidy ball of mucous flying and landing just where I'd aimed past the sideline. Pretty girl ran past me, straight blond hair swinging and legs gleaming, shaven. She stopped long enough to tell me: "That's disgusting."

I had no friends. I ran. I ran in the places where I still mattered: across the hockey field, through the woods, I dived after volleyballs, scooped up grounders. At hockey camp, I watched the varsity girls put on their bathing suits, bake on the pavement behind our dorm, stroke the lotion on their skin, wrap towels under their arms. I watched and watched. I needed to learn.

One night I ran alone, melting Michigan July heat, twilight coming down along the quiet two-lane road. He stepped out of the scrub, curly brown hair and mustache, clothing dusty, bottle balanced in his hand. He ran behind me, I ran faster, he reached out and grabbed my crotch, palm up, fingers forward, diddling and twiddling between my legs on the run. I don't remember what I screamed. I remember I was faster. Long fifteen-year-old legs, panicked kick, down the hill and behind the high school, away into the headlights, pairs of white eyes lighting my way home.

My shorts were thin green nylon, and I threw them in the garbage. They had been my favorite shorts. For a long time I was angry that my favorite shorts were gone.

Dateless, you and I go out for Valentine's Day. Lush Atlanta winter, warm and wet, we walk down North Highland and gaze at the expensive soaps in the windows. You are laughing, telling a story, you swing your arm and clap me on the back. I decompensate.

I stop in the middle of the sidewalk. Sense falls away, and sensation, and language. I do not breathe. This is what I know about panic attacks: it's not that I *can't* breathe, it's that it's so easy not to. Why breathe, why move, why let time go on, when I could freeze and disappear, collapse to a point like a dying star? Dimly I see your face, huge and white like the moon, I know you must be worried. I form sludgy words: *I'm panicking.*

You sit me on a wall. You rub my back. The first breath comes in, painful as birth. The second. The third. Air is whistling in my lungs, or are those birds and their early-morning keening? My vision's collapsed along with my voice, I'm looking through a toilet-paper tube. You are speaking. After a while we're walking. We make it to the restaurant, we order wine, we twirl our pasta. The floor rocks gently, like a boat deck. You hold my hand, warm real fingers, broad strong knuckles. I'm afraid I will die from the feel of your gentle skin.

"I'm sorry," I say.

"You have nothing to be sorry for," you say.

Neither of us cries. Both of us have wept enough for the girls we never were.

The first boy who loved me was a poet, six feet tall and skinny as a newt, wide blue eyes behind round gold glasses, journal always in hand. He scribbled entry after entry about my beauty. We slept in single beds, we learned how to do it with me on top. I could make him groan, swoon, fall back. I broke his heart soon after, by leaving his bed and going to a party and fucking another boy. Avidly I read his anguished letters. I kept them, gloated over them, saved them like deeds. I'd never known the power of being loved before, and all I knew was how to swing it like a sword.

The first boy I loved was my best friend. We shot pool, walked up mountains, spat off balconies. We wrestled in bed like puppies, cranking the Sparks as we fucked and fucked in every way we could imagine. We did it in elevators, in fields, in tents, in a chapel, in the balcony during a string-quartet concert, in the ocean. We were playing.

When he and I parted, he knew I wanted to date women, and I asked him, trembling, how to do it. He said, "It won't be too different from dating boys." He said, "You can do it." He said, "You already know."

The ones I liked had broad shoulders, tough faces, assurance in their strides. I couldn't imagine what they might see in me, my heavy boots and rugby shirts, men's jeans, close–cropped hair, my undecorated face. Mostly they didn't see me.

The first one who saw me was Sami, and she taught me manners. Not mine: hers. She kept me on the inside of the sidewalk, opened doors, bought my drinks. She said I was a femme. I said I wasn't.

"Why not?" she asked.

"Femmes are weak," I explained. How did I know this? I just knew, the way I knew how to separate an egg, the way I knew the taste of a swallowed screw. I knew.

She let it go. I undressed her and discovered she wore blue–flowered cotton panties. "I thought you were a butch," I said.

She grinned. "I don't like doing what people expect."

Then she turned me over, unzipped my skirt, and showed me how to take a fist. She told me that I did it like a femme. She asked me where I'd learned that.

I thought about launching a sled down a ski slope at midnight, laughter muffled to keep the security guards away, my body prone and stacked between two boys', leaning together, side to side, avoiding the trees by hair's breadths, screaming. Unkilled, uncaught, and the pure laughter on the other side. I told her it felt natural.

It was Michigan, it was 1995, and no one was *a* femme. Some of us were *on the femme side*, maybe even *were femme*, were adjectival. Mostly we just wore skorts. I wondered if I'd have to give up softball.

I began to research. Anthologies, anthropologies. I drew the map again and again.

Femmes date butches. Except when they don't.

Femmes wear dresses. Except when they don't.

Femmes bottom. Except when they don't.

Femmes are catty, smart, small, large, tough, butchy, macho, femmey, high, low, slutty, slow. Femmes receive. Femmes give.

The only thing that stayed on the map was this: *someone touched you when you didn't want them to.*

Or was that simply everyone?

Now I am apparitional; I play with ways of showing up. My hair grows long, it curls and puffs, I cut it off. Skirts brush the floor, they barely clear my ass, they swing and cling. Eyelids sparkle purple, brown, waist pinches in and out, laces string me up and hold me in. Heels rise off the floor, four inches, five, one, none. I grow and shrink. I hook my garters, touch my butch, change my oil. The only thing that never changes is my stride.

I went to a class, and they showed me how to walk. I was thirty. Echoing Saturday high-school gym, fourteen women wearing sneakers, all of us survivors. Marian, the teacher, showed me how to square my shoulders, uncurve my frightened spine. Head up. Eyes direct. "Try it again," she said, "again." She said, "You need to take up space." I paced the floor, masquerading unassailability. "Don't rush," she said. "And don't look back."

We fought men in padded helmets, fought with knees and hips and fingertips, kicked the air and punched their faces. We practiced shouting *No.* That was hardest. We were not allowed to fight in silence.

My first femme friend was Jen. Long blond hair, wide blue eyes, dirty mouth. We taught at the same school; we wondered what our students made of us. "They think you're straight," I said, "and they think I'm a big butch dyke."

"What they really think," Jen said, "is that we're *old.*" It's true; we were thirty-two. Some days we felt quite old.

"Do you identify as a femme?" I asked. The language of the new millennium: we *identified as*, we *presented as.* Good perverts, we subverted and inverted. We were subjectivities.

"I think so," Jen said. "Do you?"

"Yes," I said. It was the first time I said it without qualifying.

I taught her how to drive a twelve-foot truck. She taught me how to line my lips. We told each other we were beautiful.

Frosty early morning, barely light, I am walking up to work. Streets deserted, except for the man in the long duffle coat who shouts at me. *Hey. Hey, boy.* I don't change my stride. He is coming from behind me. *Hey, white boy. I'm talking to you, boy.* Close now, one sidewalk square behind.

I spin and snap, *What?*

He takes in my face, my treble voice, and his eyes bug out. Hands out of pockets, raised palm-forward as he steps away. *Sorry,* he says.

Did it save me that I was a girl?

Did he only mean to ask for money?

For a while, after I learned to fight, I walked in the world thinking, *Don't you fuck with me.* As time went on, I began to wonder—of every face I saw—*Who hurt you?*

A party at Jen's house and along came Ryan, old-school butch, bleach-blond hair and seven studs in each ear. Jen asked to take her coat. Ryan swung it over, then turned and said to someone over her shoulder, "That's one thing femmes are good for."

And I was grateful, all at once, to the men in my family, for all the times I saw them push women, ridicule them, squeeze their asses when they weren't looking. Even for the heaviest hands, even for the cruelty. For I knew this: Ryan's nasty comment—it was not a butch thing. Just an asshole thing.

I am thirty-four, I meet you at a party. Mostly FTMs, a few butches and femmes, everyone uncomfortable. I introduce myself, and you are cold. Later you tell me, "No, not cold, just socially awkward." I'm not sure I believe you. I know how femmes sometimes hit on you, how they won't take no for an answer, the ways they touch you—neck, arm, even your ass—when you don't want them to. I think you may have been telling me, *Be careful.* I think you may have been telling me, *Don't touch.*

I think about the word *pursuit.* Sometimes it's alluring, touch and go, faster, slower, hot. Sometimes not.

You and I, we want to change the world. We live in the deep South, search for decent bagels, fear the hatred. We march, we organize. Our skins are pasty white, our accents northern. We try to find the boys, the butches or the bears, the handsome kind ones who will pick us up and throw us just enough.

One night you call me. Someone mugged you on the street. They pointed a gun, took your wallet. You are shaking, I am shaking; I'm not there, I can't hold you, I can't offer you my practiced small femme hands.

But they did not see all of you. We both know how much worse it could have been.

Ungracefully, I date. I call you to report; we dish and giggle. I feel absurd, I feel delighted. I am thirty-seven. I don't act my age.

I go on a date with a woman and tell her I'm a femme. She purses her lips at my jeans and boots, she shakes her head. "You're not a femme," she says.

I know enough by now that I can laugh. Just enough.

"What bullshit," you say when I tell you.

Maybe it was only you, sweet brother femme, who could unlock my heart, who could make it ready for whomever might float in. You and I, we're opposites, we're complements, we're strange animals with different faces and a similar smell. I think you taught me how to love.

I find a butch online. Jake. We meet, we kiss, we tell the litany of exes. I explain about the hands, the heavy hands and why I never sleep. Jake strides in leather jacket, low-slung jeans, boots. "I've been told I'm too gentle," he admits one night.

I tell him what I know by now: you cannot be too gentle.

He: this is new to me. Jake is not transgender, nor a boy, though he is my boyfriend. Nor is he a man, except when he is my man. *He* is a mark of validation, of respect. It's a secret code, a shared vocabulary among butches and femmes and those who know. Not so secret when we're at my straight friends' house eating meatloaf. Our private lives turn public, stumble out our mouths. I say *he*. My straight friends follow suit. Then they slip up and apologize profusely. They are nervous.

These are not the people whom he wants to see him. Still he is gracious and easy. He goes back for seconds; he reassures.

I step out in a silver glittering dress, four-inch heels, a long brown wig. Blue eyeshadow is back, it takes me back, back to the unholy girls' bathrooms of my junior high. Now I brush it easily, I blend.

You see a picture of me from a butch-femme formal ball. "My God," you say, "is that you?" The eyelashes, the hair. "It's your smile," you say. "Your smile is different." Different how, I ask. You take a minute. Finally: "I don't mean that you usually look scared. But here, you look….You look fearless."

No, not fearless. You know this. You know the diagnoses: post-traumatic stress disorder. Chronic anxiety. Borderline personality disorder. I've been given so many names, told so many times what I am or am not. Sometimes *borderline* becomes a garden-variety insult for femme. *She's such a borderline.* I walk plenty of lines, but not the ones they think.

When we walk in crowds, you keep me on the inside of the sidewalk. You hold my elbow. *How you doing*, you ask, and *Do you need to take a break? You say, I'll get the drinks.* You are chivalrous and careful, mindful of my unseen bruises. Yours are not the manners of a butch.

Jake is his parents' daughter. In their house, I say *she*. At first this makes me angry. Cowardice, I think, denial. I don't say these words, but he reads them on my face. He explains in his gentle Georgia drawl.

"It's courtesy," he says. "It's manners. Baby," he says, "my parents are doing the best they can. Try to understand."

I am mannered in their house. I don't swear, I don't take the name of the Lord in vain, Jake is Katherine, and we are merely friends. I wipe my lips and ask for seconds. I watch. I walk the hard–won borders of their truce.

We join hands and say grace, we thank our Heavenly Father, and silently I think of all the names there are for love.

For Thanksgiving you go home, home to the northern state where you were born, where your parents call you by your girl name, and your brilliance is not seen. You send me messages by phone. *Four more days*, you write, and *They're driving me crazy* and *My niece is beautiful*. You send a picture, and she is: gremlin face, pink dress, ruffles, bows. New girl, dauntless and unthinking as the sun, not yet collapsed, maybe never.

I have nephews; I am still the only girl. The only girl, and yet I'm not alone. I know that she'll be safe with you. Sweet femme brother, I know that she will never fear your hands.

Femme Bookworm, or,
What's a Girl to Read When She's Feeling Invisible?
by Anna Watson

"Never go anywhere without your book."
—Dr. Richard A. Watson

Diagnosis: Femme Book Addict

I am quite sure that I wasn't able to come out fully in 1980—the year I first kissed another girl romantically—because Diane DiMassa hadn't written *Hot Head Paisan* yet. *A Persistent Desire, Bi Any Other Name,* and *Dykes to Watch Out For* were similarly far in my future. In other words, I couldn't find any books that would help me understand what I was feeling—something not reflected back to me anywhere else.

I just wasn't able to figure it out on my own, especially given my location, my shy temperament, and the friends who surrounded me at the time. The only homos I knew were artistic gay boys whom I loved fiercely and found ever so fascinating, but whose presence in my life wasn't enough to clue me in about my own sexuality. My best friend and confidant, Kathleen, was straight as an arrow and disappointingly provincial when it came to the female queer. There I was, marooned at the University of Michigan, intensely crushed out on a fellow dorm-mate (oh, Laura Z.!), with no printed material to illuminate me. It was hell! I spent hours fossicking forlornly through the stacks of the graduate library looking for a book that talked about lesbians, but I kept coming up empty. No wait, I think there might have been something about Sappho.

When I was in grad school in Washington, DC, I finally made it to the gay bookstores in Dupont Circle, where I was drawn to the aforementioned books by a miraculous queer magnetic force and was at last able to situate myself more or less comfortably among other queers. That is the way of this femme bookworm: when others reach out to me through the printed word, when I can read about the possibilities presented by their lives, I am in turn able to see my own life more clearly. Books, literally, mean the world to me.

I read like I breathe, always have. I *never* go anywhere without my book, having long ago incorporated my father's sound advice into the very core of my being. I read everything from long-forgotten, earnest anti-feminist tracts à la *The Total Woman* to the latest cutting-edge collections à la *Nobody Passes.* I love autobiographies, especially those written by women, who, say, in their old age acquire a donkey and a little cart and go trotting about the English countryside (*Travels in a Donkey Trap*). I read other types of nonfiction too and am grateful to Dave Zirin for his insights about sports that I rely upon to help me stay centered as I drive from game to game, following the careers of my two sports-playing sons.

Overall though, I tend to prefer fiction and do enjoy a family saga, maybe *A Suitable Boy, The House of Nire, Mona in the Promised Land, The Marketplace* books, and anything by Mavis Gallant

or Ruth Prawer Jhabvala. I thrill to a smutty short story, and open every new anthology that comes into my hands with a sense of greedy anticipation, never having forgotten the indelible impact made by Trish Thompson's masterpiece, "Me and the Boys" (*Leatherwomen*) or, more recently, by Sidonie Perrault's steamy "A Little Indiscretion" (*The Golden Age of Lesbian Erotica, 1920–1940*).

As far as particular genres, I pledge my love to more than a few. I love science fiction and reread the very sad and maybe a little brilliant take on culture clash, *Brother Termite*. As a young person, I read obsessively books by Suzy McKee Charnas, Theodore Sturgeon, Robert Heinlein, Phillip K. Dick, Arthur C. Clarke, Clifford D. Simak, and Zenna Henderson. I also read horror when I can stomach it—Stephen King and Kathe Koja, for instance—and I have a special place in my heart for young adult literature. It is a wonderful thing to see new kids' books with queer main characters, like those written by Julie Anne Peters and M.E. Kerr (one of Marijane Meaker's pen names). I like a self-help book now and again and have relied upon Anthony E. Wolf for parenting advice, and, by golly, Karen Kingston has given me a tip or two. Finally, I am completely addicted to mysteries. It is with a mystery, actually, that this essay for *Femmethology* came to me.

Betrayal: When Good Books Go Bad
I go to mysteries when I need reading to be a total escape, which is why I found myself standing in front of my mother's mystery bookshelf recently. I had dropped everything to fly out to Montana in order to keep her company through her hip replacement; what with one thing after another, I was feeling stressed. As fascinated and moved as I was by the book I had just started, *Dancing at Halftime: Sports and the Controversy over American Indian Mascots*, I simply couldn't concentrate enough to do it justice. Instead, I pulled out a couple of Susan Conant's to tide me over.

Oh, I love Susan Conant! Her first book, *A New Leash On Death*, came out in 1990, and I've been a fan ever since. Her detective, Holly Winter, is a writer for a dog magazine and is herself a knowledgeable and loving dog owner. She lives in Cambridge, MA, about which she is very funny (did you know for example, that it's a law in the People's Republic of Cambridge to listen to NPR while breakfasting?). Well written, funny, informative, and usually full of good suspense to boot, these mysteries are just the kind of easy read a girl needs when life is overwhelming…which is why it was such a blow when I started the third book of the series, *A Bite of Death*, and came up against some serious problems.

Before I begin, let me issue a SPOILER ALERT, as I am about to talk in detail about the story and even say who done it. Consider yourself warned.

In *A Bite of Death*, Holly meets a feminist therapist who has adopted a female malamute from a client who ostensibly committed suicide. Holly begins helping train the very dominant animal, quickly becomes friends with both woman and dog, and is catapulted into the mystery when the shrink dies in exactly the same way as her client. Enter Joel Baker, another shrink, who may or may not have something to do with what Holly is beginning to think of as murder. He is handsome, clean-shaven, impeccably dressed, and is that rare male therapist with whom women feel entirely comfortable, as he has an almost uncanny knack for understanding their lives and problems. He is married to Kelly, who is also something of an anomaly: in the rabidly feminist environment of Cambridge in the late eighties, she has an unabashed feminine style, relishes her

status as a homemaker, and is proud to be able to provide homemade gourmet food for Joel and their friends. She is also a tortured–to–the–point–of–insanity murderer, killing to preserve the secret that her husband is a biological woman. Upon discovering this secret, Holly says,

> If people had known, he wouldn't have been Joel Baker anymore. And of course, Kelly wouldn't have been Kelly. In the eyes of most people, even in Cambridge, liberal heaven, where lesbian couples can live about as openly as they can anywhere, he'd have been a freak, a woman passing herself off as a man. *And what would Kelly have been? If the word existed, I'd never heard it*" [emphasis mine].

Leaving aside concerns as to whether or not this scenario is even believable, Kelly as a person— her needs, desires, sexuality, reason for living—is completely opaque to everyone in the book, including her husband, who acknowledges that she's been living in denial, but offers no illumination as to what might be in his wife's heart or to the inner workings of their relationship.

Who is the bigger freak, the deviant or the person who loves the deviant? Kelly, a woman who looks like some version of femme to me, isn't even allowed the dignity of knowing who she is. She's a null, a void, a person who has built her life around a huge, freaky lie about something she can't even admit to herself. When Holly tells this nonentity that she knows Joel is a woman, Kelly acts like she has no idea what Holly's talking about. Moments later, Kelly commits suicide using one of her own meticulously sharpened kitchen knives. She leaves a note claiming she killed herself because she couldn't bear dealing with her infertility issues any longer.

Long ago, I had a job as a playground supervisor. One day, a little boy I really liked came up and whopped me in the stomach, hard, for no reason on earth that I could see. That's how I felt when I read the above scene: sucker–punched by someone I've learned from, laughed with, and let into my heart. Oh, and did I mention how miserably invisible it made me feel? Oof.

I forgive Susan Conant. I still love her mysteries, and I don't think she would write anything like this today, when transgender issues are so much more visible. When she was writing *A Bite of Death*, I'm sure she was seduced by the *queerness* (in the old sense of the word) of the idea of a passing woman—Billy Tipton had just died in 1989, after all—and by the incredibly cute gimmick of having her dog uncover the secret by sniffing Joel's crotch and communicating to Holly that Joel, like Holly that day, was having his period. Yet Conant writes compassionately about Joel, and I believe that with more information and a little schooling, she would find compassion for women who love people like Joel, as well.

Heal Thyself, Read Thyself
I have gone on at such length about this particular novel because I am guessing that any queer who loves to read has similar book–inflicted wounds to staunch. For those of us who are incapable of separating their need to read from their sexuality ("Anna the Reader" equals "Anna the Femme"), negotiating the straight world as contained in the pages of a book can be a complicated and painful experience. Much of the time I can translate or mow right over even the most unsavory of heterosexual scenes, and often it matters not a whit whom I'm reading about as long as their story holds my interest.

When I want to rest a bit, I retreat into the arms of queer literature, and read nothing but Michelle Tea, Carol Anshaw, Tim Barela, and Mary Jacobsen, but even with these books, I can feel invisible and sustain hurts of a different nature. I love Armistead Maupin, for example, with his over-the-top soap opera, but he is hard on his women characters in a way that makes me wonder if he actually likes us very much. Sarah Waters is marvelous, and I just adore her books; however, they can be quite dark, and her queers—most of them—don't look much like me.

Wounded by reading, I must heal myself by reading, so I reach for works by or containing butches and femmes. Marijane Meaker's memoir of her relationship with Patricia Highsmith, *Highsmith*, is a fascinating read (and has a kick-ass cover!), but it makes me sad too to see Patricia Highsmith so tortured. Julie Anne Peters creates a simply marvelous butch, Jo, in her young adult novel, *Between Mom and Jo*, but I am sorry to report that the femme character is not believable, and that her realization is a serious flaw in an otherwise lovely book. Ivan E. Coyote's first full-length novel is about a straight man! It's fine, really, fine, no problem, it's a good book, really, but I had just hoped it would be about femmes and butches.

Stone Butch Blues changed my life. I will never forget the breathtaking thump of visceral recognition I experienced when one of the femmes adjusts Jess' tie when they're helping her shop for a suit—I knew someday that femme would be me. As important as this novel is, though, it is drenched in agony and is difficult to read for that reason. And it is only because of my irrepressible love of butches that I made it through *Godspeed* by Lynn Breedlove, where the butch narrator abuses herself so horribly. Joan Nestle, Amber L. Hollibaugh, Minnie Bruce Pratt: I treasure their work and am sincerely grateful for their bravery in the face of adversity and that they took the time to write about their lives so honestly. Their words offer such hope, yet can be so heartbreaking to read.

As vital as these works are, when I have sustained a blow such as the one Conant dealt me, I am looking for something happy, not for more pain. A book where femmes and butches appear as the complex people we are. Where this magical sexuality is part of what makes up a character, contributing to the mix of her life, a source of joy not despair, a thing of beauty. The book tonic I seek in order to make myself well is an interesting, thoughtful, exciting, sweet, sexy story about people like me.

Unless I get really lucky and stumble on something new that fits the bill, there's really nothing for it when I'm feeling this in need of a doctor but to reread a few tried and true books. I cannot say enough how grateful I am for these novels. They remind me of what I tend to forget under stress: my flesh and blood; my beating heart; my blessed and miraculous physical presence on this beautiful earth; my sexuality, vibrant and wonderful; and all the sweetness of being alive and connected physically, emotionally, and spiritually to all of those I love.

I am strong.

I am voracious reader.

I am femme, but there are times when I feel myself fading out, passing from view, when I look in the mirror and see nothing but a misty shape, rapidly receding. For those times when this feeling might come upon you, I would like to offer up four dear friends. Read and be healed!

Patience and Sarah by Isabel Miller, 1969 (originally titled, *A Place for Us*)

If you've avoided this book, as I snobbily did because Naiad touts it as "the beloved lesbian classic" and you think it might be as cheesy and disappointing as *Claire of the Moon*, avoid it no more! You won't be able to stop reading, it's so well written and delightful. Set in the mid–1800s in the U.S. and based on a real–life couple, this is the story of Patience, an intelligent, well–spoken artist, and Sarah, younger, unschooled but smart as a whip, good with her hands. Right from the beginning, I could feel the good medicine begin to work in my gut. Here is a sensual snippet from when Patience first sees Sarah, who is delivering wood to the household:

> With my fingertip I melted myself a peephole in the frost on the window quarrel, but the woodpile was too far around and I couldn't see.
>
> "Is it a woman or a boy?" I asked.

Now *there* is a femme question for you, if there ever was one!

The novel switches back and forth from Patience's voice to Sarah's, each unique and distinct, each a pleasure to read. The women face down adversity and come out on the other side, in love and together. Please allow me to reappropriate a few clichés as I write about these books and say that this is a love story you really don't want to end. Coming to the last page is having to say goodbye to two wonderful people, and you want to start right back in at the beginning again. This isn't a fairy tale, either, and it is good to see that a realistic novel about queers doesn't have to be fraught with gloom and doom. *Patience and Sarah* is as believable as it is life–affirming.

The Leather Daddy and the Femme by Carol Queen, 1998

Recently reissued, thank goodness, and what, I ask you, *what* is not to love about this book? The saucy femme heroine who cruises the "real done–up daddy, yeah" is whom I like to imagine I could be if my libido was amped up to the nth degree and I had the sexual stamina of ten femmes. This is a seriously hot read! The femme narrator, Amanda, is a complicated and delicious character, able to channel all different kinds of energy—boy, girl, woman—as she seduces her new pal, the daddy, who himself may be gay, but who's been around the block enough not to be scared off by such a wonderfully creative sex partner. "He's a real fag!" Amanda boasts to her transgender roommate, Ariel. "He sucked my cock and everything! That waterproof harness works great, by the way."

When I first read this book, I was back in the closet to myself about being femme, and thought of myself as simply lesbian. Trolling the dark and delirious back rooms and alleys of Queen's San Francisco with her cast of un–pin–downable genderqueers gave me a taste of what was to come when I began to embrace my full sexuality. Years later, rereading this book is like visiting old friends in whom I can see aspects of my own femme self and with whom I share a past and can envision a wonderful future.

Dusty's Queen of Hearts Diner by Lee Lynch, 1987

Dear Lee Lynch, thank you for your tireless effort in writing about dykes in general and femmes and butches in particular! I have learned so much about queer history reading your novels, and have found such peace from following the stories of women like me. *Dusty's* is my all–time favorite

as it shows in loving detail the development of the relationship between a femme and a butch who are in it together for the long haul.

Elly and Dusty run a local diner (Dusty bought it for Elly for Christmas), where members of the local queer community meet and mingle with the straight inhabitants of Morton River, an imaginary New England town. The novel is set in the early 1970s, and the lives of its characters are not without conflict, brought on both from an uncomprehending general public as well as from their own human challenges. In essence, however, this is a book filled with optimism and love, infused with femme/butch sensibility. Here is a bit from the first chapter, when Elly is coming back on the train from a trip out of town, dreaming of her butch the whole way. Waiting for her at the station, Dusty is

> …tall, her dark–framed glasses giving dignity, like the gray in her auburn hair, to her boyish face. Hands in the pockets of the aging peacoat she wore over a turtleneck and faded jeans, she'd propped one foot up behind her, against the wall of the old brick station next to the sign for Morton River, her hometown. So this was what it felt like, Elly thought, to come home to Dusty Reilly.

A little later, as they pass a gang of local toughs, Elly says something to reassure Dusty, since, "[i]f Dusty got scared, who could she lean on?….Dusty might be the answer to her dreams, but her strong, confident exterior often needed bracing. Elly was an experienced bracer." What braces me is that this novel pays such respectful homage to this particular unique femme/butch couple, their quirks, their humor, and most of all, their humanity.

The Case of the Not–So–Nice Nurse—A Nancy Clue Mystery by Mabel Maney, 1993

Sinking into Maney's queer take on Nancy Drew, Cherry Ames and her ilk is as satisfying as reading smut that speaks right to your kink. Maney effortlessly reproduces the fatuous tone and abrupt and improbable plot twists of the genre while at the same time warping the world so that queer is the norm. This is so deeply satisfying! There is a reason that people reach for romances, mysteries, fantasies, and other genre books when they are in need of the literary equivalent of warm tummy food: you know everything will turn out okay in the end, and in the meantime, you can relax, sit back, and gobble chocolates. The problem for me, as we have seen, is that so many of these books are far from queer. Thanks to Maney, however, something that is so ubiquitous and straight finally comes home to mama:

> Cherry was jarred out of a deep sleep by someone knocking at her car window. She opened her eyes and found she was eye–level with a police officer's wide leather belt.

> "Jeepers," Cherry thought. "I've never seen a gun up close before."

> Midge stirred in the back seat. "Cherry, get rid of him," Midge whispered groggily. "Use the Girl Scout nurse story again."

> Cherry rolled down her window and pasted a big smile on her face.

> "We'll be out of here in just a minute, officer," she said politely.

The police officer leaned down and looked into the car. Midge sat up when she saw the face of a *girl*—a handsome girl with warm brown skin and dancing black eyes.

"Are you by any chance a friend of Betty's?" Cherry asked, staring straight into the girl's deep-set eyes.

A wide warm grin broke over the officer's face. "I'm Officer Jackie Jones. Call me Jackie." She took off her hat and ran a hand over her short slicked-back hair which glistened blue-black in the sunlight.

Cherry noticed that the girl's short hair-do made her strong jaw even more prominent.

"I'd feel safe with her anywhere," she sighed. Although the sun was shining, Cherry was aware of shivers running down her spine.

Oh, yum!

The Last Page

The life of a femme bookworm is fraught with pitfalls and peril. I never know when a book is suddenly going to turn on me in the most vicious manner—sear an image into my brain that will haunt me forever, say something so heartless that I lose sight of who I am completely.

In her memoir, *Two or Three Things I Know for Sure*, Dorothy Allison speaks about "what it means to have no loved version of your life but the one you make." As a queer femme, I know exactly what she means. As a reader, I have to keep turning pages. The authors of the above books have given me the great gift of writing loved versions of lives that look a lot like mine. Reading and rereading their work allows this bookworm, for brief restorative moments, to realize fully my femme self.

References

I know there are books I've forgotten, books I haven't read, and books I need to read. Please educate me! I would be grateful to anyone who would like to send me titles of the books that sustain and nurture them.

Allison, Dorothy, *Two or Three Things I Know for Sure*, 1995

Anshaw, Carol, *Lucky in the Corner*, 2001

Anthony, Patricia, *Brother Termite*, 1993

Antoniou, Laura, *The Marketplace*, 1993

Antoniou, Laura, ed., *Leatherwomen*, 1993

Baker, Daisy, *Travels in a Donkey Trap*, 1974

Barela, Tim, *Domesticity Isn't Pretty (Leonard & Larry Collection)*, 1993

Bechdel, Alison, *Dykes to Watch Out For*, 1986

Breedlove, Lynn, *Godspeed*, 2002

Brownnworth, Victoria A. & Redding, Judith M., eds., *The Golden Age of Lesbian Erotica, 1920–1940*

Charnas, Suzy McKee, *Walk to the End of the World*, 1974

Clarke, Arthur C., *Childhood's End*, 1974

Conant, Susan, *A New Leash on Death*, 1990

Conant, Susan, *A Bite of Death*, 1991

Coyote, Ivan E., *Bow Grip*, 2006

Dick, Philip K., *The Man in the High Castle*, 1962

DiMassa, Diane, *Hot Head Paisan: Homocidal Lesbian Terrorist*, 1991

Feinberg, Leslie, *Stone Butch Blues*, 1993

Gallant, Mavis, *The Pegnitz Junction*, 1963

Heinlein, Robert, *The Star Beast*, 1977

Henderson, Zenna, *The People: No Different Flesh*, 1967

Hollibaugh, Amber L., *My Dangerous Desires: A Queer Girl Dreaming Her Way Home*, 2000

Hutchins, Loraine & Kaahumanu, Lani, eds., *Bi Any Other Name: Bisexual People Speak Out*, 1991

Jacobsen, Mary, *Blood Sisters: A Novel of an Epic Friendship*, 2006

Jen, Gish, *Mona in the Promised Land*, 1996

Jhabvala, Ruth Prawer, *Three Continents*, 1987

Kerr, M.E., *Deliver Us from Evie*, 1994

King, Stephen, *Cell*, 2006

Kingston, Karen, *Clear Your Cutter With Feng Shui*, 1999

Kita, Morio, *The House of Nire*, 1984,1985

Koja, Kathe, *The Cipher*, 1991

Lynch, Lee, *Dusty's Queen of Hearts Diner*, 1987

Maney, Mabel, *The Case of the Not-So-Nice Nurse*, 1993

Mattilda, a.k.a. Matt Bernstein Sycamore, ed., *Nobody Passes: Rejecting the Rules of Gender and Conformity*, 2006

Maupin, Armistead, *Significant Others*, 1987

Meaker, Marijane, *Highsmith: A Romance of the 1950s*, 2003

Miller, Isabel, *Patience and Sarah*, 1969

Morgan, Marabel, *The Total Woman*, 1973

Nestle, Joan, *A Restricted Country*, 1987

Nestle, Joan, ed., *The Persistent Desire: A Femme/Butch Reader*, 1992

Peters, Julie Anne, *Between Mom and Jo*, 2006

Pratt, Minnie Bruce, *S/He*, 1995

Queen, Carol, *The Leather Daddy and the Femme*, 1998

Seth, Vikram, *A Suitable Boy*, 1993

Simak, Clifford D., *City*, 1952

Spindel, Carol, *Dancing at Halftime: Sports and the Controversy over American Indian Mascots*, 2000

Sturgeon, Theodore, *More Than Human*, 1953

Tea, Michelle, *Valencia*, 2000

Waters, Sarah, *Affinity*, 2000

Wolf, Anthony E., *Why Did You Have to Get a Divorce? And When Can I Get a Hamster? A Guide to Parenting Through Divorce*, 1998

Zirin, Dave, *What's My Name, Fool? Sports and Resistance in the United States*, 2005

Prayer
by Miel Rose

Tattoo

In an attempt at visibility, I tattooed the word "femme" on my fingers. Alone in my kitchen, I traced the word with the charcoal end of a burnt rosemary stem and pricked the letters into my skin with tiny needles. I burned honey incense in honor of the femmes who have walked before me, those who walk with me and those to come.

I thought about the limits of space and how we navigate the confines of what is allowed to us as queers, as women, and as queer women who claim a gender legacy with hundreds of years of misogyny attached. I thought about how much courage, energy and dedication it takes to make space for ourselves and others. I thought about the women who have made space for me to live in this gender, and I thought about the women who don't feel safe being out as queer femmes.

There's nothing like the idea of taking up space in a way that makes room for others to put some steel in my spine and to harden my resolve always to present exactly who I am. There's nothing like thinking of those femme elders and ancestors carving a space big enough for me to hear my own name that makes my heart swell with pride, courage and commitment to walk this path. I tattooed the word "femme" on my fingers as an act of defiance in the face of frustration and exhaustion that were threatening to overwhelm me.

Tightrope

Maybe if I lived in a vacuum, this tightrope would cease to be this expanse of razor wire I sometimes see pulled taut and stretched before me. Maybe if I lived in a vacuum, only myself reflecting myself back to me for infinity, this razor wire called my femme gender would become a hard and clear path, one I could walk with ease in 5" heels, hips swaying, never rolling my ankles. But I don't live in a vacuum, and some days my feet are cut bloody to the bone from this razor-edged tightrope. Some days, I just fall off.

These are the days you'll find me crying in the bathroom, small torrents of black kohl running down my cheeks, smearing the lipstick from my mouth, scrubbing my face raw, those bad voices in my head full blast like they will never shut up: "Stupid bitch. You think you can play this game? You think you can make the rules your own? Turn hundreds of years of danger and hate into safety and pleasure? Think again."

Sometimes being femme is about finding power and strength through a devalued kind of vulnerability. But in practice it often feels like wrapping bravado around tender insides, and bravado can only take one so far. When did my bedroom become the only assured safety in enemy territory? How often do I feel like a mythical animal or an antiquated stereotype, even among other queers? How often do I feel on display, judged way too femme, or way not femme enough?

These issues are complicated and intersected by body politics, culture, race and class. Being fat and low income often feels like a stumbling block in my heart to presenting and being acknowledged as femme. When the most accepted image of femme is skinny, fashionable by middle–class standards, and beautiful by eurocenteric standards, being anything else adds razors to the wire.

This image of what femme should be further defines the limited space we have and makes us mistrust and fight each other for resources perceived as finite: validation, attention, acknowledgment, appreciation, and space. We exist in a culture that hates women and queers, in a subculture that regards expressions of femmeninity and feminine sexuality with distrust and contempt. This keeps the razors sharp.

Spectacle

What is it that I'm doing when I get dressed for the day? By presenting this femme gender, am I automatically offering myself up, exhibiting myself for masculine approval or disapproval, whether from straight guys on the street or the queer guys in my community, my house, my bed? What does femme mean when I tell the fiftieth dude flirting with me on the street that I'm queer, and he says, "Girl, you are NOT a lesbian! I don't believe it!" When masculine queers "boys' club" me, assuming my outfit excludes me from intelligent conversation? When I'm in queer space and queer eyes slide off me like my skirt is a cloak of invisibility? When my heart is breaking, and I think it would be easier to present androgynous, like when I was eighteen and hiding from myself? At these times, the tightrope is the most real, and it becomes hard to balance.

These days stand out because fighting demons is hard and horrifying work.

Some days, I'm able to reap the benefits of this work. When I get ready in the morning, I know who I am and what I'm doing. Sometimes this skirt, this low–cut top, this lipstick are fucking armor because, darlin', some days walking out my door feels like fighting a psychological battle. Some days this armor anchors me in my body so thoroughly that nothing can shake me loose. I have a core of liquid steel running through my center. If you want to see me as an object for straight–man desire, dismiss me as stupid, or not see me at all, fine with me. Everyone has a path to walk, and mine is firmly planted on this tightrope: there is no fucking way to push me off.

The popular belief that femininity is an offering/spectacle without power or conscious choice was firmly impressed upon me as a small femme. Despite the isolated rural upbringing, despite the feminist, hippy parents, this lesson crept in and took root. Few of us socialized female escape it. It's a knife that stabs me in the gut, fills me with shame. What can be offered, can be rejected; what can be displayed, can be scorned. I never wanted to play that game by those rules. I never wanted to let others set my value for me.

The spectacle that is my femme–ininity is a double–edged blade, no doubt. If one edge is named shame, the other is desire. Both cut as deep, but in different ways, and sometimes they seem to inhabit the same space simultaneously. I practice remaking the rules to this age–old game of feminine sexuality because of who I am: I am erotically wired to feel pleasure in the role of an offering and a spectacle. My challenge lies with embodying the power and strength of that role.

My existence requires me to change the rules of patriarchal domination, as they exist within my body and intimate relationships, to remain whole.

It's all about timing and place. It's all about terms and consent. It is specific, the way I offer myself up to a lover. It is specific how wet my pussy gets while being an object of desire for someone who knows and loves me, someone who understands the ways we are remaking these rules, someone who can look at my legs spread wide and see my soul. When she beats my ass, holds me down, fucks me, calls me her bitch, it's with the full knowledge that even as I give myself up to her, essentially I am no one's bitch but my own.

Nostalgia

After nearly ten years in a city, living rurally again puts a different spin on the isolation I feel in this gender. There's a different kind of heartbreak I feel seeing visible queers on my infrequent rides into town, not knowing how to bridge the gap between us here, outside of a queer context. There's a different kind of heartbreak when I check out the stylish ladies around town and have no idea which ones might be queer femmes. Being rural again makes me shy and socially awkward. I'm starting to appreciate certain things about being an established queer in a big city, even in a scene where I felt ignored.

I miss other femmes. The telephone is a stupid substitute for my sisters warm and solid next to me. Being on this mountain is making me nostalgic for so much. Days filled with femme laughter, making food, working in our gardens, in overalls, our painted nails in the dirt or wrapped around power tools, building some shit we need. We know who we are, and no matter what we do, we are always femme. We talked about shit I used to think was stupid, shameful, patriarchal and vain, as I so shyly asked for tips on makeup, waxing, and hairstyles. Lounging around in fancy panties and heels, we fed each other chocolate and fruit, drank cordials and mead, rubbed each other down with homemade lotion, reflecting our beauty back to each other, lingering over every scar, literal and figurative, places that have caused us pain for a long time. We harvested medicine together, rode bikes, talked about sex, practiced magic, made each other cheesecakes for our birthdays. We stood in kitchens, bedrooms, and dance parties practicing our spanking techniques with hands, belts, yardsticks. We vented about days filled with frustration, harassment, heartache. We held each other while we cried, protected and cared for each other, guarded each other's backs.

We share so much collective grief, even when our experience of pain differs, even when we face different oppressions. There is tremendous healing in tapping into that shit together, that collective grief, and oh, did I mention rage?

Prayer

I want you around me now, those who hear this word "femme" and feel it resonate like a bell sounding deep in the gut. This is a prayer for those whose brilliance is consistently ignored, whose talents, skills, hard work, and strength are consistently devalued. Those who often feel out of place wherever we are, who are either too femme or never femme enough. Those who need to be seen so badly it's breaking our hearts. Those with hearts that are silver armor–plated, so jaded

we convince even ourselves we don't give a fuck. Those whose beauty is rarely recognized. Those who feel people never see past their beauty to all the other ways they are amazing, complex, and powerful.

I'll tell you this: it is a deep and old mistake to underestimate us.

Femme is a legacy. Femme is a word that has history in a queer context. It connects us to women who have come before us, who have laid groundwork (however shaky) for this gender space.

This is a prayer I make with my whole heart to see this space widen, open with enough room to hold all this insane brilliance. To see us loving ourselves and knowing our true value. This is a prayer to see us walking our different paths strongly, with the courage never to be any less than exactly who we are.

Femme(In)visible or Gender-Blind?
By Traci Craig

You have to be *really* butch for me to be femme. This is a direct impact of sexism. As a girl and a woman, I've been repeatedly exposed to sexism and misogyny. From the time I was in elementary school, it was clear that masculinity was rewarded and femininity was punished. I learned this not only from male and masculine figures in my life, but from women as well. My grandmother told me that every time I cried, a woman lost the vote. I don't cry much.

I learned that enacting masculinity via nonverbal behavior and knowledge of masculine domains gave me access to privilege. Access was good; it felt good; and it allowed me to feel that the American Dream wasn't a sham. As a white girl, I certainly had more than my fair share of privilege. It wasn't until I was in my teens that the disparity came into relief against the New Mexico small-town backdrop. I could enact masculinity in ways that my Mexican and Hispanic friends could not. Their mothers insisted they wear makeup, do the housework, and abide by other feminine mandates from which my class and race excused me. I was free to play computer games, to work on my car, and to engage in masculine behaviors that brought me positive non-sexual attention that my Fair Queen title simply did not.

I was still a femme, but enacting femininity came at a price. When I was in high school, I was elected County Fair Queen. It was a title that primarily put me in harm's way by creating a target to prey on for local young men. It did not give me the sort of attention I really wanted from the butches in town who steered clear of me because I was young and so clearly straight. It was a small town, but I still knew who the lesbians were (well at least the butch ones). I wanted them to see something in me that I could not articulate. I felt amazing empathy when I heard about their lives, and I wanted them to see me as one of them. They did not. They never did. I was femme-visible, and they were gender-blind.

My best friend in junior high and I were very close. At some point probably too close to be just friends. I never told her I was lesbian or how I felt about her. She knew, and when she put it all together, she decided she had to tell people. She ended our friendship abruptly and outed me to a good portion of the town. I did not protest. I waited. It did not work. No one believed that a female who looked like me could be a dyke; they instead preferred the stories that I was a slut. Stories told by the young men who cornered me in pick-up trucks and turned reality kisses into rumors of full-fledged sexual encounters. A femme can be a slut, but not a lesbian, not a dyke.

Femme-dar
In some ways, my femme identity is about how I am seen rather than how I feel or behave. There are barriers to visibility as femme lesbians are mistaken for straight women and have to prove to the lesbian community that they are in fact "family" and not just experimenting or curious. As a femme, I also have to explain to men who may inquire as to my availability that I am not available, *and* I am single. I have been told by straight men that I'm not "too far gone" yet as I have not cut my hair. Unlike butch women, I can still be *saved*, or perhaps I'm just bisexual.

My twenty–three–year–old femme self had to come out not by just telling other people that I was lesbian, but by demonstrating through a relationship that I was not merely giving lipstick–service to lesbianism. Coming out to the straight community can be challenging; coming out to the lesbian community as a femme is a whole other puzzle. There are several strategies I have employed over the years:

Strategy 1: Lesbian by association. Find the butchest, most OUT lesbian in the group, and befriend her. Others will assume that you are most likely "family."

Strategy 2: Do away with your fashion sense. Make huge sacrifices in your appearance, and take on androgyny, denying femmeness until the community accepts you. Then and only then do you ease the community into your femininity, lest they mistake your dress for drag. (Tip: avoid making sudden changes on Halloween.)

Strategy 3: Have a *relationship* (not just sex) with a woman. This is easier said than done, if you can't meet anyone because you are still invisible to other lesbians.

Strategy 4: Wear rainbows. Wear t–shirts that say, "2–4–6–8—Do not assume that femmes are straight." Wear buttons that say, "I'm not an ally, I'm family!" Continue to display your sexuality on top of your femme wear, until you can enact Strategy 1 or 3.

Femme–visible
My experience as a femme has meant that it is hard to find the community. I was with a friend who looked somewhere between andro and butch. When we were visiting a medium–sized city, some dykes walked up to her and gave her the 411 on where the lesbian party was that weekend and invited her to be on their softball team.

"You two together?" one of them asked, pointing her chin at me.

"Well, not like that," said my single friend who was seeking a partner.

"Oh, alright, 'cause there aren't really any guys, so not sure what she'll do all night," another piped in.

I had again been read as straight. It was unfortunate because one of those women was so dreamily butch and had gorgeous eyes that could not see me. They do not even see me in the way that men see me, as a piece of meat. To her, I am a non–entity, not even eye candy. All of this is made more difficult by the fact that I completely understand aversion to straight women. I know the heartache of falling for someone who has no interest, or expressing interest only to be shot down when the boyfriend shows up. I understand the caution with which I am seen. This knowledge alleviates no pain.

As it is difficult to find community as a femme, I often find myself opting for online community to make initial contacts. It can be a daunting task. What I was seeking was a butchish lesbian, not necessarily stone or diesel, but I wouldn't have said no. If I am going to be in a relationship in

which I get to let my femme–light shine, my partner has to be willing to butch up to make that space feel safe to me. However, the first responders tend to be bi–curious couples and women who are looking for their first time with a woman who isn't "scary butch." As one misguided woman told me, "You looked harmless." This was insulting, and frankly in the presence of a woman who is more femme than I, I can butch up with the best of them. I pull out chairs, open doors, and swagger instead of sway. It's disturbing to see, I'm sure, but more disturbing to my inner femme who is really just looking for that safe space to be feminine and respected. Not to mention there are many high femmes who could hardly be described as harmless.

During my college years (another experience afforded by class and race), I spent some portion of time feeling invisible. It was not until later that I realized it was not invisibility: it was femme–visibility. I was being read as female/feminine, not lesbian. Being seen in only one dimension. I was discounted by the lesbian community and not at one with the heteronormative society. I wanted to date those amazingly sporty butch soccer players, but they did not talk to women like me. Not because they were rude, but because I didn't play soccer and was in effect femme–visible, or perhaps they were gender–blind.

The Not–Femme–Enough Problem

A femme conference seemed like the perfect place to come out as a femme in my late twenties. The first workshop I attended was titled, "Stalking the Wild Butch." I was early (for a femme). The butches and I were sitting there, and I was sitting there, legs crossed at the knee and feeling quite safe and femme. Then a little past the start time, the high femmes arrived with heels, skirts, hose, makeup, the works. I was no longer read as a femme. In the one space that I thought it was okay to be femme, it was made clear I wasn't femme enough. If you had asked the butches, at best I would have qualified as a baby butch or soft butch but still not a full-fledged late–twenties butch woman; they probably wouldn't have said I was femme either.

The facilitator asked the butches what butch silence means and how do butches speak non–verbally. Silence persisted, and finally the facilitator said let's just go around the room and looked at me. I wanted to pass and say I was a femme, but I clearly did not meet the standards the high femmes had set. I proceeded to put my non–high heel but femme–ish tennis shoe in my mouth by commenting on my own feelings when enacting masculine behavior. Mainly, I said that when I enact masculine behavior, I feel in control, powerful and respected. This was not the right thing to say. One of the high–femme women said, "I feel that way when I use feminine behavior. You're being a butch misogynist!" I had been put in my place and read as butch, for once not straight.

In retrospect, I realized I needed someone to tell my soft–femme (or is it baby–femme) self that coming out as femme is not a smooth road, and that most of us have some internal struggles about femininity. This is not because we are lesbian, but because we live in a society full of sexist assumptions, interpretations, and socialization. I have now reframed it for myself and understand that my reticence in embracing my femme identity is born of many layers of misogyny both in and outside of the lesbian community. It is difficult as a woman, in any space, to feel empowered, and we know this because those moments when we do experience empowerment or respect stand out in stark relief to the rest of our lives. Somehow in my mind what makes being femme safe is being with someone who sees me as a femme dyke, respects that identity, and can enact masculinity when necessary.

What sort of masculinity might one need to enact that I cannot quite accomplish from a femme posture? The first things that come to mind are fashion-bound and not likely to apply to me in femme form anyway. For example, if I'm wearing a skirt, I might not be willing to pick the keys off the floor if I drop them. The lady-like squat that would be required is simply not in my yoga repertoire. Perhaps a better example is outside-community threats. Imagine a hetero man makes a move. The standard response is to insist repeatedly that I am not interested. The ideal response would be for a butch to ask me to dance in a way clearly demonstrating that we do not need a third wheel. If instead of a butch a femme attempts to step in and ask me to dance, the man might believe he can join us.

Another example is if I am really comfortable in my femme-ness, this means that I am usually not quite so vigilant about homophobic others. I am less likely to monitor my display of affection and might be more likely to hold a butch's hand without checking to see if there are any pick-ups with gun racks and anti-gay slogan bumper stickers around. It is nice to have someone else take on that vigilance task (it would be ideal not to live in a world requiring such concerns). In my experience, femme women en masse are less vigilant about homophobic threats than are butch women. Butch women are more likely to incur homophobic-based violence; therefore a butch's vigilance is naturally higher for self-protection. I like knowing that there are butch women in the space keeping watch. If I'm the butchest woman there (that would be a *really* femme sort of place), I immediately become the vigilant watch guard. Overall in order to feel safe enacting femininity, I need to know that someone understands the complexities of what it means to be read as a femme dyke and not just as a woman.

Now, that being said, I must also acknowledge that I feel a strong need (socialization-inspired I am sure) to protect femme women from harm or discomfort. This is known in academic circles as benevolent sexism. When men perform this protection, it implies that women are weaker. When I feel this way, it implies that femininity is weaker. Not something that I want to endorse, but my socialization here is strong and difficult for me to overcome. Butch chivalry doesn't exactly shun this idea either. It is difficult for me, as another femme, to protect femme women in ways that allow me to maintain my femininity and to protect hers as well. There are certainly femmes out there who are fierce and protect their sister femmes with vigor. Somehow when I am fierce, usually in response to feeling threatened, a lifetime of weak moments has taught me that masculinity is my best weapon, and I have not yet learned to use femininity to its full effect.

I want the feminine to be powerful. I want four-inch heels with silencers so no one hears me coming, but they all know I am present. Lipstick that calls attention to my voice and not only my mouth. Curves that have the power to comfort and allow insults to bounce off without the least bruise. Powerful hips that with only a sway cut wide paths through crowds. Femininity that no one dares to touch without permission. Delicate, soft hands that create thunderous orgasms.

Femme-Visible and Separated
The more my body screams woman with the curvy hip, I become a larger target for misogyny, sexism (benevolent and hostile), and even some in-community stereotyping. High heels still strike me as an impediment to speed rather than a way to be taller. Read as femme, I am expected to want to hang out with other femmes, and that we will have some common interest. I am not

welcome at the butch poker night, unless I bring snacks. I am not asked to carry anything too heavy, and I'm expected to help with the dishes. No one expects that I have worked construction, and sadly no one ever expects me to strap-on. Some people would go so far as to say that if I do not enjoy doing dishes and want to strap on, then I might not even qualify as femme. I'm pretty sure there are plenty of femme tops with maids who would disagree.

If my partner and I went out with another couple, there is an expectation that my partner and the butcher of the other couple will go chat, drink beer, stare under a hood, or fix something while the femmes do whatever it is that femmes do. This cannot be stated without also acknowledging the long history of butch/femme community in which the segregation of butch and femme women served many purposes and provided unique types of support to women of both genders. However, I still long to know what they are talking about and dislike being in segregated butch/femme environments. I like everything about the butch/femme dynamic and the way it allows for expression of gender in our lives and our relationships. I do not believe they are just "roles" that we play. I like when there is butch/femme *interaction*.

I have little interest in allowing these differing gender expressions to segregate me from butch women who move about in this world (and our community) with more power simply because their masculinity renders them visible. I have been rejected from too many masculine environments (dominated by bio-men, transmen, butch women, etc.) with negative consequences for my own opportunities to have my social space integrated. I believe that masculine and feminine are both powerful gender expressions in their own right. Integrated spaces that are inclusive of the two (and all of the gender expressions between) create a synergy in the queer community that feels to me the most like home, family, and freedom. Spaces where I am seen as I am.

Some say they do not see—or worse, do not "believe in" butch/femme. When unseeing people render me and others invisible because of class, race, sex, gender, or sexual orientation, the outcomes can be dire. Relationships with people who claim that they do not see "race" or "gender expression," or only "woman," can be painful for those who live in bodies where our race, class, sex, gender expression, butchness, or femmeness are essential to our self-identity. When people say they love the person but not the gender or the race, I find it painful to think that they do not love the person because of all the things that constitute that person, *including* sex, gender, class, race, and orientation. Color-blind approaches did not end racism, and sexual orientation-blind approaches will not end heterosexism. The lesbian-as-androgyne 1970s did not render us genderless. Denying that I am a femme won't de-femme me any more than telling a stone butch you do not think of her as "butch" will de-butchify her.

Visibility is not just about being seen as a person, but about being seen as the person you are. Until we can see each other *as we are*, we are not only invisible but blind.

Meet Me on the Mobius Strip
by Carol Mirakove

The Self-Fulfilling Prophecy

If a child is encouraged, she is more likely to excel. If an adolescent is treated like a criminal, she is more likely to engage crime. If a woman is taken as straight, she is more likely to couple with a man.

Girls Will Be Men

Growing up my girlfriends and I were big on sleepovers. We indulged the perennial favorite "truth or dare" as well as video games, virgin Jell-O shots, and contests to see who could stay up all night to catch *The Smurfs* the next morning. One time when I was nine years old, I slept over my friend Elizabeth's house, and she proposed that the two of us play a new game. There would be a script with two parts: one, a man named Pierre, and the other, a woman without a name. We would take turns playing each part. Elizabeth took tissues and wadded them up, taping them into a mound. Whoever would play Pierre would make such a mound and stick it down her pants. We would press it against us and figure out our female parts.

It was a dangerous proposal. We knew it would have to be secret from all of our friends. It was exciting. It seemed exotic to adopt the persona of a French man. It seemed exotic to adopt the persona of a woman without a name.

We were slow to come up with story lines, and I grew impatient with the effort required to generate a script. The formality of dialogue seemed merely an excuse-of-a-vehicle towards sexual experimentation. I wanted to get on with it. We pretended that we were preparing each other for being sexual with men, but I, for one, was completely in the moment of being with another girl.

Elizabeth was clever in creating French characters; as such, it seemed that what were doing was far outside of "real life" and that we could act without consequence. The mornings after, for example, we would hit double-dutch sessions without missing a beat.

Elizabeth and I had pretend-sex on three consecutive sleepovers.

The next time I slept over, Elizabeth said she didn't want to do it anymore. I shrugged it off like her shift was no big deal. The truth is, I laid awake for hours processing my disappointment.

I declined future invitations to sleep over her house.

"All I Want Is Boundless Love"[1]

I dated a slew of boys throughout junior high and high school with my first boyfriend at the age of

1. Frank O'Hara. "Meditations in an Emergency." *The Collected Poems of Frank O'Hara*. Berkeley: University of California Press, 1995: 197.

ten. I was perfectly comfortable dating boys. It didn't occur to me that my reality could or should be different, my allure to Elizabeth notwithstanding.

In the 1980s, when I was in high school, the AIDS epidemic made headlines. Everyone was talking about the disease and about gay people. I didn't know any gay people. I began to catch comments about gay men being sex–centric. No one talked of gay women; gay women were doubly discounted. As in mainstream culture, women are fundamentally secondary to men, and homosexuals are secondary to heterosexuals, such that lesbians weren't even visible in high–level household conversations about gay culture.

I couldn't make sense of the implication that an entire segment of the human population—gay men—were interested only in sex while everyone else was supposedly more evolved as to require love. This disparity prompted me to question what it could mean to be gay. I knew of same–sex attraction, and I already had a substantial history as a heterosexual. From this duality in myself, I began to ask my parents, "Isn't everyone potentially bisexual?"

I would ask this question of my parents for years until they died in my early twenties. It speaks to their great credit that I could ask this question over and over in earnest. It speaks to my naiveté that I didn't realize what a lightning rod I was asking them to engage.

My parents weren't culturally liberal, but they were thoroughly loving. They had weathered religious differences in their coming together: my father's family did not attend their wedding (held in my mother's church), and my mother's family broke off communication after they baptized my brother in my father's church, converting their family from there on out to his religion. Fortunately, my parents' families did after some years reconcile, but the tension was always present. From the senseless divisions between my parents' families, I derived that we err gravely when we fail to realize that true love is boundless.

In my youth, it made sense to apply this principle to the sexes. Women could love women, and women could love men, and men could love women, and men could love men. I leveraged my family's fighting in asking my parents again and again that if we love people for who they are and not for their pedigree information, then, "Isn't everyone potentially bisexual?"

Stating the Obvious
I've always taken for granted that everyone regards women as more beautiful than men. I thought it was normal for a woman who was with a man to be excited by women. I thought everyone was excited by women. I didn't think that my attraction to women bore a necessary conclusion that I should be with women. I never thought any of this meant that I was gay. I would later come to understand all of this to mean that indeed I AM GAY.

I didn't know any gay women who looked like me. Gay women I thought had short hair, didn't wear makeup, wore simple or loose clothes, and flat shoes. My hair length has varied, but I've always worn makeup and treated fashion like a hobby, favoring form–fitting clothes and sassy footwear. I thought women who looked like me partnered with men.

I tend not to feel entitled to things. I wonder whether or not this sensibility is somewhat common among women. In conventional households, women dwell in the kitchen (shared space) while men dwell in the den (private space, with dad controlling the TV selection). I fantasized about sexual encounters with women, but I didn't feel entitled to be with women. I felt it was given to me to be straight. While I was unclear as to whether or not it was my true nature to be straight, it was—and is—my true inclination to be femme.

From time to time, I did wonder if I was gay, but I couldn't make sense of myself as a lesbian. Because I didn't "look" gay, even if I did have the courage to come out, I felt I lacked credibility as a lesbian. It seemed to me that "real" lesbians who were "out" prima facie would probably see me as reinscribing the hetero-dominated status quo, contributing nothing to the range of how we as women present ourselves.

"You Actually Have the Courage to Tell People And They Say, 'I Don't Think You Are Gay'"[2]
I spent my twenties in two consecutive long-term relationships with men. Both relationships were meaningful and substantial. Neither was sustainable. After the second one dissolved, I started dating women.

In my foray to dating women, I thought I should date specifically bisexuals. I thought that my history with men and my femme inclinations would render me a liability to lesbians. I thought that I would be taken as an experimenter. If I looked overtly feminine…If I had a history with men…I couldn't be veritably gay. It seemed right to identify as bisexual.

I was very, very, very excited for my first date with a woman. I wanted to tell everyone. You know when you feel like you've finally done right by yourself, and you feel like you're reaching your potential? It was like that.

She was hot, she was cool, she had long dark hair, and she wore a cropped leather motor-racing jacket: she was femme, and she was tough. She seemed like a great prospect. But I quickly learned that she had a penchant for casual sex, and because she wanted no strings, she resented when men automatically assumed that she as a woman was after a relationships. I then had to confront a grim reality: no-strings sex was not my thing. I couldn't bring myself to kiss her because the Virgo in me did not want to swap spit with her extensive catalog of paramours. Shit.

The bisexual women I proceeded to meet invariably spoke of men in substantial measures, which posed for me a disconnect; I wanted to date a woman, and I wanted a woman who wanted to date a woman. I began to think that I was on the wrong trail.

I knew I was gay, but I didn't know how to construct a compelling case. Lacking a history with women, I had no proof of my gayness. My appearance was not going to make my case. I felt lost. I resumed dating men.

After some time, I burned out on self-betrayal, and I sought again to meet other queer women. This time I would identify as a lesbian, and I would look for other lesbians.

2. Portia de Rossi. "Portia heart & soul." *The Advocate*. 946 (13 September 2005).

I met a femme. She was very romantic and soft and pink and pretty. Being with her, I understood "the gape," which a male friend once tried to explain to me: you can look at woman and fall completely jaw–dropped and stupid. I took my gape–inducer to two art installations, a Mariko Mori exhibit at which we crawled into a space–pod and a Gilbert and George exhibit in Chelsea. Our exchanges throughout the afternoon were smart, generous, and dreamy.

Despite this chemistry, and even though I believed that I designed a fairly exceptional outing, I felt like everything I did was wrong. Her femme–on–a–first–date presentation entailed gentle, curly hair, minimal makeup, Birkenstocks, jeans, and a soft, white sweater; mine entailed an up–do, platform boots, tight black pants, and a yellow–and–orange sparkly Custo Barcelona top. Given her natural style, I sensed that my trash–glam dress may have presented a clash (however appropriate for Mariko Mori).

When I quickly hailed a cab in the rain and I got in before her—rather than seeing her in—I got the sense that she expected a more conscientious courtship. When we entered the gallery and I held the door behind me—rather than holding the door for her—I got the sense that I was not honoring her ladyness. I wondered if there was room for two femmes in a coupling. Despite these awkward elements, I felt googly–eyed over her, and I sent her a "let's hang out again" email.

I never heard back. I felt convinced that I wasn't going to make it as a lesbian. Significantly, I was crushed to be denied common courtesy from a woman. I wasn't prepared for that kind of disappointment.

I expected more from women.

Not willing to risk another deep disappointment, I again resumed dating men. After a spell, I got back on the mare. I met another woman who, like me, had a substantial history with men and who, like me, proclaimed she was now clear on her future being with women. We connected in variously meaningful ways, personally, and professionally, as teachers. We spoke of love and betrayal, we spoke of our tricks in entertaining our students, we spoke of our belief in the kids and our frustration with the system. We planned to collaborate on our curriculum maps. And then she flatly flaked on me. It was a real blow.

These highlights from a five–year stretch show that I would cyclically assert myself as a lesbian and then retreat to suspicions that I was not valid in lesbian culture. I feared that my feminine appearance disqualified me from participating in a community of strong women. I figured that because I passed as a straight woman, I was doing nothing to buck oppressive cultural norms.

I felt like I was the only one who knew I was gay. And that was not enough.

"We'll Meet on a Mobius Strip. They'll Never Find Us."
Last year I met my love. She sent me the above proposal in an email when we were longing to break out of work and to steal time away together.

I fell in love with her in an afternoon. Even if it would be unrequited love, there would be no turning back. It was July. It was blazing hot. People all over the city were watching the World Cup

while a small group of us gathered at a poetry club for a book party. She played her guitar, sang, and read poems. Her cheekbones made me want to believe in God.

I counted blessings that on a hot summer day, I got to sit in a cool space and to stare at this beautiful woman, taking in her beautiful voice, smiling at her endearing modesty and reveling in her minimalist tendencies. She was stunning. She wasn't obviously straight or gay; she had long hair, but she wore a thick, simple belt and boxy, cuffed jeans; she wore eyeshadow, but her shirt resembled that of an auto mechanic. Fortunately, the content of her art provided me with signs: she had written a song for Aimée and Jaguar, and she read a poem about The Defense of Marriage Act. I felt safe to assume she was gay.

And I made a point to meet her. And we became fast friends. And I knew I had to be with her.

I did worry that she would think me too girly to take seriously as anything more than a friend. But this time it had to be different; I had to find the courage to assert unwaveringly that I was gay. For two summer months we spent all kinds of ostensibly platonic time together. One night I got up the nerve to kiss her. Her immediate response was, "I didn't know if you were comfortable with women." Her words hit like a punch to the gut. I had discovered my fears to be true. I wasn't a veritable lesbian. But because it was clear to me that we were in love, I was able to stand up and say, "I am totally comfortable with women."

At the time I am writing this essay, six months have elapsed since that first kiss, and we are blissfully together. Six months may not sound like a lot, but when they are the best six months of your life, they are tremendous.

I needed love to make sense of who I am. There is now one other person who knows how gay I really am. It's a start.

I Know You Are (But What Am I?)
by Stacia Seaman

A few years ago, I watched *Solaris*, the remake. The movie centers on a planet that is able to sense strong emotions, such as loss and need, in visitors, and it feeds these emotions by sending the visitors a loved one, someone who is lost to them and whom they miss. The catch: these are not duplicates of the loved ones but are facsimiles based solely on the visitors' memories and perceptions of them. The planet cannot imbue these facsimiles with anything it cannot learn from the thoughts and emotions of the visitors.

The more I thought about this storyline, the more interesting it was to me. Can anyone really know another person? To my friends, am I really *me*, or am I simply the memories and emotions—their own—that they associate with me? What is *identity* really? How much of it comes from within us, and how much from others' reactions to us?

For most of my life, I identified as straight. It never occurred to me to question my heterosexuality. I was raised by a single mother and was surrounded by strong, independent women. I went to an all–girls, Catholic school. My idols, my role models, have always been women. My closest relationships—the strongest emotional bonds—have always been with women, and it never occurred to me that these bonds weren't the norm.

I grew up in Texas, home of the beauty queens, where there's a strong emphasis on improving one's appearance by means of cosmetics, hair products, and rhinestones. I have very fair, very sensitive skin, and very straight hair, so even if I'd wanted to go the Miss Heart of Texas route, I would have had a difficult time of it. As it happens, my mother was a very down–to–earth woman who encouraged me to go for the natural look. "If they can tell you've got makeup on," she'd say, "then you're doing something wrong."

My stepmother was the polar opposite of my mother. Appearances were supremely important to her to the point of obsession. During my teenage years, she nagged me constantly to change my appearance. To pay more attention to the latest trends. To wear more makeup, to wear tighter clothing. To be more feminine.

My mother, thank goodness, gently reassured me that I was doing just fine on my own. She'd tell me, "Sexy is being comfortable in your own skin." Most of the time, this advice had me swimming against the tide: when jeans were supposed to be skintight, I wore men's 501s; when jeans were supposed to be flared, I wore men's 501s; when jeans were supposed to be low–waisted, I wore men's 501s.

I went with what fit me, with what was comfortable. Still, my stepmother's criticisms stayed with me. Yes, I was happy with how I looked, but somewhere along the line, I accepted that I wasn't particularly feminine. That I was, somehow, a tomboy—albeit one who read books and did needlepoint rather than skateboarded with my brothers.

And so it was with sexuality. Without realizing it, I had created a sexual identity based on what people expected of me, not what I actually was. Like the facsimiles in *Solaris*, my reactions were based on the perceptions and expectations of others rather than on anything that came from inside me.

I was comfortable dating guys because that's what I knew. There was always an undercurrent of dissatisfaction there—I always knew that whomever I was dating wasn't the one I wanted to be with for all time—but I assumed that was because I just hadn't met the right guy. It never occurred to me that the problem was I needed to meet the right girl.

My friends included butches, bois, and any number of fags—people whose appearance, in part, defined their sexuality. I always admired their bravery: they looked different; they *were* different; and they weren't going to bow to any pressure to change who they were. In some ways, they were forced into self-discovery. I, on the other hand, though I wasn't ultra-feminine, was feminine enough to fit society's stereotypes: I had long hair and manicured nails. I wore makeup and jewelry. My clothes were obviously designed for women. There was never any external reason for me to question my orientation, and so I never did.

That's all it would have taken—the smallest nudge. When I was in college, experimentation was not only encouraged, it was expected. I kissed several women—including a few whom, in hindsight, I had fairly serious crushes on. Back then, I perceived it as friendship and admiration; I was completely unaware there was a sexual component to my feelings. If just one of these women had pushed things, had asked me for more than just a kiss, my life would have been totally different. There's no doubt in my mind that I would have said yes, and something inside me would have unlocked then. Instead, I laughed; I rolled my eyes at the wolf whistles and catcalls and went on assuming I was straight.

This pattern finally changed when I was having a conversation with my closest friend. She's a lot like me—the oldest daughter, Catholic family, voracious reader—and we'd bonded instantly when we met at college. Back when we were seventeen, we'd had lengthy discussions on the nature of sexuality. She was of the belief that most people are bisexual, but whether consciously or unconsciously, choose not to explore that side of themselves.

Years after we'd graduated, after she was married, we were discussing a television show, and she mentioned her attraction to the lead character. I didn't admit it to her at the time, but I was stunned. Just her use of that phrase—"I'm attracted to her"—made me question so much of what I'd taken for granted for so long. Suddenly I was able to see clearly that what I had viewed as hero worship, admiration, and respect had another component: attraction. The more I thought about it, the more it made sense, and finally I decided it was something I needed to explore.

I like science fiction, so when I heard that Gaylaxicon would take place near where I lived, it seemed like a good place to start. And it was. I figured I'd be comfortable with the science fiction aspect of things; what surprised me was how comfortable I was with the gayness of the convention. I didn't quite fit in, but I didn't feel like a total outsider either. I made some good friends there, including a woman who helped me to sort through all of the conflicting emotions and reactions I'd been dealing with for months. She took me seriously, and she understood that

I wasn't just experimenting, that I was struggling with the idea that I wasn't who I had always thought I was. That everything I thought I knew about myself was open for question, and that I was going to determine who I was from within this time, based on my feelings, my needs—not what others expected of me.

Yet I still find myself in the same trap, like I'm caught between worlds. I belong to a subculture that perceives me as feminine even when mainstream culture does not: although I'm not conforming to society's ideal of a feminine woman, I'm perceived as being too conventionally feminine to be gay. The criticism is the same from my straight and my gay friends: I'm not trying hard enough to look a certain way. The problem is, the "certain way" each group speaks of is the opposite of the other. There doesn't seem to be any room in the middle.

Last year, I went to a wine and cheese party. I was dressed in my usual fashion: tank top under a cardigan, jeans, Danish clogs. I was somewhat worried that I wasn't dressed up enough; other women were in pantsuits or blazers over trousers. It wasn't until I'd been there for over an hour that one of the women I'd been chitchatting with said, "Oh wow, you *are* a lesbian." Even at a lesbian fundraiser, people assumed I was straight. As we left, my friend said to me, "It's because you're not in a dress." Ah, the irony. The one occasion when I wasn't femme enough!

About two months later, a butch told me she'd never thought of me as anything other than a femme lesbian. She was the first person who saw me for what I was, from our very first meeting. Is that because she assumed I was what she wanted me to be? Or was it because of my reactions to her? Or was it that perfect moment when the two were one and the same, when identity equals perception, the femme interested in the butch?

I don't know, and I don't care. All I know is I'm finally secure in who I am, and I'm with a strong, independent butch who both affirms and supports my identity as a strong, independent femme lesbian. I only wish I'd met someone like her when I was younger.

Some Femmes Don't Wear Heels
by Joshua Bastian Cole

The Social Map of the Femme Trannyfag
Most femmes are invisible queers, right? Well, how about a transitioned FTM who passes full-time as male and part-time as straight? Talk about invisible!

I am assumed to be a great many things, none of which is femme.

My experience as a femme is, in a way, the reverse from that of many femmes, and not just because I'm a boi. The visibility, or rather, the lack thereof, for femme women boils down to perceivable queerness. It's the queerness that gets lost in assumptions, but not the femmeness. That part is often clear. But not for me.

Once someone gets to know me well, my femmeness is unmistakable. To look at me, though, most people see just a guy; "guy" does not mean the same thing as "femme" to them. Of course they are different things, but my point—my reality—is that one can be both things at the same time.

I am living proof, as are many other femme men, trans or not.

To a surprising number of people, queer and non-queer alike, the word *femme* brings certain images to mind, such as: long hair, dresses, heels, lipstick, maybe fishnets. Perhaps other words arrive as nouns to follow femme as an adjective: *woman, womyn, girl, grrrl, lesbian, dyke.*

None of those are words for me. How many people, I wonder, immediately come up with words like *man, fag, goatee, pomade, cologne,* or *bottom*? How about *metrosexual*? Try this one on for size: *straight*. Need I clarify that it is possible for a transman who passes and dates women to still be femme, still be queer, while simultaneously being hetero-identified? It is not only possible; it exists.

Personally, I don't identify as straight per se, though I sometimes date women. Primarily, I date other transmen. Due to my lack of interest in the flirtations of non-transmen, along with my very boy-like masculine energy, gay men tend to think I am not gay. However, my clearly effeminate behaviors and my snazzy clothes lead many women to assume that I am gay. When I out myself as trans, both men and women conclude that my effeminacy is only residual "girlyness" from my former self, and that I must be some sort of lesbian and therefore must be into dating lesbians. Whether or not it is in those words, that is the popular train of thought. It happens time and again, except for one demographic: many lesbians do not have this thought pattern, concluding that I am anything but one from their queer community, and that if I ever was, I am now a sellout or a traitor to male privilege. This group often assumes that I must date straight women and that I must not be at all related to the queer world because I now blend in with the straight and straight-acting populus.

My trans brothers make a different set of assumptions. Most of them pick up on the femme thing right away, but similar to non–trans folks, they do not label it "femme" because to many transmen, "femme" means their girlfriends. In general, transmen think I'm gay, meaning that they think I date non–transmen.

Very rarely has anyone said to me, "Let me guess: you are a femme trannyfag," and never has the speaker been non–queer, non–trans.

Now, certainly there are a great many femmes out there who recognize and acknowledge that there are masculine femmes, and that *femme* does not necessarily mean *feminine*. Of these, shall I say, more aware femmes, some like to use femme as a gender, as it obviously has nothing or little to do with sexual identity or sexual orientation (although the term varies somewhat of course in usage per individual).

Identity Recipes, Peer Politics
Gender identity, or any identity for that matter, comes from two main sources. The first, and more important of the two, is one's self–identity: the person who is there when no one else is, eyes closed and alone, regardless of physical attributes, presentational modifiers, and performative behaviors. Who are you?

The second source is one's peer group. Whom do you surround yourself with, and why are you friends with them? One usually finds commonality and support among groups with similar interests. A sense of safety underlies immersion in a shared experience. There is less fear of misunderstanding and mockery. As with anything else, peer groups can change. Because they are so closely linked to self–identity, they are equally fluid. That is why people "grow out of" one another. Sometimes peer groups can evolve if everyone changes at the same time.

My peer group has recently mutated and expanded. I didn't come out as a femme until after I came out as trans. I discovered being femme along the path of my transition. Upon initially coming out and meeting other transguys, I found I had more in common with the femme girlfriends of the guys I met than I did with the guys themselves. Besides the trans–specific conversations I had with the guys, I much preferred discussing with the women things like shopping, dancing, pop culture, hair and skin care, and clothes, to things like beer, motorcycles, being a sex top, and other things the guys I met liked to discuss often. The group of transguys I met was comprised of guys with a rugged, conventional type of masculinity, having recently emerged from experiences as butch lesbians. This crowd liked hiking, camping, and football.

My peer group remained virtually unchanged from the time before coming out as trans to the time after it. I was surrounding myself with queer femme women, our commonality being that we were all queer femmes, though not all of us women. My only significant difference with this group was that these femmes were dating my transguy friends and were not dating women. This dynamic—as any partner of a transguy can tell you—is very significant. Being partnered to a transman heightens their invisibility as queer because they are then seen as a woman dating a man, and thus presumably heterosexual. Looking like a straight woman was not a concern of mine, but dishing about cute bois was certainly always a fun time had by all.

For several years, my peer group and these dynamics remained the same until this past year when I was forced to interact with a larger set of people in my workplace. I was surprised to find similarities between myself and the people I work with because I have never put myself in male spaces. I never felt comfortable in them because I never felt those places could be my space to share. I do not feel that I am the same as assigned males, and so in male spaces, I feel that am an outsider. It is usually a feeling I create myself, as many non-transmen who are trans allies have been very welcoming.

Trendy Men: How To Subvert a Perfectly Good Gaydar
My current job is in a higher-end fashion retail store, a large chain that is known for an image of clothing for clean-cut, exceptionally good-looking, rich business people. There is a high expectation of staff to posses a groomed masculine image in the store. With such an emphasis placed on looking good and creating interesting, fashionable wardrobe options, I expected many of my male coworkers to be gay, but surprisingly, I found that not to be the case.

It is not a secret that gay men dominate the fashion industry, and that different companies have different looks to match their overall images. Bluntly the image of my store is, perhaps, a bit too fancy for the typical straight man. The level of detail in the clothes and the outfit combinations are things that I have rarely seen straight men wear. It is not the typical straight man who considers accessorizing and creating an entire wardrobe, even in the age of post-metrosexuality.

I have worked in clothing retail before, and I have been in the queer community for quite a while. I know the cultures and behaviors associated with both worlds. To my surprise, I came to my current workplace, which is filled with effeminate men who actually did their hair in the morning and thought about which socks matched their belts and shoes; they date women! My own comfort levels in my femme presentation have been strengthened by seeing so many men present in a way that at one time was perceived to be characteristic of only gay men. It's been a welcome surprise to be in a space where I can match the men around me.

To the everyday type of straight men at my job, I am completely invisible because many of them do not perceive anything of the queer world. I have been horrified by some comments that have been made by these men who have not realized that I do not share their experiences, nor do I share their opinions of women in particular. In a different, less fashionable job, I found myself in the midst of a group of straight guys, all of them all kinds of stereotypical and overcompensatingly masculine; I, the transguy, the one not assigned male, noticed the desired machismo of this particular group of non-transmen. They used wonderfully disgusting if not colorful nicknames for female body parts. I was simply horrified and felt it unsafe to be the odd one out, though I desperately wanted to be the awesome feminist and say something. It is not always the right thing to do if it is potentially dangerous. I said nothing and hoped it would not happen again in my life.

But men and their power do exist in other places. A fellow coworker in my current job blindly suggested "rocking out with your cock out" to myself and a roomful of women. While I get the joke and don't mind the comment in certain spaces, I was disgusted. I, once more, felt insecure approaching the situation myself, though I eventually reported it to management.

There are women, too, in my workplace, and though they present femme, its meaning is lost because, in their case, femme is not a consciously chosen representation of their identities. If you were to ask them why they present as they do, their answers would have very little to do with complex identity politics. Their answers would likely be about what flatters their bodies—and maybe that's really all it has to be. But then, that wouldn't be what being a femme is about, and that is why my non-queer female coworkers are just female, just women, though they look like femme women I know.

Our queer society is no longer so highly recognizable: its constituents' gaydar now encounters metro men, urban-chic women, gay transmen, boydyke transgirls, straight-men hipsters in jeans so tiny they might as well be tights, and Monique Coleman wearing a bow-tie in *High School Musical 3*. Inside and outside the queer community, we're all missing the sexual identity targets we thought could be hit by presentation alone. It's getting to the point queers have been yelling about for ages: you can't tell how someone self-identifies just by looking—you'll have to ask.

The world is slowly getting mushier.

A Place I Know
by Sheila Hart Nelson

I am going to tell you something I tell few people; I was a little boy, once, too. Before you look at me now and decide that I'm doing some weird co-opting thing, let me be clear. I am not joking. On the wall of my grandmother's house in Jersey are two framed pictures that have hung as long as I can remember. One is of my older sister who wanted to be a fairy princess when she grew up, posing fetchingly in my aunt's silk slip, complete with lace and a big hat with bows and perfect little blond curls. The other picture is of me dangling over the stone wall at the mudhole where we swam, wearing a tiny flannel shirt, denim overalls and my favorite baseball cap jammed low over my perfect brown bowl cut.

I wasn't really a tomboy, not in that slightly precious sense, like, it's–just–a–phase or she'll eventually become a lovely swan or a beautiful butterfly. Take one look at that picture, and it is clear that my future as butterfly or a swan was seriously in doubt. I wasn't cute, just awkward and confusing; from all the kids in Mrs. Rimbauch's third–grade class who asked if I was sure I was a girl, to the shoe clerk at the department store who looked at the perfect purple Velcro sneakers I presented and said, "Oh honey, you don't want those shoes. Those are girl's shoes." I don't remember my answers; maybe I was ashamed that they saw me as a boy, but the fear of actually having to be a little girl was so much worse. My father made sure I knew this from birth, and my mother's desperation was not something to which I aspired. Little girls got held down. Women did not get back up.

If you want the moment it changed, I cannot give it to you. There never were butterflies; there was no epiphany. This is not the second coming of Mary Magdalene. Maybe it was because at eleven the body I had counted on to hide me took away all my choices, and all my sullen, hunch–shouldered defiance made no difference. Now I look at the wide wine–colored fans of my stretch marks and think, even my skin resisted. This is not an awakening story, where you showed me the self I had always been, although I remember looking at my first butch lover's sleeping body and thinking, if you are something, maybe I am something too. When she woke up and told me what she thought I was, we had a screaming fight, forgetting that fighting something passionately is usually the best indication of passion that there is.

When I finally stopped fighting, I found out you already had all the best names. In my time I have known, sometimes biblically, stone butches, soft butches, butch boy/bois, tranny boys, tranny fags and plenty of genderfuckers who are still waiting to get back to me.

What does it mean that we've been right next to you since the beginning, got rounded up in the same bars as you, got thrown out of the women's movement with you, asked back, and thrown out again, heard too that we are perpetuating patriarchy, playing into roles, holding the community back, too radical, not radical enough or only doing it to be cool, and we still only have one damn name? I realize you could argue that high femme is a variation, except that our quotient apparently ran out before we even got to medium or low.

I am telling you that I need a name or at least a modifier, because right now femme is what I am, but I do not know how to keep it from being made for me into something that I am not. I have let femme become the clothes that I often don't want to wear and which usually don't fit me, the mascara brush I still stick in my eye accidentally, the cute purses I just forget in restaurants. I have let femme mean cute and pretty, which I know I am not, and beautiful, which I have never known myself to be.

I have let femme describe a woman who looks good against you, who commands your attention, a woman you have looked past me to see. When you do this, I feel I am failing at being myself. I want to say, I am femme like a fishwife, femme like coal miners' daughters are femme. I am femme like the rural Appalachian women of my childhood who knew how to stay strong and still in full times and in hunger, in drought and flood. I want to say, look for me in the details, when I lean my hip against the sink, the places where my thighs have rubbed my jeans soft and white, all the times you have sat at my kitchen table in the warmth and eaten well.

If I said, the most feminine place on my body is the curve between my wrist and the base of my thumb, could you forgive that my hands are bigger and stronger that yours?

I need you to do more than overlook these things. If you need a contrasting color to show up in the light, I cannot be that for you. You are kidding yourself if you think it is that easy. Yes, this is a place I know from loving you, but do not assume that you know the road to get here. It is a stunning act of faith to desire in another those things that once marked the shame of what we could not be. In you I see the fulfillment of what I gave away, and when I reach out in the night and put my hand on your skin, I think I am making love to all that I did not become.

And if you were ever a little girl and you think of her when you slide against me, I want to tell you that I hold that precious. Because it is in the space between us that I can both love the little boy/girl I was and let her go without loss or remorse. But I have kept things too, and you need to hold them just as carefully and tightly.

I cannot be your perfect other. I will probably never manage to be your princess. But I can be your sanctuary, your kitchen table, your good earth. And the meaning of all earth is the promise of fulfillment under your hand.

Journey to Femme
by Emjāen Fetherston-Power

I came out in the early 1990s, at a time when it seemed like no one who was anyone was femme. I went to my first Midsumma Gay & Lesbian Carnival in '93, when lesbian separatists were still around and still going strong, and bisexuals and non-drag queen-transfolk were unheard of. The place was packed, and I was the only female there in a dress, the only female there wearing makeup, and the only female there with long hair. I remember sitting in front of a stage of bad but politically-correct "women's" music, and the singer yelling, *"hands up all the lesbians"* (this was before the days of queer, remember). The looks I got—ranging from disbelief to death stares—made their message all too clear. To be a real lesbian was to look "like one"—and that meant not looking femme. More the fool me, I bought it. A couple of weeks later I shaved my head, stowed away my dresses and (most of) my lingerie, and went shopping for t-shirts, jeans, singlets and Docs.

I realized that I had made the "right" decision as I witnessed lesbians on campus ostracize the only self-identified femme on the uni Women's Collective. Other lesbians omitted her from all party invitations and never gave her the choice tasks. She was always treated as the outsider. The prevailing wisdom was that, as a femme, she was not (and could never be) a "real" lesbian or a "real" feminist. Her makeup, long hair, heels and dresses were subject to constant ridicule and criticism, though never to her face. After all, we *were* civilized.

I have to admit I joined in. I was afraid. I was cowardly. In coming out, I had already lost family and friends, and here I was accepted, desired and valued. I didn't want to be excluded.

A couple of years passed. Pushing aside the feeling that I wasn't being true to myself, I had bought into all those femme stereotypes. We've all heard them. We all know them. Femmes as trying to "pass" as straight, femmes as housewives. Butch/femme as mimicking straight nuclear families, as try-hard heterosexuals, with femmes as inferior and butches as superior. Femmes as asexual or sexually passive. Femmes as sexually submissive. Femmes as the antithesis to feminist. Above all else, I bought into the notion of femme as inferior. If this was what femme meant, I didn't want it.

I like to read—big surprise, this one! During this time I kept reading—and not just the prescribed uni texts. I discovered Barbara Findlen and Arlene Stein. I found Minnie Bruce Pratt and Lesléa Newman. I devoured Leslie Feinberg and Pat Califia. I read and reread Joan Nestle, every femme's heroine. These writers saved my life. These writers showed me—or should I say, reminded me—of the strength of femme. That the stereotypes were no more than that—stereotypes. They reminded me that as a femme, I could be strong, beautiful, articulate, powerful, sexy, feminist, and courageous—if I chose to be. They reminded me that femme was intentionally feminine, not a product of society's straight and male-centered expectations.

Above all else, these writers reminded me that femme could be sexual, chosen, contemporary, intentional, and active. I discovered that these ideas even had a name and identity: PowerFemme. So after all those years of trying to walk away from being and identifying as femme, here I am:

Femme, High Femme and PowerFemme at that. It's in the way I walk, the way I talk, how I dress, who turns me on. It's who and what I am. The older I get, the stronger my femme identity and femme pride grows.

There are days when it's hard. I get tired of the invisibility that is somehow rendered by my femme presentation. All too often, lesbians look through me as "another straight chick," and straight folk see me as one of them. All too often men think I'm available for their consumption. The stereotype says this is "trying to pass." Bullshit! That's the last thing I want, but I don't see why I should have to confine myself to some narrow box to be visible. I like the way I can educate from inside. I like to shock. And quite frankly, I like dresses and heels and makeup and lingerie. I like dressing up and performing femme. I love my femme energy, my femme strength and my femme power.

While things have come a long way since the 1990s, I find there is still a lack of acceptance for femme in the wider queer community. The stereotypes continue to prevail, though it makes me happy and proud when I see, among the newly-out queers, baby butches and baby femmes. I like it when I go out and see other femmes all frocked up—be they female, male, or trans—but we continue to be few and far between. I find myself made most welcome in the queer and leather communities. Frankly, it is—and always has been—in the lesbian so-called community that I continue to feel least wanted, least desired, and least valued. I'm tired of the lesbian nation doing its goddamned unsisterly best to make me feel bad for finding Self, a sense of identity in being a femme…and pleasure.

Let's be clear about pleasure. A woman in lingerie and dresses doesn't excite me. Femme girls just don't do it for me, and men do even less. I get off on grrrl bits on a nearly-boi body. I get off on that same woman's body either as a boi or dressed in nothing but a cock and a cunt, just for her lover. Give me a kinky boi, genderqueer, androgyne or butch: they'll make my cunt do backflips, not to mention my heart. What attracts me is their soft, strong multigendered energy. How these so-named "women" view and define themselves doesn't really matter; what counts is the chemistry that joins us cunt-to-cunt even when we're not touching, and even when the bits don't quite match. When you get down to it, what I'm attracted to is the multigendered masculine qualities of butches and genderqueers because these qualities serve to emphasize their beauty.

This eroticism doesn't make me straight or bi. With men and femmes, I become a non-orgasmic, asexual creature whom no lover of mine would ever recognize. But with a trans or butch, I'm me, I'm sexy, I'm femme, I'm wild, I'm alive. The key is that I get off on genderqueers above and beyond all else—those butches, bois, and transfolk who don't get a choice but to be differently fe/male and to genderfuck because that's who they are.

I'm a queer. I'm a femme. And if you're who I think you are, I doubt you've got a problem with that.

Femme–Lesbian Autobiography, or
How Can You be Certain That You are *That Way*
by Yael Mishali

"I do not know if sex is an illusion
I do not know
who I was when I did those things

or who I said I was

or whether I willed to feel
what I had read about
or who in fact there was with me

or whether I knew, even then
that there was doubt about these things."
—Adrienne Rich, "Dialogue"

If sex is an illusion, why does it matter whom we do it with?

I experience this illusion as well, over and over again—who was I when I was with a man six years after coming out of the closet? Could I have missed what was in my closet and was still my size? But, I could no longer enter the closet, or even open it to take something out. I never saw myself as straight, and still, there was a time in my life in which I had countless opportunities to start sentences with the words, "my boyfriend." Saying this was an almost erotic pleasure. I was attracted to my normality. I was attracted to the nods of agreement with my half sentences, to the smiles in response to what my words implied. I know that I tried to feel things that I had read, had been told, or had heard. Who was there with me? Mom? I know that I didn't know a thing then, and if I had doubts, they were only about myself.

In her later writing (2005), Judith Butler states that my personal story is erased if I don't find a supportive audience for it. If my story has no right to exist, not only can't I tell it, but also the story can no longer continue to exist within me. What can be told is not under my control. In order for others to listen to my story, I need to be in the correct body, the correct gender, the correct sexuality. Everything that I can say about myself is sent to someone who has the ability to affirm or to enable it. There is no "I" that precedes the dialogue, and therefore my story is always a form of addressing the other. While on the theoretical level one can speak in a clear, organized and unequivocal manner, personal discussion has subversive potential precisely because it complicates the presentation of the fixed, unified and coherent "I" that would have been possible in abstract terms free of any specific addressees. The dialogue structure is conducted through norms that dictate whom to recognize and how, and the questions that I am asked will always be formulated based on social conditions. I am always dependent on others' responses in order to exist as I perceive that I exist. I am always dependent on the other's gaze to tell me what I look like.

So how does the dialogue structure, within which lesbians are situated, work? What questions will people allow themselves to ask lesbians? What do these questions advance? Can they be refused? Is silence a form of resistance? Is speaking an option for establishing the lesbian subjectivity? What can be answered in response to questions on lesbianism, femmes in particular, and is this not a secret maze where all questions lead to one human answer, which is always straight?

Through Butler, I will claim that lesbians' dialogue with the straight world is always conducted within a framework of giving an account, because even when lesbians talk about themselves willingly, they are necessarily responding to the initial expression of blame. Lesbians' personal story will always try to explain what made them this way and what happened to the life they were meant to live. The lesbian life story will always try to place a convincing model of identity, but this model will always be used as a trap. When someone asks me "who I am," I need to have the words and legitimacy to express them; and mainly, I need the question directed at me not to be rhetorical. It is important to check what situations in life are not questioned. Even if I am holed up in my house, in my body, in my heart, but there is a man by my side, I'll always be considered taken care of; but if a woman replaces him, and she always replaces *something*, my life must be examined more thoroughly.

If I want to be recognized and understood, I would like to present a story that will give an account of my life, but this story will always be comprised of things that aren't mine. Anthony Appiah (1994), a black homosexual philosopher, claims that the struggle waged by minorities for recognition is the struggle over a previously scripted identity. Each story representing an identity wishing to be recognized will not be able to detach itself from the oppressive image through which it was created and to start with a clean slate. Being who we are means negotiating with oppressive stories. Telling my story means telling the story of the deviant femme lesbian, of the dirty *Mizrahi*[1], of the stupid woman. My voice will always include voices that hate me and are unwilling to accept my story. Therefore, Appiah believes that while my struggle for recognition as a lesbian is necessary, it is only a preliminary phase. In the next phase, I must return to my personal story, as a Mizrahi femme, because there is always a gap between my identity and the group's identity, and erasing it may cause additional oppression.

Even if it is easy for us to consider the oppression apparatus that is activated through the lesbian–straight dialogue, it isn't always clear to us how the apparatus applies itself to the lesbian—and queer—community. Arlene Stein (1999), who writes about the lesbian identity that developed within the lesbian feminist framework of the 1970s, demonstrates how coming out of the closet serves as a collective confessional apparatus obligating lesbians to tell the "truth" about their

1. In Israel, Jewish ethnic origins serve to categorize the Jewish population into two distinct groups: *Mizrahi* (Oriental) and *Ashkenazi* (European). The term "Mizrahi" refers to Jews who immigrated to Israel from various Arab and Muslim countries as well as from the Far East, while the term "Ashkenazi" refers to Jews who immigrated to Israel from western European countries, as well as English-speaking countries in the Americas. In Israel, Mizrahi and Ashkenazi are cultural categories similar to "Black" and "White" that hold class and economic value, as well as both negative and positive symbolic meaning, which serve the Israeli-Ashkenazi hegemony in determining the social standing of Ashkenazi people and Mizrahi people, and in defining the hierarchy and power relations between them. Please see Dahan–Kalev 1999, 2001, 2003, and Shohat, 1998, 2001.

lives. Stein shows how the story designs a linear narrative of a "return home" that concludes with coming out of the closet. The "personal" lesbian story was actually written in accordance with a fixed, unified model in which a woman goes from oppression to freedom, from hiding the "true" self to displaying this authentic self. Through Appiah, it can be argued that lesbian feminism created clear sexual scripts that forced women to rewrite their past, their desires and their fantasies so that everything considered an expression of heterosexuality was labeled as a characteristic of oppression.

The gender roles in the butch-femme culture were also considered a reproduction of the oppressive heterosexual apparatus and as an artificial style, as opposed to authenticity found beyond gender. The lesbian story sought to erase the gender differences and re-encode a natural, androgynous body. Lesbian feminism's use of terms of authenticity stemmed from the violent dialogue with the straight world that identified everyone who was not a straight male as an artificial, perverted or failed formation—someone who was not entitled to an identity. The desire to run away from the female fate, in a society that makes comprehensive, aggressive use of gender differences, led to reducing and erasing the differences among lesbians so that the same narrative that provided a home for only some lesbians left many to roam the dark alleys of gender.

The lesbian feminists did not view gender differences as a potential for resistance or erotic relations among women. Through working class lesbians' personal life stories from the 1930s–1960s, Elizabeth Lapovsky Kennedy and Madeline Davis (1994) demonstrate how the butch-femme roles constituted a pre-political form of resistance to the heterosexual decree. This culture was not based on abstract theoretical perceptions but revolved around their desires and was created so that these women's bodies could survive. The butch-femme community presented, for the first time, sexuality as a source of autonomy and pleasure for women, and enabled thinking of women's sexuality beyond that feminist prism that focused on sexual oppression.

As a femme who came out of the closet in the 1950s, Joan Nestle (1987) understands that she is not considered one who took part in historical events, but believes that her body was present at a significant, historical moment of signifying a collective desire of the body. Nestle claims that while the deepest oppression is written on the body, the body appears as irrelevant in regards to the events that we have taken part in. She presents a different view of history, attentive to the personal, and therefore insists on giving an account of our days and nights, of the ways in which our bodies survive under the political systems and the way in which we experience femininity and masculinity through frameworks of class and race. She suggests that erotic writing has no less potential to serve as documentary than other forms of biography because fantasies are a person's most private political territory. Fantasies can incorporate powers of relations, oppression and pain, but can also offer the possibility of amending the past. Erotic writing challenges the homosexual community's defensive approach, which declares that, "We aren't *just* our sexuality," and claims that if we place sex in the historical narrative, maybe we can stop apologizing for being sexual creatures, and sexuality will become our contribution to history.

Do you have a boyfriend?
No.
That's fine, you'll probably find one soon.
I'm a lesbian.

So you've never had a boyfriend?
I had a boyfriend three years ago.
Was he your first boyfriend?
Yes.
The first time you were with a man?
Yes.
Had you ever kissed men before ?
No.
How did you know you were a lesbian if you'd never tried?
I didn't feel like I wanted to be with men.
So you were with girls because you hate men?
No. I later understood that…each time I'd felt admiration for girls was a form of falling in love.
But how does one know such a thing? How could you be sure?
I tried to go out with all sorts of boys and…at the end of the date when they leaned in to kiss me, just like I'd seen in dozens of movies and billboards and TV shows and advertisements and weddings, the only thing I could do was turn my face away at the last moment and give them my cheek as a consolation prize.
So you never wanted to kiss a man?
No.
Didn't you know anyone whom you were attracted to?
No.
Really, never?
Oh…there was this guy in the army. I enjoyed thinking that he was protecting me. And…there was the psychometric teacher, whom I fantasized about occasionally throughout the course.
What do you mean "fantasize"?
I had…erotic, and somewhat violent, fantasies about him.
So you're attracted to boys; you're not completely a lesbian.
I am.
But you fantasized about men?
Yes, I still do.
And you call yourself a lesbian?
That's what I'm called.
Can you fantasize about a man when you're with a woman?
Yes, many times.
Don't you think that indicates that it isn't natural, that you're lying to yourself?
No. That means that I'm sick of lying to others. I can be with women and fantasize about men.
So why not be with men and fantasize about women?
Because I don't want to, and I can't. One of the mistakes that I made was to confuse my fantasies with what I want. I found myself with a man, against my body.
But what's more important—what you imagine or what you do? Body or mind?
I don't know. My fantasies are based on what hurt me, scared me, humiliated me and pushed me up against the wall. With a woman I trust I can enjoy something that, with a man, would be the realization of a nightmare, or the creation of a new one. That's also what happened.
But they say that in fantasies we allow ourselves to want everything we truly desire, free of judgment.
So you think that what I really want is for a group of men to rape me?

Fine, but how is it that you had a boyfriend for two and a half years? So you weren't a lesbian then?

I've been a lesbian for over a decade.

But three years ago you had a boyfriend, right?

Yes.

Were you attracted to him?

No.

And didn't you ask yourself why?

At first I thought I was attracted to him, and later I thought it was because we didn't get along. I thought it had to do with the fact that I'm a difficult person to live with, or because I come from a difficult home, because I was used to fighting for my home. That fighting was my home.

And you didn't stop for a minute to consider that this wasn't good, that you want to break up?

No, I didn't want to leave him. He wanted to break up sometimes, because who wants to be with a girl who always cries and doesn't leave her body or her house, as the boundaries between the two keep getting blurred. Who wants to be with a girl who doesn't want to be touched, whose face portrays a struggle, who is always in pain, who never remembers to take the pill, and who believes that the most important thing in the world is not to be woken up in the morning.

But if you stayed there two and a half years, there must have been some good times.

Not really.

So these were two and a half years of suffering?

Pretty much. The good times were short, kind of like two children fighting for their mother's love and then, when she leaves for a moment, they settle down and try to pass the time until she returns, and the only mother I know rarely left the house.

But you're not answering the question.

What was the question?

You had good times with him, right? You know that everyone has good times and bad times with their partners, and that doesn't mean that everyone is a homosexual or lesbian.

Obviously.

If you weren't attracted to him, how did you sleep with him?

It was when I'd been alone for quite a while. I'd also met a woman whom I'd liked in the past, and we thought we might get back together, and then she said that she'd decided that she wanted to be with men, so I told him that I thought I'd try being with a man. He liked the idea of turning a lesbian straight, or being my first or something like that. And I enjoyed the fact that sleeping with me had been someone's life mission. As long as nothing happened, I was happy. There was even sexual tension. I enjoyed flirting. I enjoyed the way he looked at my boobs, at my ass, how his eyes became piercing. I enjoyed being the center of attention. My friends asked me if I was attracted to him, and I said I was attracted to the fact that he was attracted to me. You see, even back then, I didn't know how to answer the questions. Every time we met up, he wanted to come up to my apartment, and I wouldn't let him. On the phone it always seemed to me like I wanted to, and then when he came over it was clear to me that I didn't.

Did you flirt with him on the phone?

Yes.

And when you were together?

Sometimes.

So you used him?

No, I wasn't sure what I wanted. I never wanted to be with him when I was with him. In theory, it seemed right.

What happened when you were alone?

Nothing. I didn't want to.

What didn't you want?

I didn't want him to touch me and I didn't want to touch him.

So how did it finally happen?

We talked about him coming over to my house, uh…on Friday night and that we'd do it.

And?

My roommate gave me condoms. I didn't even know what to do with them. Up 'til then, I'd only been with women and didn't know you had to plan ahead, that something could be torn. But that conversation with my roommate was really good. I felt like we understood each other. That he saw me in a different light. I suddenly saw my body through his eyes. Friends at school were also excited because they all knew both of us. They knew I was a lesbian, but they'd only known me a short while, so they didn't ask questions. None of my close friends were in Israel at the time, and that's all I had. A friend of mine says that if she'd been in the country, it wouldn't have happened.

So he came over on Friday night and you slept together?

No, he came over, we talked a little and drank wine, and then I asked him to leave.

Why?

Because, again, I didn't want to.

Wasn't he sick of it?

I guess not, because…the following Friday he came over again, and we drank wine again, and I didn't want to, again, but this time he was persistent.

So, how was the sex?

I felt like something irreversible had happened to me.

What did you do afterwards?

Nothing. I was on the left side of the bed, near the wall, under the blankets. I was cold. I can't remember if it was winter or not. But I was cold and couldn't talk. There was no blood. He kept asking if I was all right, but I couldn't speak.

Did it hurt? You know that the first time is painful for all girls.

That's hard for me to understand because it wasn't my first time. I've slept with women, with lots of women, and I've never felt that kind of pain. And not because we caressed each other gently, because I do like penetration, even hard, but underneath him, I knew that that was it. That life as I knew it was over.

You could have said no.

No, I couldn't have.

Why?

I've been saying "no" for over twenty years. Since I was a little girl who fell and my mom promised that, "It will all blow over by your wedding day," and every time I go to a wedding and people kiss me and pinch my cheeks and say, "I shall dance at your wedding," and to all of my mother's dreams, and to those of her brothers and sisters and their children and their husbands and wives and their children, who have married or are about to get married, and to all of the guys who look at me on the street or on the bus or at the university, and to all of my friends and acquaintances from work and school who offer to introduce me to their cute, sensitive friends who also dislike blind dates. I say "no" until I'm blind. Until I want to say yes. I no longer want to be the tough, aggressive girl. I want to be a soft, beloved woman. So I don't say anything and think it's like riding a bicycle—but I was never able to do either without falling down. With both I felt that I'd been deceived, that someone was rearranging my body, taking what allowed me to stand.

And then, what did you do?

I called a friend. She came over and told me that she felt the same way the first time. That the first time is kind of like rape. I wanted to say again that it wasn't my first time, but I couldn't say anything. I couldn't leave the house either. He wouldn't stop calling, but I refused to talk to him.

And then what happened?

A week later, I answered the phone. He apologized and said he felt like he made me do something that I didn't want to do. He wanted to meet up, and I told him that I did not want to see him alone, only in public places. I still believed there was a distinction between the two.

Why didn't you want to meet alone? Were you afraid that he would do something to you?

No. I think I felt like I had done something to myself and was afraid that I would do it again. You know, when I came out of the closet at the age of sixteen, lots of people thought it was a phase. As the years went by, they realized I was serious, but they still didn't understand how I could so easily give up the life I could have had. How I wasn't afraid of what people would say and how they would treat me. But I was happy. I started seeing a future for myself; I felt normal.

How did your parents react?

Not my mom. I couldn't bring myself to tell her directly. I was willing to do a lot in order to cuddle with her on the couch in the living room and pretend that she didn't control my life, so we'd watch TV, seeing what I imagined a mother and daughter looked like. I admired her strength, her body, the way she made people do what she wanted.

So maybe your attraction to women stems from unresolved emotions towards your mother?

Maybe. My relationship with her is the longest I've had with a woman. And the hardest. Besides, I've never met a woman who has resolved her feelings towards her mother.

But you slept together again, didn't you?

After the first time, I didn't want it to happen again. I can't explain it, but I just forgot.

Forgot what?

I forgot my body's detachment from me, how I wrapped it as if it was a package that I mistakenly received and I didn't want anyone to see that I'd opened it. Slowly I started gaining weight, but that didn't help. He was still attracted to me. A few weeks later we slept together again. Again I couldn't talk. It repeated itself three or four times. By then I'd completed the mourning period over my life and my body. After that, it was easy.

What was easy?

Sleeping with him. It fit in with the fantasies. I wanted it to hurt, to be hard; I would come; we would have sex for entire days.

So it seems like you accepted your sexuality, that you enjoyed yourself?

I can't remember myself there. Soon after, I started getting urinary tract infections.

What does that have to do with it?

The doctor said it was caused by excessive friction while I closed myself and made a muscle. I guess I did that every time we slept together, because after every time, I'd have an infection, and then we couldn't sleep together for about a week.

You know, you don't seem like a lesbian.

Yeah, I know I'm not seen.

Amber Hollibaugh and Cherrie Moraga (1983) claim that regardless of our sexuality, all women are influenced by heterosexuality and the values that it dictates. They criticize the feminist theory that presented lesbianism as a practice defining those who can miraculously free themselves of the

heterosexual conditioning and skip towards egalitarian sexuality free of struggles. They state that feminism's focus on theory gave it priority over experience; without providing an account, who can really live this ideal or what is women's sexual behavior in reality. They suggest returning to the model of dialogue, which enables conversation about women's experiences in order to research sexual possibilities and sexual differences.

Hollibaugh, who identifies as a femme, and Moraga, who identifies as a butch, engage in a dialogue on sexuality, in which they discuss their fantasies and the roles that they like to play. They argue that sexual fantasies that include violence or straight characteristics express the reality that we all live. The feminist yearning to evade heterosexual control of the fantasy has made almost every type of fantasy inappropriate or unsafe because it involves power. They believe that erasing the fantasy won't change reality and that repressing it may even lead to its realization. On the other hand, within the framework of the fantasy's safe space, through sexual dialogue between a femme and butch, they can use the same pain to heal each other's wounds.

The open framework of dialogue allows Moraga and Hollibaugh not to surrender to general questions like: who is a lesbian or who is a butch or femme, but rather ask each other what it means *to her* to be a butch or femme. Through the dialogue, they describe the different and similar ways in which they experience their sexuality. The gap between heterosexist regulations on sexuality and gender and the manner in which each of us understands herself as a sexual being can be a limitless space for sexual creativity and healing. While feminist theory can work towards a separation between female sexuality and female pain, in a dialogue between women, it is hard to think of a woman whose pain is foreign to her sexuality, especially when the woman is a lesbian.

How is a lesbian expected to respond when she is asked: have you ever fantasized about a man? What do you like to do in bed? And what if the answer is outside of bed, out of a relationship and with women who look like men, and the fantasy is violent, and its fulfillment is necessarily heterosexual; one can only conclude that she is not a lesbian and for our sake as feminists, it would be preferable if she weren't. What is the life story of a lesbian who doesn't enjoy caressing and tenderness, but rather penetration and force? After all, under the held hands, the shared house, the understanding and love, the lesbian just wants cock. Some of us do, but, as Jan Brown (1992) says, we want a woman on the other end. But this woman doesn't really look like a woman, not like the ones from straight men's wet dreams or the ones from feminists' theoretical, asexual dreams. Sometimes she actually looks like a boy, a guy, a man, a man and woman or none of those. Sometimes she opposes the conditions of what can be seen. Until when will the anxiety from the question, "Who is the man and who is the woman?" make us deny that gender is erotic and that the erotic always has a gender? What makes me a lesbian if I'm feminine like a woman and want a woman who looks like a man and have sex that looks straight? Could it be that the question itself leads many women who can only feel sexual through roles and power relations to live a straight life because they are forced to live what they could not fantasize?

It's impossible to avoid the dialogue with the straight world, with the lesbian community or with a partner, and maybe we don't really want to. Dangerous as it may be to answer those trick questions, we must remember that questions have a tendency to reappear precisely during violent instances and to force themselves as answers. The story of the body that is horny, sick, battered, changing, healing, silent and refusing should be told. The body that is always recruited

to tell the truth has the power to reveal the lie when given specific, concrete sexuality and gender that someone, someone with pain and a past, lives. Telling the story of the body does not mean articulating the destiny of its sexual organs, but rather sharing what the body goes through, its changing, the dysphoria within it and its adaptation to whoever we want to be. If we don't tell the story, it will be told anyway, and we'll have to listen to a distorted version of it, revised and edited by whomever has always tried to prove to us that *this* is not a story. The story of the things that happen and happened has the power to place different identities in the historical space, to link us to our past and leave room for whoever will want to be similar to us, but also different from us.

Shoshana Felman (1993) says that women can't write their personal story because their history is a history of erasing, and their life story is a story of forgetting. She proposes a framework of subjectivity comprised of two halves in which a woman is dependent on the "other" in order to appear, because she is necessarily blind to what she lost. I suggest considering butch–femme relations as a dialogue structure in which one allows the other to be who she is, precisely because she can be different from her, but also similar, and a partner to her pain. The butch and femme respect their differences enough to mark the boundaries on their bodies. The manner in which each of them dresses and behaves is her way of expressing herself, or daring to pronounce her desire.

Within the framework of the butch–femme dialogue, we may regard the butch's silence not as being silenced by an oppressive society or an inability to express herself, but rather as what the femme hears as a form of active butch resistance in which she says "no" through her body and voice to the straight inquiry, who understands that the questions set a trap for her that she previously identified with her body. The femme, who seemingly says "yes" with her body, even if she says it in the butch's ear, is forced to *speak* her objection to everything straight: she has to tell the "truth"; she is asked to say "no" to penetration, to submissiveness, to weakness and to every violent fantasy, before she is led in handcuffs to a trial, and given a sentence that she will never be able to complete, and in which she will be considered an unreliable lesbian witness. The butch and femme can help each other talk about the pain or to listen to its silence, but can also go beyond that, to the places each of them would like to reach. The dialogue between them can allow each of them to rewrite her story, but this time without being forced to strip or to sleep with the researcher, but to actually write what she would like to wear, who she would like to be, so that for once the body will not be erased, but rather will appear in more than one possible performance.

> Your shirt is buttoned
> precisely up to where you have a scar
> I put my finger on the place that might open
> Your hand is conversing with my hip
> and your other hand is moving us forward
> I am trying to wrap around you
> with two arms
> everything I have to say
> and your body can hear
> My face is in your back
> Hiding from the too-bright light, the smoke, the stares, and the cab driver's honking
> which reminds us that we aren't supposed to take up a lane

and slow down traffic
At the light you notice
from a distance
a man overtaking you
to undress me with his look
to undermine you with his look
You quietly tell him, "Keep looking straight"
And the man next to him says to you, "It's no skin off your back if he's enjoying himself"
They don't know that it is
skin
off your back
because once again, they've erased you
in order to mark me

You continue driving
hit a traffic island
but still stop at the crossroad
to let another woman
pass.

References

Appiah, A. 1994. Identity, authenticity, survival In *Multiculturalism: Examining the politics of recognition*, ed. Amy Gutmann, 149–163. New Jersey: Princeton University Press.

Brown, J. 1992. Sex, lies, and penetration: A butch finally 'fesses up In *The persistent desire: A femme–butch reader*, ed. Joan Nestle, 410–416. Boston: Alyson Press.

Butler, J. 2005. *Giving an account of oneself*. New York: Fordham University Press.

Dahan–Kalev, H. 1999. Mizrahi feminism In *Sex, gender, politics*, eds. Dafna N. Izraeli, Ariella Friedman, Henriette Dahan–Kalev, Sylvie Fogiel–Bijsoui, Hanna Herzog, Manar Hasan, and Hannah Naveh, 217–267. Tel Aviv: Am Oved Press.

Dahan–Kalev, H. 2001. You're so pretty—You don't look Moroccan, *Israeli Studies*, 6, 1:1–14.

Dahan–Kalev, H. 2003. The gender blindness of good theorists: An Israeli case study, *Journal of International Women's Studies*, 4: 126–147.

Davis, M. & Kennedy, E. 1989. Oral history and the study of sexuality in the lesbian community, Buffalo, New York, 1940–1960, In *Hidden from history: Reclaiming the gay and lesbian past*, eds. Martin Duberman, Martha Vicinus, and George Chauncey, Jr., 426–440. New York: New American Library.

Felman, S. 1993. What does a woman want? The question of autobiography and the bond of reading In *What does a woman want? Reading and sexual difference*, 1–19. Baltimore: The Johns Hopkins University Press.

Lapovsky, E. 1994. *Boots of leather, slippers of gold: The history of a lesbian community.* New York: Penguin Press.

Hollibaugh, A. & Moraga, C. 1983. What we're rollin' around in bed with: Sexual silences in feminism In *Powers of desire: The politics of sexuality*, eds. Ann Snitow, Christine Stansell, and Sharon Thompson, 394–405. New York: Monthly Review Press.

Nestle, J. 2003. *A restricted country.* San Francisco: Cleis Press.

Nestle. J. 1992. The femme question In *The persistent desire: A femme–butch reader*, ed. Joan Nestle, 138–147. Boston: Alyson Press.

Shohat, E. 1998. Mizrahi feminism: the politics of gender, race, and multiculturalism In *Daheim im exil: Orentalische' Juden in Israel,* ed. Ulla Philipps–Heck, 106–123. Frankfurt: Wochenschau–Verlag.

Shohat, E. 2001. *Forbidden reminiscences: A collection of essays.* Israel: Kedem Publishing.

Stein, A. 1999. Becoming lesbian: Identity work and the performance of sexuality In *The Columbia reader on lesbian and gay men in media, society and politics*, eds. Larry Gross and James D. Woods, 81–91. New York: Columbia University Press.

Femme for Life
by Moonyean

I noticed the cute butch in the camera section of the store and wandered closer. She was wearing jeans, a leather jacket over a pressed white shirt, and motorcycle boots. Her short, dark hair flowed straight back from her forehead. As she turned to leave, I gave her a sweet, knowing smile. She looked at me—and looked straight through me. No smile, no nod of recognition, nothing.

My jaw dropped. I was shocked. An obvious dyke totally ignored me! I wanted to call after her, tell her I'm of her tribe, demand she acknowledge me. I felt hurt. Then, I felt angry.

It was my first experience of femme invisibility.

Lesbians in the fledgling seventies women's movement thought butch/femme was outdated and patriarchal. In their zeal to fix the world, many young lesbian feminists made butch and femme lesbians feel unwelcome, to say the least. Rather than learn from their elders, the youngsters made huge assumptions and passed judgment, condemning butches and femmes as passé and hopelessly brainwashed. I am guilty of this line of thinking myself, since I came out during the burgeoning women's movement of the seventies.

Somehow, though, I knew that deep down I was wildly attracted to the butch/femme dynamic. I never told anyone in my circle of political lesbian friends about this attraction.

My first visit to The Habit, Phoenix's only lesbian bar at that time, was on a weeknight, and business was slow. My friend and I sat the bar and watched the only couple on the dance floor. I felt a visceral attraction.

They were great dancers. The butch was slightly taller than the femme, and she wore a cream-colored, button-down shirt with pressed, fitted slacks. A heavy, silver link bracelet graced her left wrist. I stared at her hand on the middle of the femme's back, holding her close in a slow, sensual way during a slow song. They seemed to be barely moving, in a world of their own.

Finally they turned, and I could see the femme's face. Her eyes were closed. She snuggled comfortably on the butch's shoulder, and I longed to get close enough to see if there was a matching red lipstick print on the butch's neck. I marveled at her sleeveless dress, a striking teal with a plunging neckline and a full skirt that looked like it would have been popular in the 1950s. It looked perfect on her. The femme, with her brassy blonde hair, was probably twenty years older than the butch. I ached to be in her place, wearing that dress, and in that butch's arms. I knew my friends would never understand.

A few months later, another lesbian bar opened. This place was a more upscale attempt, offering dinner and a small stage for a band that played easy–listening background music. The dance floor was a token small square in front of the band area. I went with a group of friends, and we sat at a table near the bar, which ran along one side of the room. It was early yet, and the crowd was sparse.

There was a woman sitting at the bar, alone. She was drinking something dark amber in a small glass. She was probably about fifty years old, had a beehive hairdo, wore a slinky, black tank top, skintight flowered pants, and red spiked heels. Someone at my table made a derogatory comment about how the oldsters should stay home, but not loud enough for her to hear.

The only man in the place moved from the far end of the bar to a barstool next to the woman. "Let's leave this dyke joint," he proposed. He was loud and very drunk. "Come on, honey, let's get out of here. I'll show you what a real man's like." He leered, patting his crotch. He was not well dressed, and he drooled as he slurred his words.

She turned to look at him, and I could see her heavily made-up face in profile. "LEAVE ME ALONE," she said clearly, then turned back to face the bar and to resume her solitary drinking.

He kept it up. "Aw come on, baby, how long's it been since you had a man? You look like you could use one. You look like a real woman. I know you want it. Come on, sweetheart, let's you and me go to my place."

She ignored him.

"If you want, we can go to your place. Or I could get us a room. You know you want it."

She turned her head again and said, "GO AWAY."

I began to feel embarrassed for him. Or her, I couldn't tell which. I wanted him to shut up and go away. She continued to ignore him.

"Hey baby, I know you're not like these diesel dykes in this place. Let me show you a good time."

Then he made a mistake. He reached out and put a hand on her arm, as though he sensed consent and was going to take her away.

She turned toward him and slid off her barstool, facing him. She placed her left hand on his right shoulder. He probably thought he'd finally won, and she was going to leave with him. Before any of us knew what was happening, she cocked her right arm, her hand shot out, and her fist connected. She decked him! He fell to the floor, out cold.

The room was suddenly silent.

After a few seconds, everyone was talking at once.

The bartender came out from behind the bar and escorted the woman to the door. The bouncer, who had just come in, came over to check on the guy on the floor.

I don't remember what happened next. All I remember is my awe and sudden realization that just because you wear heels and lipstick, doesn't mean you're powerless.

A lesbian feminist activist in the Phoenix, Arizona, community for more than ten years during the mid–1970s through the 1980s, I owned the local feminist/lesbian gay bookstore. I tried to blend in. For many of those years, I dressed in jeans, t–shirts and sandals. Winter wear was jeans, flannel shirts, and sandals with socks. I never gave up my long hair, although I did let my underarm and leg hair grow and didn't wear makeup. Eventually I got tired of this uniform and started branching out. Or…was it because I started dating a butch who encouraged me to be sexy? Maybe it was the Halloween party.

For the party, I wanted to change my image totally. I got my legs waxed and shaved my underarms. I bought a pair of black heels and a black slip at a thrift store. The day of the party, I colored my hair a deep auburn. Then I went to the cosmetics counter at an upscale department store where I told the plastic–looking sales clerk I needed a new look for a party. My only requirement was ruby red lipstick. She put more makeup on my face than I thought was possible. When I looked in the mirror, I was shocked to see a sultry and sexy woman staring back at me.

At home, I made a fake, long cigarette–holder from black construction paper. Then I put on the heels and slip.

The response from women at the party was beyond my wildest dreams: women I'd known for years stared at me, ran their hands down my back and thighs. The bold ones ran their hands across my breasts and belly. And it wasn't limited to the butches. Several women said, "I can't believe you did this. You look great!" I was pulled onto women's laps, where I was fondled and kissed. I got three offers to go home with other women, something that had never happened to me before.

I began to wear Danskin leotards with my jeans and mascara all the time. Then I began to wear wrap–around skirts with the leotards. Winter wear became tights with the skirts and leotards. Because I had long established my lesbian feminist credentials, people in my community said little about my change of attire—at least to my face.

After I started dressing in skirts, I suddenly found that I was inadvertently "passing" as straight. I didn't like it one bit. I didn't care much what the rest of the world thought of me, but I wanted to be recognized within my own community.

Shortly after I opened my store in 1974, a lesbian visiting from out of town told me I would never been taken seriously as a lesbian until I cut my long hair. At the time, I was insecure enough to be upset by that comment. Ten years later, a lesbian friend visiting us from Canada watched me sitting at the kitchen table applying fingernail polish. She whispered to my lover, "Are you sure she's *really* a lesbian?" By this time, I realized it was her problem, not mine.

I have a black–and–white snapshot of myself at about four or five years old. I'm draped across a child's rocking chair, arms above my head, eyes half closed, my long hair trailing to the side. Friends see that picture and exclaim, "Look, how adorable you were! A perfect femme, even at that age." I remember the fire–engine red of the pleated skirt of the dress. I remember how I felt wearing it with my black patent leather shoes that my mother only let me wear on special occasions: pretty and totally happy.

The problem of femme invisibility is probably as old as the butch/femme dynamic. A femme is often seen as a straight woman especially if she is not accompanied by a butch. A butch is obvious. A butch may pass for a man in the world at large, and most butches I've known do not mind passing. "I've never been upset about the assumption that I'm a person with power in this society," said one butch friend. I, however, have occasionally felt incensed on a butch's behalf at the lack of recognition.

Long before I identified as femme, I was always attracted to the butchest woman at any gathering. I am now married to the butch of my dreams, and we've been together for nearly eighteen years. Last year, she began a transgender transition.

At first, I was a little uncomfortable. If she becomes a man, what does that make me? Will I still be the femme lesbian I have been all of my adult life?

She started taking testosterone shots, and a mere three months later, she decided to have "chest reconstruction surgery" to remove her breasts and to give her chest a more male appearance. I was a little startled by how quickly everything seemed to be happening.

The hardest part for me has been the pronoun transition. After years of referring to my lover as "she," remembering to use "he" is a major change.

Then one day, while watching him shave (an erotic experience in itself), I realized the transition wasn't sudden at all. It was only the outer manifestation of an inner reality, and I happily support anything that helps him to feel more at home in his body. My sweetheart's changes are primarily cosmetic; he is still the same person he was before the hormones and surgery. The transition did not alter who he is or how we relate to each other. (It *is* odd to kiss someone who has hair on his face, but...um, I like it. It feels—well, *kinky*.)

It helps me a great deal that he is not identifying as a straight man, but as a transgender butch. It sometimes irritates me that when people see us together, they assume we're a straight couple—but then again, that's not any different than it was pre–transition. If he shaved all the facial hair, he would look pretty much the same as he did at our first commitment ceremony, just a little older. Oddly enough, the opportunity for us to be legally married is now available to us. However, we've chosen not to go that route, feeling it would be a betrayal of our belief that gay marriage should be legal.

I'm sure there are lesbians who would say I'm not a lesbian if I'm sleeping with a man—never mind that there are lesbians who sleep with men. Perhaps some would insist that I'm bisexual. However, I still identify as a femme lesbian, and I feel secure in that.

Being femme feels integral to my being. Sometimes it saddens me that the more I "become myself," the less visible I am to my community. To cope, I wear rainbow jewelry. I speak up. I am an out, proud femme lesbian, and I am comfortable with myself. It's too bad if other lesbians are uncomfortable with my lipstick and nail polish. Butches certainly don't seem to mind—and now I make sure they recognize me.

In 2006, I attended the first–ever Femme Conference in San Francisco. Hanne Blank put words to my feelings of femme as a complicated, contradictory, subversive gender that requires strength, resiliency and an enormous amount of pride. Writer and activist Amber Hollibaugh's keynote address made me stand up and cheer, as she addressed issues of aging and health care. Jewelle Gomez made me realize just how courageous it is to be a femme in a world that devalues the feminine and sees the feminine as weak. From the Femme Conference, I found the Bay Area–based Femme Posse, where I am now attending the monthly meetings and making other femme connections.

And my search for the perfect red lipstick continues.

Can You See Me Now?
by Sassafras Lowrey

I always ran away from femininity, especially my own. I spent my childhood a failed tomboy. My bedroom was perpetually littered with families of toy cars and collages of the baseball cards I wished I could find joy in collecting. I convincingly feigned hatred of ruffled dresses and patent leather shoes, but secretly I always dreamed of feeling safe enough to be pretty.

In middle school, my stepfather, my rapist, was briefly out of the home, and I began to play with femininity. Cloaked in rainbows and paradoxically lusting after the goth girls, I looked like a preteen drag queen. For the first time, I remember being happy and unashamed of my body as I walked the halls of the junior high school in neon orange heels, a lime–green dress with black–and–white checkered tights.

And then he came home. I was the only girl at the co–ed baseball tryouts that year.

When I was seventeen, I came out as a lesbian and immediately struggled with a fear that no one could see me. I worried that I wasn't gay enough, that the ponytail nearly reaching my ass anchored me firmly into the realm of heterosexual. Each night I sat transfixed by the glowing computer screen bringing radical, queer voices into my semi–rural bedroom, plastered with pictures of country artists I'd painstakingly cut from magazines. It was here that I received my first lesson in queerness. I learned the lingo, the dress, what music was cool, and what books I should try to sneak out of the public library when my family wasn't looking. I learned from the people I met that "femme" was a reference to some relic of the past who wasn't really gay, and that it made a great insult when you wanted to challenge someone's place in the queer community.

When I left home a few months later, blackened eyes, and a life in shambles, I knew that no matter the cost, I needed to be visible. In a matter of weeks, the hair was gone, shorn to an appropriate length for the andro–dyke city where I landed. I had lost everything, and above all else I desired a feeling of belonging. Finding other queer people and having them be able to recognize me was so powerful that it made the charade of masculinity worth it.

After only a few weeks of telephone courtship, I moved to the deep South at eighteen, the summer after graduating high school. I had moved from the wet and liberal Pacific Northwest in order to be with my first butch lover. From our chance meeting a month previously at a queer youth conference, his drawl and southern charm captivated me. At the time, I called myself "butch," an identity that was a never–ending source of confusion for my girlfriend who (until me) had only dated high femmes. I vividly remember sitting on a bed watching a lesbian movie, air conditioner whirring, with a big mug of sweet tea resting on the chipped nightstand beside me. In a moment of pure ecstasy, I watched a 1950s butch rumble onto the screen. I was paradoxically overcome with desire and fear; my heart was melting, and I was sweating. What did it mean that I was attracted to that butch? What did it mean that with every fiber of my being I wanted to wear a sundress, wanted to feel the light floral fabric clinging to my hips?!

That night I wrote in my blue spiral journal about how I lusted after that sort of masculinity and dynamic. I wrote about wanting someone to open doors for me and to wrap zir arms around me. I wanted to place paint–tipped fingers at the nape of someone's neck, and I wanted to straighten hir tie…And then I stopped myself. I couldn't believe what I had written, and in a moment of terror, I ripped out the page in my notebook. How could I have all those desires fulfilled yet remain visibly queer? Sitting alone in the darkness, baggy jeans and bound breasts, I knew that I was an imposter, that my masculinity was a lie, and that it always had been. The ice from my tea long melted, I vowed I would never admit my truth out loud. I still saw anything feminine as weak, and I had promised myself that I would never again be anyone's victim.

Later that year I came out as trans and started identifying as male. I even went so far as to get a prescription for testosterone and began injecting every week. I had to teach myself to inject because one night I confessed to the friend who had been doing my shots that I didn't really want to be on hormones but was afraid to quit. She refused to stick a needle in me after my disclosure. Each week I would plunge a needle into my cramped and knotted leg muscles. I wanted the injection to be the answer to my prayers, to take away the hurt and the pain of a lifetime of lies. I had carried my childhood fantasy of becoming a tomboy into adulthood. By this time, I had repeatedly failed at butch, and I saw hormones as a way out. So long as I had a needle in my leg, no one could question my identity. I lived that way for two years.

I came out as femme on the train sobbing next to my partner. I sat there and cried as I confessed to hir my deepest and darkest secret, the one that I had harbored all those years. I could barely speak through my tears, but I whispered that I thought I might be a femme. Ze put hir arm around me and simply said, "I know." All this time I thought I had been fooling the world, but I had only been tricking myself.

Coming out as femme was a process. The first few months I lived in ripped jeans with fishnets underneath, stating that I would never wear a skirt. Later I confessed to my partner while walking home one night that I might like to try wearing a skirt, but I would never wear a dress as I considered that "high femme," an identity I wouldn't claim for nearly another year. Once, before coming out, I spent hours agonizing about whether or not my bag looked too much like a purse. I tortured myself with all of these arbitrary lines drawn in the proverbial sand about what is and isn't acceptable, what is too femme or not enough femme. Everything came down to visibility and the fear of having one's identity interpreted incorrectly. I feared that if I were to be as femme as I dreamed, then I would fade into the background, and I would be alone.

Amid the fog machines and flashing lights of the all–ages nightclub where my partner is conducting research on queer club culture, I stand in my miniskirt and tank top. Topless gay boys and lesbians with backwards baseball caps dance past me. To the majority of the club–goers, my queer femme identity is unrecognizable. I am forced to endure a new invisibility. Standing outside gasping for fresh air, my ears finally stop ringing, and I watch men unsuccessfully flirting with my partner. In that moment I realize that I am passing as straight, read as nothing more than a "fag hag" to my partner who is in their eyes a young gay man. Even the baby butches in their white A–shirts with black sports bras underneath don't recognize me for what I am. I feel the cold, familiar sting of invisibility settling in my stomach; I feel old and tired. It is only one of the bouncers, much older than the majority of clientele, who gives me that knowing smile, and I remember that there are people who can see me.

Visibility is still something that I continue to struggle with on a daily basis, and I am consciously aware that I pass. For a time after coming out as femme, but before I quit injecting testosterone, I passed regularly as a tranny girl. One night walking down Vaseline Alley, I heard someone yell after me, "You buy those titties in San Francisco?" Now most days I pass as a heterosexual female; I'm learning to face my deepest fear, but my life has more questions than answers. Am I a traitor? Am I selling out my community when I pass as my partner's wife? Am I less of a femme?

My partner is a transgender butch. Ze injects testosterone and passes as male, although that is not how ze personally identifies. It is not uncommon for hir to be read as a straight man, and it is only when I appear with piercings and tattoos that the situation starts to be read as queer to the outside world. Although my presence frequently queers people's perceptions of our relationship, when I am out on my own on the bus or at work, my queerness becomes invisible once again. Sure I'm seen as strange, an eccentric dresser tattooed and pierced, but exactly what I am is often not recognizable. People don't know what a femme is, and I daily endure the flirting and catcalls of straight men. Worse yet, I often pass under the gaydar of people who should know better. I've read postings in online communities saying that femmes should wear rainbow jewelry at all times so people can pick us out, yet never once have I heard those same requirements being given to androgynous lesbians or to butches. Comments like these from my people hurt more than the prying eyes of straight men on the bus that explain in great detail with they would like to do to my body.

My kind of femme is big tits and even bigger tattoos; it's fat, and it's raunchy. Femme is a perversion of traditional femininity; it is tight clothes, loud makeup, fishnets and lipstick. Femme is perpetually misunderstood and remains cloaked in silence and invisibility. Femme is a glitter-filled explosion of the gender binary. On a daily basis, queer femmes must confront the pain of invisibility: we know what it feels like to be dismissed and not taken seriously, to have our very lives, families, and identities questioned by queers and straights alike. When I came out, I sought visibility, little things like a nod on the bus symbolizing the recognition of "family." I desperately wanted to be seen, to connect with other people who like me were challenging the norms in our heterosexist society. But that recognition never came until I shaved my head. It was only then that my queerness was recognizable, only when I appropriated masculinity that I became visible as queer.

So much of femme history has revolved exclusively around being the other half to a butch, and I in no way wish to contribute to this narrow definition of who and what femmes are. At the same time, I cannot deny my own erotic and spiritual attractions to butches. My femme identity and my journey are intimately tied to my attraction to butch masculinity and my sense of peace in a butch/femme dynamic. From this dynamic and from my relationship to my partner, my strength finally came to embrace a queer femininity.

My biggest fear has always been invisibility. To be read as straight and not queer—particularly to other members of the community—is the nightmare that has been a driving force in my life. My journey to femme was not short, nor was it simple. Femme still is a journey, etched into my body and my soul. Fighting the invisibility faced by femmes means challenging definitions of who and what queer looks like. Being femme means recognizing our strength and power; it means holding onto the knowledge that femmes have been and always will be fighters, and that when we fight, glitter flies.

Rebel Girl:
How Riot Grrrl Changed Me, Even if it Didn't Fit Just Right
by Gina de Vries

i. "I Wanna Take You Home, I Wanna Try on Your Clothes"

My first leopard–print skirt was golden brown and fuzzy. It ended right above my knee, and at that point, it was the sluttiest piece of clothing I'd ever bought. That skirt is the closest thing to a Gateway Drug I've ever experienced. After buying it, there was no looking back. I was fourteen, and I planned that day down to the last detail. When I got my allowance from my dad that week, I counted all the money I'd saved up. I realized I could go shopping, and I knew exactly what I wanted to buy. After school that Friday, I scoured the Haight–Ashbury thrift stores for leopard print.

I'd only very recently met other femme dykes. All the queers I knew were older, and most of the queer girls were either androgynous, bisexual goth–punks, or baby butches with spiky hair and wallet chains. Nobody had an aesthetic I wanted for myself, although I definitely had crushes on a lot of those girls. But the winter of my eighth-grade year, I went to a queer youth conference and met a high–femme riot grrrl named Lila.

Lila talked about being femme and queer a lot. She was one of those adorably serious and seriously smart queer sixteen–year–olds. I was probably even more serious than she was, so the friendship stuck. We had long, deeply earnest conversations about bands, veganism and pornography. Lila was from Marin, and I was in San Francisco; the grrrl scene we hung out in was mostly in Berkeley. I remember taking a lot of public transit to hang out with her and her friends. She lived in a house that felt palatial compared to my parent's modest place—endless, well–lit, spotless rooms, no leaks in the ceilings, creaky stairs or fucked–up pipes. Lila dropped a lot of money on clothes, records and shows like it was no big deal. I saved up for things meticulously.

Even though I knew my family wasn't exactly poor, I felt like a pauper compared to the punk girls to whom Lila introduced me. I learned how to emulate their style by making do with what I had, making every purchase count. I recycled the same three dresses, ripped tights and scuffed–up boots over and over. They all wore different outfits every time we went to a show, or had a mostly–white discussion about how racism was bad, or ran around the Japantown mall taking photo-booth pictures.

Lila lent me a thick stack of zines and made me a bundle of mix tapes with Hello Kitty stickers on the covers. She talked about shopping for sex toys at Good Vibrations and instructed me to read *The Persistent Desire*. That was the year I discovered Dorothy Allison, Carol Queen, Leslie Feinberg and Patrick Califia. That was the year I traded zines with every girl I met, and dozens— maybe even hundreds—of girls I only knew through the mail. I met Kate Bornstein at the Second Annual Femme Conference. She signed my book and we talked about lipstick and Laurie Anderson, and I swear, I almost died from being so star–struck.

I was dizzy with it all and filled with relief that I was finally getting taken seriously as a queer girl. When I'd come out at the age of eleven, I'd learned very quickly that being girly made me less believably gay, so I hid as much of the girl-ness as possible. I needed the queer community because it was the only thing I had that made me feel sane, even if a lot of the older queers I knew were waiting for me to decide I was straight and to go back to being a normal middle-schooler. But meeting Lila, meeting the other femme riot grrrls, listening to those records, reading all those zines and taking bus after bus to get to those conferences…I know: it all sounds like a big mid-nineties riot grrrl cliché, and I laugh about it now because we were so little and so painfully earnest.

But back then, those girls, oh my god, they were The Biggest Deal, they were The Coolest Thing. I bought that leopard print skirt, and a month later I bought a black lacey bra and fishnets and garters, and I dyed my hair blue and pink and purple, and I wore a dog collar, and I bought my first tube of red lipstick, and I scrawled *DYKE* across my arm in Sharpie, and I danced to Bikini Kill and Team Dresch and Patti Smith and Huggy Bear and Heavens to Betsy in my living room, and I met the person who became my first boyfriend, a scruffy indie-rock trans fag who'd only recently relinquished the punk girl title himself. And I stayed up late late late into the night, buzzed on coffee, writing and printing and cutting and pasting zines about *GIRL LOVE* and *THE TRANSGENDER REVOLUTION* and *WHY BIPHOBIA SUCKS* and *FEMME PRIDE* and *DYKES AND FAGS WORKING TOGETHER* and *RADICAL QUEERS FUCKING SHIT UP*—and I meant every single word. It made me feel alive, it made me feel real and authentic, and after three years of feeling like the world's littlest and loneliest homo, it was amazing to feel like I finally belonged.

ii. "Rebel Girl, You Are the Queen of My World"

But I wanna tell you about before the belonging point, because it didn't happen overnight. I'd spent so many years wearing shapeless clothes that when I started dressing femme, I did it clumsily. At first, I tried to dress up my baggy tomboy clothes with femme accoutrements. I wore shapeless t-shirts, jeans that were too big, stompy boots, and paired them with dangly earrings, silver rings on my fingers, and glitter gel on my eyelids. When those combinations stopped working, I picked through the baby t-shirts I hadn't thrown out when my fashion went butch lite, wore the flowered sundresses I hadn't worn since sixth grade, and let the hairstyle that I now refer to as Bad Lesbian Haircut #5 grow out. I saved up my allowances—five dollars a week—and I started buying my own clothes instead of letting my mother pick out what I wore. I stopped going on the long, excruciating shopping trips with her and my grandmother—the ones where they'd buy me clothes that were made for middle-aged women, not teenaged girls, and tell me that I'd be beautiful if I just lost twenty pounds.

Ma and my grandmother, Stella—whom I still call Nana—have harassed me about my weight my entire life. They started putting me on diets when I was six. I was an active kid. I played three sports all through elementary and middle school. I rode my bike everywhere. I ate vegetables, and my doctors said I was perfectly healthy. When I hit puberty when I was nine, I started to develop the curves that most of the women in my family have, and I've kept them. Looking back at childhood photographs, I've been amazed to discover that I was actually not a fat child. I developed the body shape I have now when puberty hit. But long before I went through puberty and became an actual fat girl, I was told that I was fat on a regular basis. When fat started showing

up on my body, the shaming grew worse. Ma and Nana's criticisms of my child body so quickly turned into criticisms of their own adult bodies; me being put on a diet so quickly turned into all of us dieting together. I never knew what was about Ma, and what was about Nana, and what was about me.

Nana is ninety-four years old now, still round, and still blessedly spry and healthy. She used to be 4'11," the same height that I am now, but she started shrinking sometime in the 1980s. Now, when we hug, her plastic, old-lady glasses bump my cheekbones. In pictures of her from when she was younger, the resemblance between us is uncanny. She used to wear thick cotton pants and shirts to work in the factories and canneries, cute little dresses and ladies' jackets and skirts to go out. Now that she's retired, she wears homemade dresses, muumuus from the sale rack at Penney's, and my dead grandfather's polyester knit cardigans with the little alligators on the left breast.

Nana subscribes to the philosophy that once you're over ninety, you should be able to do whatever the hell you want as long as it doesn't hurt anyone. So she wears her muumuus from the sale rack at Penney's out to fancy restaurants, and eats her meals with her fingers, and loudly calls people she doesn't like "assholes" in earshot of the waiter. She watches WWF wrestling religiously, and she routinely stays up 'til 3 am and sleeps in 'til noon because the best western and mafia movies are on late at night. And she still bitches to me about how she needs to lose weight, about how I need to lose weight, about how she's worried about my mom because Ma is losing too *much* weight.

When I came out to Nana, she was mad about how I was going to hell for about a year. Ma went to bat for me, took all the freaked-out, late-night "oh my god, my twelve-year-old granddaughter is a godless heathen!" phone calls, and answered all the offensive questions so that I wouldn't be burdened with them. Then Nana started looking at our family tree and found one queer person in each generation since she'd been alive: that uncle who never married and that girl-cousin who had the female friend she lived with until she was seventy. Nana convinced herself that being queer just runs in my family, and that God must be okay with it if he made at least one person in each generation—

"Gina, what do you call yourself, gay? A lesbian?"

"Bisexual, Nana."

"Okay, whatever, I can't keep up with you kids."

And then my mother interjects that the kids these days are actually calling themselves "queer," that they're "reclaiming the word!"

Nana's eyes go wide, and she crosses herself, saying, "Oh, my god!"

This is the complicated part: to love the women in my family so completely, to feel so thankful that I was not one of many queers who got kicked out or rejected—and to know that the values they instilled in me about my body and how to dress it were harmful.

I didn't realize it at the time, but buying that leopard-print skirt was one of my first rebellions against my mother and grandmother. How I dressed became a point of contention between us from that moment on. Nana was pissed about my increasingly crazy hair and piercings. Whenever she'd slip me a twenty at a family gathering, she'd instruct me, sternly, "Don't spend it on any more purple hair or earrings that aren't in your ears!" But Ma had a vested interest in me looking asexual. Ma liked my aesthetic best of all when I cut my hair and wore baggy clothes to fit in with all the older dykes I knew. She wanted me to be a tomboy—at least then I wasn't dressing sexy; at least then my fat wasn't noticeable because it was covered under the layers. Having a bookish, shy, baby-lesbian daughter with a bad haircut and clothes that were too big was okay with her. Having a radical bi-queer, sex-positive femme daughter with purple hair and a tight, leopard-print skirt and big revolutionary vocabulary was not.

As much as buying that skirt was about belonging to particular groups of women—the queer femmes, the riot grrrls, the bi revolutionaries, the sex-positive punk dykes—it was also about separation, about drawing a line between me and the other women in my family. This is me; and that's you, Ma; and that's you, Nana. We're separate.

iii. "In Her Hips, There's Revolution"

At the Femme Conference in 2006, eating cheap pad thai in the Tenderloin with a group of ex-punk femme girls—mostly older than I was, mostly women of color—riot grrrl came back to me unexpectedly. My friend, Leah, and I were comparing lipstick tips. She was singing the praises of MAC; I was showing her how I layer a bright pinkish red and dark purple burgundy to get my lips just right. I'd only met Leah in person a few months before, but I'd read excerpts of her old zine, *Patti Smith*, in *The Girls' Guide to Taking Over the World* when I was sixteen. At lunch, she introduced me to her friend, Iraya, who joined our lipstick discussion. *Iraya*...I kept thinking, *Iraya, Iraya, why is that name so...*

"Hey, Iraya...This has nothing to do with makeup, but were you in a band called Sta-Prest in the mid-nineties?"

Iraya's eyes went wide. "Oh my god, yes!"

"Dude, I totally had your seven-inch and read your interview in *Outpunk*! I put the 'Vespa Sex' song on so many mix tapes!"

And then Kristy, who was sitting next to Iraya, said: "Wait, you said your name is Gina ... You aren't Little Gina, are you?"

I laughed, and Iraya and Leah looked at me quizzically. "I was Little Gina back then, because I was thirteen, and short—well, I mean, I'm still short—and there was another riot grrrl, Gina, who was eighteen, and tall...Wait, are you Kristy Chan?! *Tennis and Violins* zine Kristy Chan? I met you through Ceci! Have you talked to her recently? We lost touch!"

The first grrrl convention I attended was in August 1996; the Femme Conference was in July 2006. I realized I was smack-dab in the middle of an unexpected Riot Grrrl "Where Are They Now?" Ten Year Reunion at the greasy Thai place. I started to get those same happy jitters I would

get when I was thirteen: the excitement of being surrounded by girls I thought were amazing, the high-energy gossiping, playing catch-up about our small, funny and sometimes dramatic community. But something more complicated was happening for me, too.

I want riot grrrl to be what saved me, but that's not the truth. I want the queer community and what passes for femme solidarity to be what saved me, but that's not the truth. Too many hipster dykes in identical outfits have ignored me or shunned me, discussed femmeness and fatness oh-so-radically, and given themselves pats on the back for being supposedly fat-positive at radical queer infoshops and in women's studies classes. Those girls talk in that riot grrrl/Valley girl voice that they probably don't realize they've gotten from early Bikini Kill records—the high-pitched, sarcastic, exaggerated voice, where every sentence is a question? Not because they're asking permission, but because they're questioning everything. Those girls are the ones who wear the cool outfits that I can't—the pegleg jeans, the tiny halter tops, the pointy leather or flat suede boots that slink up skinny calves to skinny knees. Those outfits don't look good on bodies like mine because those outfits don't *fit* bodies like mine. Post-grrrl hipster femme dyke fashion is hell on fat girls.

It shouldn't be surprising that I still had major issues with my body throughout high school and college. Even after all that good radical conditioning, I was still anorectic for a number of years. I still chased after lovers who were mean and dangerous because I truly believed that I was ugly and damaged, that was the best I could get as a fat girl survivor. I want my experience to be unique, but these experiences are all too common, even among good feminists, good queers, and good fat-positive, take-no-shit dykes.

Walking back to the hotel where the workshops were being held, Leah asked us to recall our favorite mid-nineties riot grrrl memory.

"I don't have one specific excellent memory," I said to her quietly. My mind flashed on so many little things: the grrrl conventions; my mom actually driving me to a club to see Team Dresch, but yelling at me about my push-up bra and fuchsia hair; eating vegan sandwiches that I wasn't really sure I could afford at some hipster café in Berkeley with Lila; making out with my first boyfriend during a punk fag Spin-the-Bottle game that I somehow got cajoled into joining; buying that leopard-print skirt.

But even with all the sweetness, a bitterness started to surface.

"I never felt like I was cool enough," I said. "I felt like I belonged to an extent, and that was amazing because I'd never felt anything like that before. But I was never cool enough because I never had enough money—and that was so huge. I had no idea that it was classism because my family wasn't on welfare, and we were so much better off than other people in my neighborhood. But I had so little compared to those other punk girls. And I was younger and bigger than all of them, which colored so much of my experience."

Leah nodded and said that at a certain point she'd relinquished riot grrrl for radical people of color spaces because she was tired of dealing with the racist and classist bullshit from the mostly-white, mostly-rich grrrl scenes. "There is life outside the infoshop," she deadpanned. I laughed.

And there's life outside the shows, I thought, *and the zines, the vegan diners, the conferences.* There is life outside the Kill Rock Stars catalogue that I painstakingly read to the last line and from which I ordered my first Bikini Kill record. There is life outside the now–trendy thrift shop where I bought my first leopard–print skirt.

As much as the fashion, the music and the movement were catalysts for change for me, none of it protected me completely from the rest of the world. Riot grrrl and the radical queer youth activist scene really did change my life. Those communities turned me around in amazing ways, helped me look at the world and myself in ways I never had before. But just because something changes your life doesn't mean it saves you.

None of those movements or communities ever completely, wholeheartedly embraced and welcomed me, but they were still better places for me than the rest of the world. As a hopeful, earnest, wide–eyed baby dyke, grrrl culture was the best fit—even if, sometimes, it was an awkward one.

The Lament of the Dolly Lama
by Clairanne Browne

"With a little lipstick, a little paint, a sad girl maketh what she ain't."
— Communication Workshop Seminar

The struggle to create visibility for Femme identity has not been given much attention in the history of queer understanding. There is a perpetual myth that Femme is only credible when partnered with butch, and that the nature of Femme is deemed a performative model of heterosexuality, as if the enchanting, seductive aesthetic and womanly sexual potency of Femme were an extension or mirror of straight women. This is not the case.

Femme is the self-asserted silhouette of not only our femininity, but our sexual desire and natural understanding of the seditious spirit of gender. However, it is essential to recognize that Femme identity is as politically potent as its historical counterpart, butch. With their roots in supporting butches from overt discrimination, Femmes were seen as the sexual temptresses and solid foundations of consolation for their battered partners within a community that alienated Femmes' very core beings. It was often overlooked, and still to this day it goes unrecognized, that Femmes, with their overt and glamorized femininity, by acquainting themselves sexually with butches instead of men, challenge and radicalize that heterosexual paradigm they are said to emulate.

As the independent Femme wilts coolly into the background of what used to be a brave political tirade of women existing as dolly birds amongst the lesbian community, we must necessarily reclaim what it means to be Femme—to celebrate it, discover it and express it, to wear it like a fabulous sparkling tiara, glittering with sass, class and all the rest.

Femmes are like nightingales that have lost their song. Reclaiming it takes time to piece together the parts that fell from memory. How is it that this unique identity encounters moments of sustained invisibility? How is it that Femme has the potential to become a paradigm within the broader queer community that often dare not speak its name?

I want to explore what Femme means. I want to express an energy that holds Femme as an exclusive gender, a powerful and credible identity. I am high Femme, ultra–high maintenance, sassy, forthright, dolled up to the nines, performative in the nature of creating and living my gender role, both as a counterpart duality on the see–saw of the butch–femme dynamic, and standing alone—delicious and free.

How important is gender? The third gender, the fourth gender? Why can't Femme be the first gender, a torch of flames that incorporates strong mother and soft lover and vivacious vixen and passionate all–pervading diva, lighting the path for all who wish to don the dress of femininity?

To those who don't hold gender as important or pivotal: what luxuries, what pills or dollar bills have they been fortunate enough to possess in order to feel this casual indifference? In terms

of what I am attracted to and what turns me on, I know that gender and its recreation are focal points in my day-to-day life.

The journey we take to discern exactly what it is that speaks our innate Femme qualities to each other, to the butches who love us and to those who have a lesser understanding of our identity, is one that is diverse and full of surprises. It is a path of self-awareness that is always evolving on a timeline of Femme expression. From the Femmes of the '40s who ingrained traditional media gender imagery into our ever-growing culture to the iconic Femme of the '80s, repainting the paled version of Femme whose color was bled by '70s feminist ideals. There are so many expressions of Femme, from the primped and preened high Femme with matching four-inch heels and handbag, to the Femme that subverts traditional femininity by challenging the socially accepted blanket objectification of heterosexual women by heterosexual men. Every facet of this Femme nature is unique.

Tell me, how does this nightingale remember her song?

It was seared in her mind when she sang it by heart, and with time and trauma, it drifted away, note by note, until there was nothing left.

Perhaps fear drives misconceptions about Femme in the lesbian community and in the heterosexual majority of society as well. Perhaps it is a sense of not wanting to amalgamate with "the other," as when the classic high Femme partners with a butch and thus heightens social awareness of lesbianism through their conspicuous expression of gender subversion. Is it safer for queers not to "rock the boat" with a symbolic challenge to what is considered the norm (i.e., hetero-normative paradigms) so that there is a common desire to silence such outwardly marked aspects of this experience?

Misunderstanding from the broader queer community is not uncommon; any of us who identify as queer likely have experienced it in some form. It poses an ethical puzzle for us as we face marginalization in our very own home. Discovering my Femme identity was fraught with these little potholes in the road to self-definition.

As a young woman identifying as a lesbian and having just discovered my adoration for butch women, I began eventually to explore ultra-feminine expression. Previously, I was attached to symbols of androgyny when I first came out. As I became more aware that other forms of expression existed, piece by piece I gave my wardrobe of oversized, button-down shirts and cowboy boots to my lover. Trinket by trinket, I collected powder puffs, vintage pillboxes, hats and heels. I started wearing heels as often as I could, gradually growing taller, and along with that height came an increasing sense of feminine empowerment. An arched back and a high Femme sashay worked with my swinging hips.

I was a performer. I sang with a band in pubs and clubs. I commanded male attention, and as I developed my Femme-ness, I noticed the sexual power that women had in the universe, contracting around genderplay like fine-fingered sculptors. That I could hold their gaze but not pander to their desires gave me incredible strength. From this knowledge and understanding, my high Femme was born. The glamour and glitz of taking the performative costume of Femme to the

very limit complemented the nature of working a crowd. The fact that versions of femininity can be appropriated and twisted to explore gender subversion gave the dramatized aesthetic a new and empowering energy.

I was told a few times that I dressed like a straight girl.

"No, I dress like a Femme. I am a gay woman. And this is what one looks like, for the simple fact that I am."

Saying these words, reaffirming my personal comfort zone and creating a platform for Femmes to be bold in our image and outward confrontation of social norms, fuels a celebration of unique gender representation. Such a celebration is at the heart of Femme identity. We are, as a gender, fundamentally sustaining a political edge that cuts deeper with every acknowledgment of who we are.

As I clearly defined my gender in parallel terms to my sexuality, I was faced with a quandary. How is it that being Femme can have such a negative connotation in a seemingly accepting gay world?

The city I am from has a lesbian bar I frequented, often to be looked at as if I had left the boyfriend at home on the couch watching football to spice up the routine of my heterosexual life by tagging along with my lesbian friends. The bar ran a regular karaoke night on Sundays. I attended one evening, along with my girlfriend at the time and her lesbian softball team. I sang Dusty Springfield's "Spooky" in a tiny, tight black dress and a pair of red Christian Louboutin heels; I poured my vocals out like a steamy seductress. It was Femme performance, and it stirred an evocative energy in the room.

The MC of the evening wrapped up my number with this statement: "Well, what do we have here? Now, who are you with tonight, gorgeous?"

Femme in black gave a shout–out to the softball team, who cheered and clapped.

"And let me ask you, as I am sure everyone here is dying to know…Look at your shoes, they are divine! Not the comfortable shoes we are used to seeing here. Those lovely pins and that very fine dress . . ."

I think there was even a comment regarding my hair, but memory fails to pinpoint the words. Memory recalls, however, the sickness I felt in my stomach, and that is surely enough.

"You certainly don't look like your fellow comrades over there. Are you really a lesbian?"

I felt like a token. I felt like a piece of furniture in an auction hall. If I were to encounter that situation now, I would have so much more to say.

I am not a straight girl. A straight girl will never hold a mirror up to one's disdain of such political blindness because straight girls are not queered and wouldn't begin to understand what it is like to walk a mile in these shoes—these black stilettos.

That day I was filled with fire. It was not that gleaming passionate fire that knocks a bad boi off his feet. It was the sort of fire that rises in your belly and makes your eyes feel tight in your head. As I tore off the stage and marched to the bar to request the manager, my girlfriend was already three steps ahead. What a beautiful reminder of the butch–femme dance, the components of each of our energies complimenting and supporting one another. We both spat vitriol about how a Femme should not be marginalized in her own community. How a Femme should be able to take up space in an environment that claims to welcome diversity, not patronized, ridiculed, objectified and alienated as so many queers have been in the history of gay politics.

At the time I was young and didn't understand the potential power of this identity. Perhaps not many do. We are so many and so strong in our common belief. Why should we not make more noise?

To regain her song, a nightingale must practice. She begins to sing and then forgets the tune. She must keep the sound alive and hum a little, then stop, then start, and let it come back to her memory in sweet interludes, until she remembers it by heart again. Then she must sing it clear and strong, so that it may seduce the ears of those who have never heard its beauty.

The developmental process of gender identity is not clear–cut for a Femme. We have worked so well as a duality that when we stand alone, we can only be recognized as a replica. What goes unnoticed is the power and sincerity of Femme temperament as well as the power to subvert the patriarchy and still be iconically sensual. We run way beyond our hair and makeup, heels and handbags. We run with a passion, entrenched deep in our history, that speaks of our diversity in gender presentation and sexuality.

We are comfortable, if not certainly attached, with a great fondness to our identity. We are not propelled by it, nor bemused by it. We hold it up to the sun, knowing it won't melt. We are what we are. Brazen Femmes. Gender outlaws. We will fight the law, and honey, this time, guess who will be victorious? Like proud flamethrowers, throwing fire in the snow.

Femmiest of Femme Hobbies
by Tara Hardy

"Femme is knowing what you're doing."
—Airen Lydick

BUST Magazine has called knitting the femmiest of femme hobbies. Funny, I thought fucking was the femmiest of femme hobbies. The kind where I'm bending someone over my work bench and really giving it to 'em. Hard. And pink. Gumming up their engines with the fine pouty lass pointing East, West, South, North from my pelvis. Dangerous as a compass pointing to my other femme hobbies such as defending genderqueers from hate crimes at gas stations, cop shops, parking lots, coffee bars, Anti–Bush Rallies (the politician, not the beaver), grocery stores, family holidays, doctor's offices, and Womyn's Music Festivals.

Of course, I can't spend all my time on my hobbies, 'cause I've gotta keep the phone on. As you know, we girls do talk a lot on the phone for purposes such as exchanging sewing patterns. Like how to stitch together a whole damn community's network of nonprofits that attend to our health, safety, and emotional needs, defend our civil rights, provide places to make art, to start businesses, to publish and disseminate—excuse me, ovulate—what we consider to be real news, like how to gender a hobby properly.

Like baking. That's definitely femme. Think about it—ya got the measure, ya got the sift, ya got the stirrin' up somethin' outa nuthin' like a reason to stay true to your hemline even though everyone around you is thinkin', "Don't she know we been liberated into PANTS?!" Which brings me to one of my other hobbies—Fending Off the Feminists. Since I am one, sometimes this means fending off myself. It goes something like this: "Self, of what purpose is the razor in your shower? Don't you agree that the dominant discourse on shaving for women means it's compulsory?" Then I really break down, my femme takes over, and she starts singin', "Stand by your...POLITICS!"
If you can trust me with a reproductive choice, then why can't you trust me with a razor? If I'm allowed to harvest my womb at will, then why the hell can't I harvest my hair?

Here's the thing—when we step outside of our meant-to-be desexualized selves, and deliberately get all gendered up...it's resistance! Not capitulating, but resistance, not capitulating, but resistance, not capitulating, but resis...(slaps self).

Where have I heard that before? Oh right, from me! And every other working-class femme I know. Which brings me to our other hobby—repeating ourselves! Incessantly. About how we know what the fuck we're doing. Which includes my grandmother: her hobbies were keeping her children fed while her husband drank away the farm. Every day for thirty years, she put on her heels and true red lipstick, took the bus to downtown, and knowingly let her boss look up her skirt, meaning an extra twenty cents an hour. If you think that's not much, you try livin' on the

seven cents per dollar that actually makes it back to the farmer. I call this the genius of working-class femininity—I don't care if you got semen or jizzum staining your sheets—femme is knowing what you're doing.

Which brings me to the real reason that I think the feminists are mad—femmes, we're gettin' laid. Since I put away my sensible monochromatic, understated, or even postmodern, urban, rippin' off the laborer gear, and took my true self out of the costume closet, it's been the second coming of Christmas. It's a strange thing: the more you're authentic to yourself and your history, the more you desire and are desired. It's beautiful like that.

But before I get all predictably femme weepy on ya, let me mention just a few hobbies of a few of the femmes I know: Amy, Michal, Jesse, Becca, Sabrina, Raquel, Debbie, Amelia—they're marching with the steel workers, building roads, queering up the media, sending packages to prisons to keep our brothers alive, doing radical drag, writing manifestos, plotting spoken word tours, composing music, singing opera, organizing rallies, wiping asses, drafting legislature, puttin' on conferences, and raising the next generation.

In short, we are Running the Fuck, the world, and our knitting needles up the noses of those who insist that there are limitations to our label. Whose agenda is that? 'Cause when I spy femme, I spot someone brave enough to swim upstream amid a hailstorm of combat boots, classism, urban cool, and feminist theory books. But then again, our number one hobby is keeping ourselves strong. 'Cause we got work to do—it's one of our hobbies.

Contributors

Amy André is co-author of *Bisexual Health*, a book published by the National Gay & Lesbian Task Force. She has essays in books such as *Nobody Passes: Rejecting the Rules of Gender and Conformity*; *Best Sex Writing 2008*; *Waking Up American: Coming of Age Bi-culturally*; and *Getting Bi: Voices of Bisexuals Around the World*, and her articles appear in *American Sexuality*, *ColorLines*, *Curve*, and *Playgirl*. She is also the director of the internationally-screened transgender documentary, *On My Skin*. Currently, Amy is pursuing an MBA in nonprofit management. Visit her at AmyAndre.com.

Mette Bach wrote about femme identity in her syndicated humor column, "Not That Kind of Girl," for nearly four years. Her work has been anthologized in *First Person Queer*, *Second Person Queer* and *Fist of the Spider Woman*. She now writes a column called "From Queer to Eternity" for her local LGBTQ publication, *Xtra West*, in Vancouver. She contributes to *The Advocate*, *Globe and Mail*, *Vancouver Review* and *WestEnder*. She has an MFA in creative writing from the University of British Columbia. Her first book, *Getting Over Delta*, comes out in 2010 from New Star Books. More information about Mette Bach's work is available at MetteBach.com.

Brook Bolen is a saucy, redheaded femme minx with more Scorpio in her chart than you can shake a stick at and mother to the two greatest pit bulls in the history of the world. When she is not dreaming of the Appalachian Mountains from whence she came, she is rescuing animals and pursuing a graduate degree in women's studies. Brook enjoys spending her free time hiking, reading (equal parts social theory and Patrick Califia), whipping up deliciously healthy eats, tending to her manicure and garden, and pursuing counter hegemony.

Clairanne Browne is sassy-mouthed, modern, pin-up high femme, scene-stealing soul chanteuse, feisty, ultra-high maintenance, known around the traps as "trouble." She feels awkward in flats, is pathologically bossy and can talk herself out of any situation. Dreamer, schemer, creator, cinnamon peeler, broken wing healer, rage tamer, genderfucker, broad who drinks. Self-professed femme bottom, one of the best in the business. Clairanne celebrates queer theory, gender diversity and motions of the heart. Find more about her at mynameislina.blogspot.com or contact mynameislinalina@yahoo.com.au.

Sand Chang, PhD, is a genderqueer, genderfluid femme of Chinese American descent who lives in Oakland, California. Sand has performed all over the country and internationally as drag king Charleston Chu and faux queen Charlotte Starlette and is a member of the hip-hop fusion dance company Freeplay Dance Crew. Sand is also an activist, musician, and psychologist specializing in addictions, eating disorders, and transgender issues. Sand has contributed to *Monolid* and *Nobody Passes: Rejecting the Rules of Gender and Conformity*. Sand can be reached at sandstar@gmail.com.

Joshua Bastian Cole is a twenty-something Yankee transplant to the South and alumnus of James Madison University. He is a femme-identified trannyfag performance artist and playwright who uses performance as a medium for activism and trans awareness. Cole has been published and seen and heard in newspapers, books, magazines, ezines, photo series, films, radio, and podcasts. He is also the bookwriter and lyricist of the new musical, *Transitions*. His website is jbastiancole.tripod.com.

Traci Craig is a femme dyke academic spoken word artist. Currently a professor in northern Idaho, her research revolves primarily around gender diversity in the workplace, LGBT issues and butch/femme relationships. In her spare time, she performs as DocTraYC as a feminist activist spoken word poet and emcee.

Jennifer Cross is a Bay Area–based writer and writing group facilitator. Her stories/writing appear in numerous anthologies (some under Jen Collins), including *Best Sex Writing 2008*; *Blood Sisters*; *Nobody Passes: Rejecting the Rules of Gender and Conformity*; *Best Women's Erotica 2007*; *Best Fetish Erotica* and many others. She spent April 2008 rocking the country open with the nationwide *Body Heat: queer femme porn tour*! A queer survivor of sexual abuse, she's a firm believer in the transformative potential of smut. For more information about Jen and her work, including her writing workshops, visit writingourselveswhole.org.

Gina de Vries still wears leopard print at every available opportunity. She's also still a radical bi–queer sex–positive femme, but she's mellowed out a lot since she was fourteen. She is the co–editor with Diane Anderson–Minshall, of *[Becoming]: young ideas on gender, identity, and sexuality* (Xlibris Press, 2004). Her work has been published in many places, including *Tough Girls 2: Down and Dirty Dyke Erotica*; *Transforming Communities*; *Baby, Remember My Name: An Anthology of New Queer Girl Writing*; *That's Revolting!: Queer Resistances to Assimilation*; and *On Our Backs* and *Curve* magazines. You can cruise her online at ginadevries.com.

Emjāen Fetherston–Power identifies as HighFemme, queer, feminist, expat/Anglo/migrant/Asian, PowerFemme, kinky, and Buddhist, among other labels. Born in Australia and raised in Asia, she lives in Melbourne, where she writes and performs her spoken word, collects and sells vintage, paints, draws and sews. She is currently retraining from welfare work to a less stressful career as a librarian.

Katrina Fox is a freelance journalist originally from London and based in Sydney, Australia, since 2001. She has worked extensively for the GLBTIQ media, including a year as editor of *Cherrie*, a monthly national lesbian magazine in Australia. Her work has appeared in a number of publications internationally, including *Time Out London*, the UK's national lesbian magazine *DIVA*, and the US national lesbian magazine, *Curve*. Katrina is the editor of three nonfiction books on sex and gender diversity: *Sex, Gender & Sexuality: 21st Century Transformations* (1999), *Finding the Real Me: True Tales of Sex & Gender Diversity* (2003), and *Trans People in Love* (2008). She is a high–femme, lipstick–lesbian, sex–positive, vegan feminist who enjoys combining high camp and glamour with ethical, cruelty–free living. She lives with her long–time girlfriend and author, Tracie O'Keefe, and a cat called Gabrielle. Visit katrinafox.com for more information.

San Francisco–based poet **Daphne Gottlieb** (MFA, Mills College; BA, Bard College) stitches together the ivory tower and the gutter just using her tongue. She is the author of four books of poetry: *Kissing Dead Girls* (Spring 2008), *Final Girl* (2003), *Why Things Burn* (2001) and *Pelt* (1999). She is also the editor of the anthologies *Fucking Daphne: Mostly True Stories and Fictions* (2008) and *Homewrecker: An Adultery Reader* (2005). Additionally, she is the author of the graphic novel *Jokes and the Unconscious*, illustrated by Diane DiMassa (2006). She was the winner of the 2003 Audre Lorde Award for Poetry and a 2001 Firecracker Alternative Book Award. Her work frequently appears in journals and anthologies including *Word Warriors: 35 Women Leaders*

in the Spoken Word Revolution, McSweeney's Internet Tendencies, nerve.com and *Short Fuse: A Contemporary Anthology of Global Fusion Poetry. Final Girl* was adapted for the stage in 2006 at University of California, Northridge.

Tara Hardy is the working-class, queer, femme poet who founded Bent, a writing institute for LGBTIQ people in Seattle, Washington. A daughter of the United Auto Workers and activist in the Battered Women's Movement, she was elected Seattle's Poet Populist and won Seattle Grand Slam Champion in 2002. She's competed on four Seattle Slam Teams, coached two teams, and most recently brought home the fourth-place trophy from the 2008 Women of the World Poetry Slam. To contact Tara, or to arrange for a performance, email wordyfemme@hotmail.com. Her webpage is tarahardy.net. You may find her on MySpace at myspace.com/tarahardygetsbent.

Electrofemme performer and artist **Hadassah Hill** (aka Axon Damien Luxe) is a repatriated expat, double agent, DIY tech geek, and high-femme liberationist who's been entertaining crowds for over twelve years. She's performed live poetry at numerous events, including Femme 2008 & 2006, Queeruption 10, Writing Outside the Margins, The Seattle Science Cabarets, Sista'hood, Ladyfest, Hysteria, Trade Queer Things, Mayworks, High Femme Friday, and at colleges and universities. Hadassah performed with the now-retired all-femme troupe, Trash & Ready (trashready.com). She has been published in *Without A Net* and *Geeks, Misfits and Outlaws*. She's a graphic designer and currently volunteers for spreadmagazine.org as Art Director, and she teaches DIY media workshops. She's also a textile artist who works in costumery, reconstructing/recycling vintage clothing, and embroidery. Lastly, she's made her mark, along with Tex Bronco, as a starlet in the ubiquitous dirtypillows.com and as a model at aslanleather.com. She loves anything on two wheels and rhinestones. For more, see hadassahsbizzare.com.

Kpoene' Kofi-Bruce is the founder of the Ladies Independent Design League. A radical queer activist who is currently taking recruits for her girly-girl army, Kpoene' is a former DJ, Radical Cheerleader, drag queen, dancer, and editor of *Tooth and Nail* and *RiffRAG*; she sat on the editorial board for *Clamour Magazine* (RIP). Her designs and writing have appeared in *Bust, Bitch, NEET,* and *The Washington Post*. She has lectured on the role of the activist in a time of war at Sarah Lawrence College, The New School, and the University of Maryland. She recently co-organized the 2nd Annual Craft Congress. When she isn't designing custom wedding dresses for queer couples through her label Mignonette, Kpoene' lives in San Francisco with her partner and is compiling interviews for a book on women of color in Third Wave Feminism. Visit her online at msmignonette.blogspot.com.

Asha Leong has always been a southern belle at heart and lives in Atlanta, Georgia. Asha is the product of many parents, is proud queerspawn, and above all loves her international family. Asha identifies as a queer, Femme, multiracial immigrant. At heart, Asha is a community organizer with a passion for social justice who has spent a decade organizing for queer-allied communities. When not rabble-rousing with the queers, Asha indulges her artistic side through writing, dancing, and performance art. Asha's drag king alter ego, Al Schlong, can be found gracing dark alleyways and stages nationwide. Full details of Al's deviant desires can be found at myspace.com/alschlong.

Katie Livingston navigates the boundaries of being femme and doing femme. She is a graduate student in Critical Studies in Literacy and Pedagogy at Michigan State University and spends her spare time hunting for feminist books and zines and facilitating a queer writing group at the local LGBT community center outside Detroit. Her little brother is still her favorite femme.

Sassafras Lowrey is a genderqueer high femme, militant storyteller, author, artist, and activist. Ze believes that everyone has a story to tell, and that the telling of those stories is essential to creating social change. An accomplished storyteller, ze was an original member of "The Language of Paradox" founded and directed by Kate Bornstein. Ze is a contributor to numerous anthologies including, *LGBTQ: America Today*, *The Femme Coloring Book*, and *Gendered Hearts*. Sassafras was honored as one of Portland's top emerging writers by In Other Words Women's Books and Resources in 2004. Ze is the editor of the highly anticipated *Kicked Out* anthology (Fall 2009) from Homofactus Press. Sassafras is also the author of *GSA to Marriage: Stories of a Life Lived Queerly* (Homofactus Press, Summer 2010). Ze lives in New York City with hir partner, two puddle-shaped cats, and a princess dog. For more about Sassafras, visit pomofreakshow.com.

Carol Mirakove is the author of two books of poems, *Occupied* (Kelsey St. Press) and *Mediated* (Factory School), and she appears on the Narrow House spoken-word CD, *Women in the Avant-Garde*. With the subpress collective, she edited *Fractured Humorous* by Edwin Torres. Her critical writing appears in the magazine *Traffic* and the newspaper *Boog City*, where she and Jen Benka were politics coeditors from 2007–2008. A New York native, Mirakove lives in Brooklyn.

Yael Mishali, a twenty-nine-year-old Mizrahi femme, lives in Tel Aviv, Israel, and is a doctoral student in the Cultural Studies Department at Tel Aviv University. She is writing her dissertation about butch-femme autobiographies. Yael has been published in anthologies and academic journals. Active in feminist queer and Mizrahi organizations in Israel, she currently runs a femme support group and performs FtF drag.

Moonyean is a life-long lover of books. A California native, she is happy to be living there again after a sixteen-year break in Arizona where she earned an English degree and owned a feminist bookstore. She lives in northern California with Lakke, her spouse, and Shadow, the most wonderful dog in the world. She was previously published in *Hitched! Wedding Stories from San Francisco City Hall*.

Sheila Hart Nelson is an Appalachian-raised femme dyke. She has been a featured reader at Gender Crash, a monthly open mic in Boston, Massachusetts. Off the page, she is an activist and sexuality educator.

Margaret Price teaches writing at Spelman College in Atlanta, Georgia. Her work has appeared in *Creative Nonfiction*; *Bitch: Feminist Response to Pop Culture*; *Disability Studies Quarterly*; *Breath and Shadow*; and *Wordgathering*. She is at work on a book about the intersection of madness with academic life.

Miel Rose is a chubby, low-income, queer femme of various european ancestry. She feels she is proof that you can be born with gender and spent her young femmehood running around the woods, climbing trees in glamorous rummage sale dresses. She wrote "Prayer" a couple years ago

during an intense period of isolation living in northern Vermont, where she grew up. Mostly she writes porn, and you can find her stories in *Best Lesbian Erotica 2008*; *Best Women's Erotica 2008*; *Ultimate Lesbian Erotica 2009*; and *Best Lesbian Love Stories 2009*. "Prayer" is dedicated to all her femme loves, especially Cory Skuldt, who brought her out.

Maura Ryan is a queer high femme, a radical sociologist, a teacher, a student, a feminist (despite its shit), a southerner (despite its shit), and an impeccable hostess (seriously write to her for a cookie recipe). She loves curly hair, high heels, Sephora, and talk of a revolution—especially all at the same time. Building femme solidarity and recognizing femme loveliness is her greatest pleasure. Contact femmehotness@yahoo.com.

Stacia Seaman is an editor who has worked with *New York Times* and *USA Today* best-selling authors. She has edited numerous award-winning titles and has herself won a Lambda Literary Award with coeditor Radclyffe for *Erotic Interludes 2: Stolen Moments*. She lives with her cat, Frieda, and enjoys being silly.

Allison Stelly is a fierce femme living and loving in Austin, Texas. She produces Kings N Things, Austin's longest-running drag king/genderbending troupe, takes the stage herself as her high-femme alter ego, Miss Cherry Poppins, reads gender theory for fun, and can't let a day go by without crafting.

Ann Tweedy is a poet and a lawyer. Her poetry has been published widely in literary magazines and anthologies such as *Knock*; *Harrington Lesbian Literary Quarterly*; *Rattle*; *Getting Bi: Voices of Bisexuals Around the World*; *Clackamas Literary Review*; *Gertrude*; and *The Drag King Anthology*. She has been nominated for a Pushcart Prize, and her poetry chapbook, *Beleaguered Oases*, is forthcoming from TcCreativePress in Los Angeles. Some of her poetry is also available on her website, anntweedypoetry.com. After several years of practicing law, Ann recently transitioned to teaching at a law school. She is also an Advisory Editor for *Knock Journal*.

Sharon Wachsler lives in rural Western Massachusetts with her partner and service dog. An award-winning poet, essayist, and cartoonist, her fiction appears in dozens of books, including *Best American Erotica 2004* and *2005*. Recent titles include *Bed: New Lesbian Erotica*; *Periphery: Erotic Lesbian Futures*; *Lipstick on Her Collar*; and *Doorknobs & Body Paint*. Sharon's been a Pushcart nominee for poetry, an Astraea Foundation grantee for fiction, and a contributor to numerous Lambda Literary Award finalists and winners. Sharon recently gave up her editorship of *Breath & Shadow* (abilitymaine.org/breath), the first literary journal written and produced entirely by people with diverse disabilities. She thanks Betsy, Gadget, her PCAs—especially Gloria—and Jen Burke for making this essay possible. Visit Sharon at sickhumorpostcards.com.

Anna Watson is an old-school femme who reads and lives in a suburb of Boston, Massachusetts, with her two sons and her butch beau. Look for her celebrations of butch/femme in *Best Lesbian Erotica 2007, 2008,* and *2009*; *Fantasy: Untrue Stories of Lesbian Passion*; *Girl Crazy* (forthcoming); *Ultimate Lesbian Erotica 2009*; and the drag king anthology from Suspect Thoughts Press.

Josephine Wilson is an academic, published writer, and performer. She is currently completing her PhD in gender studies. She lectures, writes and performs regularly about the subject of

trans, sexuality and femme, among other topics. Most recently she produced and performed in *The Genderqueer Playhouse*, a show focusing on the multiplicities of gender as performed by a company of queer artists. This show is the basis for a new film, in which she also appears: *The Lovers and Fighters Convention* (2009), directed by Mike Wyeld. She has just finished a four–month run appearing in Suzanne Osten's *Glada änkan* at Stockholm's Folkoperan. She appears in several films, including Zemirah Moffat's *Mirror Mirror* (2006) and Inge Blackman's *Fem* (2007). Josephine appears on Truly Kaput's album, *Bed Songs* (2006, Irrk records). She currently lives in Stockholm with her sometimes–femme partner, Sofia, with whom Josephine is completely besotted. More information about Josephine and her antics can be found at josephineallison.com.

J.C. Yu lives in New York City. She has worked professionally on issues of domestic violence, HIV/AIDS, and education, including an after–school program for LGBTQ youth. She has been involved in arts activism and health advocacy projects with many grassroots organizations in New York. J.C. was on the Programming Committee for the Femme 2008 Conference that took place in Chicago.

About Homofactus Press

Thank you for purchasing a Homofactus Press book. Your purchase enables us to keep doing what we love to do: make great writing available to all people, regardless of income or ability. Learn more about our business practices at homofactuspress.com.

The mission of Homofactus Press is to publish books that discuss our complicated relationships to our bodies and identities, with all the complexities and contradictions such an endeavor entails.

To chat with our authors, contributors, and other Homofactus Press readers; to find an author reading in your area; and to learn more about micro-digital publishing, please visit our discussion forum at homofactuspress.com/boards.

If you enjoyed this book, please consider other Homofactus Press titles:
Visible: A Femmethology, Volume 2, edited by Jennifer Clare Burke
Self-Organizing Men, edited by Jay Sennett
The Marrow's Telling, by Eli Clare
Two Truths and a Lie, by Scott Turner Schofield
Cripple Poetics, by Petra Kuppers and Neil Marcus

And coming in 2010: *Butch Bottoms*. Read more at butchbottoms.com.

he labored under the misguided notion that femmes must wear lipstick.

Printed in the United States
213083BV00004B/2/P